CW01269348

CHINA

HISTORY AND TREASURES OF AN ANCIENT CIVILIZATION

WHITE STAR PUBLISHERS

CONTENTS

INTRODUCTION
PAGE 10

CHINA: FROM IT...
TO THE FIRST E...
PAGE 16

THE PERIOD OF...
PAGE 100

THE SONG EMP...
THE SPLENDOR...
URBAN CULTUR...
PAGE 154

INDEX - BIBLIOG...

INTRODUCTION

The first aspect that strikes us about China is the extraordinary continuity of its civilization, which has lasted over the millennia, unlike others in various parts of the world that developed in antiquity, but which have disappeared into the mists of time through decline or destruction by external forces. The dynastic history of China evolved over 4000 years, beginning with the Xia – who are thought to have entered the scene on the threshold of the Historic Period, in the first half of the 2nd millennium BC – and ending with the relatively recent Qing dynasty (1644–1911). To this astonishing length of time we should add the fertile Neolithic cultures of extremely ancient origin. This continuity was fostered by the profound awareness that the Chinese ruling class had of this concept since China's remotest times. This awareness of continuity was clearly demonstrated by the great importance attributed to historiography, which resulted in a huge resource of documentation compared to that of other ancient civilizations, as well as the tendency to recover and study the material and artistic culture of preceding dynasties, which arose cyclically, generating moments of huge development for collecting and antiques. However, it should also be said that this type of awareness, and the ideal image of the State forged by the major players and representatives of Chinese history, inevitably influenced the development of the actual historical process: from an ideological standpoint this perception was so widespread, strong, and heartfelt that it tended to stress the elements of continuity rather than those of discontinuity, through constant reference to models drawn from the past as much from historiography as from the actual application of State power and organization.

This dedication to continuity nonetheless cannot be confused with the tendency to ultra-conservatism, nor should it be seen in the perspective of a static vision of historical development. A frequent recourse to the "cycle" concept – and to dynastic cycles in particular, understood as stages of time linked to the emergence of new reigning families – precisely by traditional Chinese historiography, has often been a misleading factor for interpreting the events and processes of revolution and transformation that Chinese culture encountered over the millennia, just like any other civilization. In this traditional vision, despite the changing dynasties, institutional and social continuity would be assured by the monarchs who undertook government, since in fulfilling their responsibilities correctly and in compliance with Virtue – no matter who the reigning family might be – they ensured a connection between human society and the cosmic order. If concurrence between human and natural order was to be lacking at any particular time due to a sovereign's default or ineptness, Heaven (*tian*) – the supreme manifestation and guarantor of cosmic order – would revoke the so-called "Mandate of Heaven" (*tianming*), and action would be taken by the functionaries, who represented State continuity, by popular demand. In fact there were many rebellions during Chinese history that put an end to one and sanctioned the birth of a new dynasty.

As contacts between Europe and the Chinese world intensified, this traditional vision was adopted by the Western world and gradually materialized in a concept that emphasized these elements of continuity, interpreted in a perspective that might be positive (those who saw China as a sort of self-perpetuating ideal State, governed by wise officials and philosophers), or negative (by those who declared that the Chinese world was immobile and conceived it as a static system, or even as the sheer negation of progress). Notwithstanding various aspects that were actually repeated with some periodicity and cyclicity over the course of Chinese history, this does not mean that substantial modifications were never enacted. In observing the development of ancient China from its origins to the time of the Mongol conquest and the Yuan Dynasty, we sought to provide a historical framework within which we could establish the salient features of the artistic developments and a standpoint for looking at the social transformations,

8 - The bronze mirror dates back to the Western Han dynasty, 2nd century BC. The rear is split into concentric bands and is decorated with human and animal figures (FSG).

9 - This imposing polychrome wooden figure of Guanyin (the bodhisattva of compassion) is possibly the best-preserved and most extraordinary sculpture of Chinese Buddhist Art of the Liao period (907–1125) (NAM).

9

the changes in the organization of the State and the economy, the evolution of general concepts that affected moral outlooks and people's lifestyles. In this overview a number of phases emerged and they are the focus of the various chapters, which are related to the emergence of identifiable phenomena that highlight the significant developments as they occur.

These stages have been described in individual chapters. The first section analyzes the period from the origins to the threshold of the unification implemented by Qin Shi Huangdi, and the creation of the first Empire (221 BC); the second deals with the birth and consolidation of the Empire and its bureaucratic apparatus, up to the fall of the Han dynasty (220 AD); the third with the period of fragmentation that ended with the reunification achieved by the Sui (589), heralding great developments despite the disintegration of the imperial structure. In chapter four we enter the cosmopolitan world of the Tang dynasty (618–907), which restored life to the centralized Empire (still organized according to eminently aristocratic criteria, but with a gradual extension of the social base from which the administrative structure drew resources) and which made the Chinese State, supported by a tried and tested bureaucratic structure, the greatest power in the world. Following a short period of division, known by convention as the "Five Dynasties" (907–960), with the Song period (960–1279) a new type of society was established – discussed in chapter five – that produced significant economic development and the birth of a "proto bourgeoisie" and a refined urban culture, with excellent results from an artistic point of view. The period closes with the Mongol conquest and the institution of the "barbarian" Yuan dominion (1279–1368), with further importance being acquired by the merchant element within Chinese society and new developments in the arts. This last period takes us back to one of the crucial aspects of Chinese history: although it is easy enough to perceive this great country as being a monolithic entity, the development of its culture must really be seen as a continuous interaction between the purely Chinese element and the populations by convention known as "barbarian," who surrounded China on all sides, the so-called *zhongguo* or "Middle Country," a term that was originally used – in the Zhou period – to indicate the "central principalities" of a more ancient tradition, located along the banks of the Yellow River. So, where possible, we have sought to take these peripheral realities into account, as well as the reciprocal influences that arose between these peoples and China itself, to the north and to the south.

10-11 - This elegant Tang period ceramic horse with colored pigments – that seems to be dancing – was produced between the mid-7th and early 8th centuries. In fact, horses were trained to perform in time to music for special occasions at the Tang court.

HISTORY AND TREASURES OF AN ANCIENT CIVILIZATION

CHRONOLOGY

FROM THE NEOLITHIC TO THE BRONZE AGE
(ca. 8,000–16th century BC)

The Chinese Neolithic Period is characterized by agriculture. Evidence of pottery making appears during the Early Neolithic period and is usually associated with the rise of agriculture and sedentary living. The Xia dynasty is traditionally thought to have flourished from approximately the 21st century BC to the 16th century BC. The historical existence of the Xia dynasty, is a major issue of contention among archaeologists.

THE SHANG DYNASTY
(16th–11th century BC)

Two important sites of the subsequent Shang dynasty have been found at Erligang, in Henan province, and at Yinxu, their final capital, in Anyang. Ritual bronze and jade items were found in aristocratic graves, and will have been used during ceremonies in honor of ancestors. Other findings include inscribed "oracle bones."

THE ZHOU DYNASTY
(1122/1028–221 BC)

The Shang were succeeded by the Zhou. The first period of the dynasty goes by the name of Western Zhou, because the capital was founded at Chang'an, in the west. In this phase a new approach to power was established and a new type of aristocracy emerged. In 770 BC the capital was moved to the east, to Luoyi, and the Eastern Zhou period began (770–221 BC), which was distinguished by the gradual weakening of central authority. Confucius (551–479 BC) was alive during this period. He initiated a system of ethical and moral values with far-reaching consequences. The hegemonic Qin state came into being at the end of this period, reunifying the various kingdoms and leading to the foundation of the First Empire, in 221 BC.

THE FIRST EMPIRE
(221 BC–220 AD)

After the foundation of the Empire, a unification of script, weights and measures, coinage, and the wheelbase of carts was ordered. A great capital was built at Xianyang, on the River Wei, while just beyond a mighty burial complex was constructed, defended by over 7,000 terra-cotta warriors, who were to guard the mortal remains of the First Emperor. A rebellion led by Liu Bang, the first Han monarch, brought the Qin dynasty to an end. The Han adopted the teachings of Confucius as the foundations of their state and the emperor's prosperity grew immensely. The Wang Mang interregnum marked the end of the Western Han dynasty. During the next phase, that of the Eastern Han, the Empire assumed different characteristics and Confucian values gradually lost their central role. A new period of expansion towards Central Asia began and led to the extending of the borders, but the Eastern Han fell into decline towards the end of the 1st century.

THE AGE OF DIVISION
(220–589 AD)

The "Yellow Turbans" revolt marked the end of the Han dynasty and began an age of division that was one of the most complex in Chinese history, during which Buddhism spread and there were great innovations in every field of art and culture.

THE SECOND EMPIRE AND THE FIVE DYNASTIES
(589–960 AD)

The Sui dynasty (581–618) prepared the way for the arrival of the Tang (618–907), who reconquered the entire Empire and initiated an unprecedented period of expansion in Central Asia, turning China into a world power. This was the golden age of Chang'an, the center of cosmopolitan Tang culture, and the arts flourished as never before. Following the An Lushan Rebellion, however, in the mid-8th century, central authority began to decline. In the 9th century the Empire was afflicted by a series of rebellions. With the removal of the last Tang emperor, in 907, a short period of fragmentation began, known as the period of the "Five Dynasties and Ten Kingdoms," which ended in 960 with the establishment of the Song dynasty.

THE SONG EMPIRE
(960–1279 AD)

During the Song dynasty there was a consolidation of central authority and a very refined material culture. There was a return to the values of Confucianism and a new elite of functionaries came to the fore, who enjoyed a meritocratic status of privilege. Merchants rose in prestige and this was a period of massive economic and demographic growth, with urban centers becoming the heart of commercial and artistic life. The Song, however, were forced to deal with the constant threat posed by the various "barbarian" empires that came and went in the north. It was the Mongols who brought this dynasty to an end in 1279.

THE YUAN DYNASTY
(1279–1368 AD)

The conquering Mongols eventually unified the entire Empire. Kublai Khan drew inspiration from Tang and Song institutions, but he created a new social order based on principles of ethnic distinction, which provided for four classes of Chinese society. The merchant class prospered enormously from the stability guaranteed by this new dynasty, which enabled free movement throughout the Empire and the caravan routes of Central Asia were now far safer. Many foreigners held important positions at court, while many literati withdrew from public life, and in some cases dedicated themselves instead to art with superb results.

14-15 - The walls of Cave 257 in Dunhuang (Gansu) depict the tale of the "deer of nine colors" (in reality Buddha in a previous life). The detail shows the moment when the animal saves a man who is drowning in a river.

CHINA: FROM ITS ORIGINS TO THE FIRST EMPIRE

The Neolithic Period
page 18

Ancestral Rituals, Ancestors, and Script
page 24

The First Dynasties:
Truth and Myth
page 26

"Satellite" Cultures and
the Sanxingdui Discoveries
page 34

Western Zhou and the Development
of a New Aristocracy
page 38

Religion and Iconography in Zhou Bronzes
page 40

Eastern Zhou and
Fragmentation of Power
page 44

The Great Southern Cultures:
Splendor and Ruin in the State of Chu
page 52

What Did Confucius Really Say?
page 53

The Establishment of the Schools
of Philosophy
page 54

THE NEOLITHIC PERIOD

Homo sapiens are thought to have arrived on the plains of Oriental Asia 100,000 years ago, probably coming from Africa. The Paleolithic Period extends over an extremely long period of time, and precisely because it stretches back into unknown and remote antiquity it highlights the absence of precise information about the progenitors of those Chinese who settled along the main rivers after the last Ice Age (10,000–5000 BC), giving rise to various Neolithic cultures. These cultures were characterized by the presence of agriculture, the production of clay and textiles, and village-based societies whose leadership was comprised of a clan system.

For the ancient periods we can only turn to the epics of mythology as they appear in literary sources between the 6th and 1st centuries BC. A female divinity, Nü Wa, a creature with a human face and snake's body, had dragged human beings from the mud and modeled them in her own image. These beings populated the world, calling it *tianxia*, "all land under Heaven," but it was indeed a rather inhospitable world, so much so that "since the four extremities of the sky were collapsing and the nine continents were splitting open," the goddess had to intervene once again and repair the celestial vault with stones of five colors, which then gave rise to the Milky Way. The most remote myths, of which there are various versions, go back as far as protohistory, when they reach the holy and virtuous rulers or Mythical Emperors, to whom the fundamental inventions of civilization are attributed: agriculture, farming, writing, medicine, the introduction of the silkworm, the making of fishing nets and hunting instruments, the calendar, and techniques for regulating water supply. Through battles, strategic alliances, and family ties – which clearly foreshadow social clan organization – the offspring of these mythological sovereigns continued to the dawn of the Historical Period, in the first half of the 2nd millennium BC, when the Xia dynasty appeared.

But setting aside traditional legends, some experts say that Chinese Neolithic cultures can be separated from the 5th millennium BC by applying two criteria: the first is geographical and distinguishes southern cultures from those of the north on the basis of material remains. In the south, the Yangtze basin is characterized by production of rice and a series of additional plants for survival (lotus, water chestnut, etc.), whereas in the northern regions, too dry and cold for rice, the chief crop is millet, fostered by the characteristics of a particular loam called *loess*.

16 - Gilded bronze heads, dating back to between the 12th and 10th centuries BC, found at the Sanxingdui site, Guanghan county, Sichuan. These mysterious faces may depict not only the divinities worshipped by local people, but also their kings, priests or ancestors (SM).

18 - Traditional mythical heroes include the holy and virtuous rulers, that is Yao (left) and Shun (right), two of the Five Mythical Emperors (MSC).

19 - This Tang period (618–907) painting, portrays the female divinity Nü Wa, with her serpent body entwined with that of Fu Xi (one of the Three Augusts or *sanhuang*) to symbolize the alternating principles of *yin* and *yang* (MRAXU).

20 top - Geometrical and anthropomorphic motifs decorate this jar which dates back to the Machang period (2300–2000 BC) of the Gansu Majiayao culture (ca. 3200–2000 BC) (MFA).

20 bottom - This human terra-cotta head, datable to the late Yangshao culture, was found in Gaositou village, in Lixian county, Gansu province (MPG).

On the other hand, along the east–west axis, Neolithic cultures can be divided according to the characteristics of artifact decoration and burial traditions. To the west the Yangshao culture (5th to 3rd millennium, between Gansu and Shaanxi) has its most representative site in Banpo, close to modern-day Xi'an. This culture featured very simple burial practices and limited clay production for everyday practical use, characterized by decorative geometric designs, some of which were very beautiful, often spirals painted in red and black, especially during the later period of the culture. The clay production of the "oriental" cultures that ranged over a very large area had very little decoration, but it was lavish and sometimes of refined quality. Burial practices were more complex, as testified by the site at Dawenkou (Shandong), where caskets are sometimes found inside wooden coffins and in special burial chambers. Furthermore, the tombs in the eastern areas are frequently characterized by jade grave goods, sometimes elegant, skillfully made zoomorphic figurines (Hongshan culture, Liaoning province, ca. 3500 BC), or of still obscure ritual significance (*bi* discs or *cong* cylinders in the Liangzhu culture sites, Jiangsu province, ca. 2500 BC). However, attempts to "rationalize" Neolithic culture distribution on Chinese territory can only be incomplete. We know, for example, that the heart of Longshan culture, one of the late Neolithic cultures, was in Henan, but its typical earthenware, characterized by a subtle blend of brilliant black color and a considerable elegance of shape, is found all over northern China, in the Yangtze basin and as far as the south-east coast. This indicates that Neolithic cultures were intertwined in a complex system of local subcultures.

The last age of the Neolithic Period is characterized by general social stratification, where a more complex division of work brought the appearance of objects with a high technological content, such as the first examples of weapons, even if they were in small numbers. The presence of a more complex and hierarchical society is likewise testified by differentiated tomb furnishings and evidence of human sacrifice.

One of the great technological contributions of the Chinese Neolithic Period that should certainly be mentioned is sericulture, which originated in the northern regions of the country.

21 LEFT - THE GLOSSY POLISHED BLACK SURFACE OF THIS VASE, WITH AN ELEGANT LID, IS TYPICAL OF LONGSHAN CULTURE POTTERY (CA. 3000–2000 BC) (MSC).

21 RIGHT - THIS EARTHENWARE AMPHORA FOUND IN THE BANPO SITE (CA. 4500 BC) OF THE YANGSHAO CULTURE HAS AN IMPRESSED DESIGN PROBABLY PRODUCED BY ROPE (BM).

22

22 left - This polished jade object with three holes, perhaps an elaboration of the ritual *bi* disk, dates back to the Hongshan culture, which developed in the north-east between the 4th and 3rd millennia BC (MPL).

22 right - The *cong* was one of the typical forms of ritual jades produced by the Liangzhu culture around 2500 BC (NM).

22-23 - This jade bird pendant was made by Hongshan artisans, who used this material not only to create ceremonial objects — such as *bi* disks — or more refined versions of stone tools, but also ornaments (hair ornaments for example) and small animal figures, such as birds, tortoises, or strange creatures shaped like coiled reptiles (MPL).

ANCESTRAL RITUALS, ANCESTORS, AND SCRIPT

The Neolithic tombs already testify to the strong link existing between the world of the dead and that of the living; the latter entrusted their ancestors with the task of watching over their destiny from the afterlife, and also of interceding with the most powerful and arcane spiritual forces, such as the "Lord Above," who could assure an abundant harvest, promote a positive result in battle, send beneficial rain, and avert terrible disasters.

Apart from the relationship between sovereign and forebears, which had a political significance and function (which we shall consider later), there was a very strong link between the world of the living and the world of the dead. The dead began their journey in the afterlife accompanied by food, drinks, and various objects, whose number and value were proportionate to the prestige of the deceased. The decoration on the objects, the objects themselves, and sometimes the wall decorations of the funeral chambers, all had a general apotropaic function (that is, they were intended to ward off evil).

Parting from the deceased was long and complex: the *hun* soul, of a celestial and spiritual nature, which was separated from the body at the precise moment of death to be reunited with the world of the ancestors, was supplicated to renounce his own journey and to return to his body through a ceremony called the "summoning of the soul" (*zhao hun*). Only when the shaman's last summons met with no response could the descendants focus their attention on the body, the corporal container of the chthonic, vegetal *po* soul, which would accompany the deceased in the afterlife. The concern of the living, as mentioned, had a dual function: on the one hand it was linked to the desire to guarantee the deceased a pleasurable existence in the afterlife, which led to a vast but recurring range of human behavior, studied in depth by anthropologists; on the other hand, it was justified by the crucial relationship with the ancestors and, in a long upward and hierarchic path, with the Supreme Ancestor, an anthropomorphized power who, until the appearance of the first Shang dynasty (16th–11th century BC), was linked directly to the dominant lineage.

Probably already in the Xia era, and certainly with the Shang, sovereigns drew the authority and the wisdom necessary to wield power from their relationship with the spirits of their ancestors. A complex system of rituals was developed. Sometimes the sovereign officiated himself, but more often it was a shaman-priest assisted by various objects with a totemic function. From the Shang period onwards the officiant's grave goods included bronze objects decorated with zoomorphic motifs, later becoming one of the most surprising legacies of Ancient China. When the Shang were overcome by the Zhou, the Supreme Ancestor predictably also underwent a transformation. The need to overcome the "embarrassment" of a Supreme Ancestor whose characteristics evoked too directly the memory of defeat led the Zhou to de-anthropomorphize this figure, which became increasingly abstract but equally more distant from ancestors in the real sense.

The cult universe linked to rituals in honor of the ancestors and of the deceased is closely linked to the appearance of script. The first written sources are "bone oracles" in the Shang period, whose deciphering also permitted confirmation of what was written in the first great historical work of Imperial China – the *Shiji* or *Historical Records* of Sima Qian (145–86 BC). He recorded information about the Shang dynasty 1000 years after its extinction. The deciphering of the bone oracles was a sort of "special evidentiary hearing," able to confirm not only the historical authenticity of the Shang but also the great reliability of this extraordinary work by the most important historian in Chinese history.

The discovery of the bone oracles was almost accidental. At the end of the 19th century, Wang Yirong (1845–1900) a man of letters and member of the Imperial Academy, collector and expert in ancient bronze inscriptions, realized that the characters traced on the bone oracles were similar to those present on the older inscriptions engraved on the bronze recipients of the Zhou period, of which he was an expert. These bones, usually bovine scapula, but also tortoise carapace, or plastrons, were well known to Chinese peasants, especially in the region around Anyang (Henan province), who assimilated them with Tertiary or Pleistocene fossils, popularly called "dragon bones" or "dragon teeth," and which they had been digging up since time immemorial to sell in pharmacies, where they were used for galenic preparations using prescriptions from the ancient book of Chinese traditional medicine.

The Shang bone oracles, however, had particular characteristics: duly prepared by the priests and shamans so that they softened on the surface, and if necessary marked with incisions, these were exposed to fire. The shape of the cracks caused by the heat revealed answers to the particular questions asked of the ancestors, usually about a lucky day for hunting, battles or the conception of a male heir. The queries and the reply obtained from the cracks were then recorded on the bone itself. Contrary to what was long believed, and which Sima Qian himself reported, although with some doubt in his mind, Shang bones and possibly also Xia bones, were not

destroyed after the conclusion of the divinatory practice, but were conserved in special archives. Today they constitute the oldest written evidence of Chinese civilization in existence. In reality the clan emblem and the graphic symbols, which can sometimes be traced back to ancient pictographic forms, have already been identified in the clay production of the Neolithic Period and in some ancient Shang bronzes, but the bone oracles reveal whole sentences which in some cases are relatively well structured. Sometimes they provide somewhat unexpected information: Tomb 5, at Anyang, which belonged to Lady Hao, is famous for its extraordinary grave goods, including jade objects, and it is the only royal tomb that was not pillaged by grave-robbers. Oracle bones were also found in this tomb and on them are descriptions of the pregnancies and illnesses of the deceased lady, and also that she frequently led troops into battle.

25 LEFT - THESE TWO ORACLE BONES WERE FOUND AT XIAOTUN, ON THE BANKS OF THE HUAN RIVER (HENAN), ONE OF THE SITES OF YINXU (IAACSS).

25 RIGHT - THE INSCRIPTIONS ENGRAVED ON THE ORACLE BONES REFER TO A WIDE RANGE OF THEMES ON VARIOUS ASPECTS OF LIFE IN SHANG TIMES (MSC).

THE FIRST DYNASTIES: TRUTH AND MYTH

"Legendary" China fuses with the China of protohistory during the Xia dynasty (21st–16th century BC). Experts have ascribed several Bronze Age archeological sites to this dynasty, the most important of which are the palace foundations excavated in 1959 at Erlitou, near Luoyang, Henan province. Erlitou culture spread here and into the surrounding areas (today's provinces of Shaanxi, Shanxi, Hebei, and Hubei) and archeological excavations have provided some historical foundation for the theory that Erlitou culture and the Xia dynasty overlap, even if radiocarbon dating provides contradictory data. It is possible that the first two layers of the site belong to the Xia and the two more superficial layers can be ascribed to an early Shang period, which revealed the remains of Bo, the capital of the founding Shang dynasty. However, some experts feel it is equally likely that the whole site belonged to the Xia and that the oldest Shang remains are in Erligang. Their most recent capital, however, was certainly Yinxu, excavated in 1937, not far from Anyang, on the banks of the Huan River, and extending over an area of almost 9.5 square miles. The discovery of Yinxu, with its grave goods — especially the bone oracles — leaves no doubt as to its belonging to the Shang, but creates a new problem. The evidence of the level of artistic workmanship and the complexity of State organization that emerges from the excavation indicates only the remote possibility of an abrupt transition from the Neolithic to this period, and reinforces the theory of an intermediary period, dominated by the Xia.

The area of influence of Shang culture went far beyond the boundaries of the Shang "state," which did not have marked "territorial" characteristics, however. The royal family governed the "internal dominion" (*neifu*), which included the capital, whereas the local gentry, of varying degrees of closeness to the royal family, governed the "external dominions" (*waifu*), often constituted by independent walled towns. In the absence of strong State organization and structured bureaucracy, it was the sovereign who guaranteed the cohesion of the State with hunts, military campaigns, and, very probably, a shrewd policy of family alliances and marriages.

The Shang, like their successors the Zhou, left an extraordinary wealth of bronze ware, which was used in the ritual ceremonies dedicated to the ancestors, and has been widely found in the grave goods of high-ranking figures. The production of these objects had such economic relevance and the need for bronze and tin was so pressing that experts are inclined to link this necessity with the frequent movements of the capitals which characterize the period of the so-called "Three Dynasties" (Xia, Shang, and Zhou).

26 - *Jue* tripods are a type of bronze ritual vessel used for wine drinking. They made their appearance during the Erlitou period and fell into disuse around the middle of the Western Zhou period (MC).

27 - Types of Shang ritual bronzes included the *yan* (left, MPJ), for steaming foods, and the *you*, lidded wine containers (right, HFAM); this *you* has a square section (*fangyou*).

27

28 - This lidded bronze *huo*, depicting a human face and dating back to the period between the 12th and 11th centuries BC, was used to serve wine in ritual ceremonies (FSG).

28-29 - This bronze vase, supported by two rams, is a ritual vessel for wine, probably produced in Hunan between the 13th and 12th centuries BC (NIFA).

29 - This bronze drum of the late Shang period is decorated all over – except for the sides – with zoomorphic masks of the *taotie* type in low-relief (MPHUB).

30 - The *you* is a bronze container for alcohol, in use from the late Shang period up to about the middle of the Western Zhou dynasty. This comes from the county of Ningxiang in Hunan (MPHUN).

31 - This solid bronze *zun* for wine is decorated with dragons and tigers in relief, and dates back to the Anyang phase of the Shang period. Bronze technology reached very high standards at Anyang, which was the dynasty's last capital (MSC).

We are, therefore, in debt to the cult of the ancestors and, in general, the cult of the dead, for artistic relics of the highest quality, at least up to the Han dynasty (206 BC–AD 220). As well as bronze ware, the Shang grave goods often include an extraordinary wealth of jade, which was as much ornamental and decorative as it was for use in ritual. For example, the cylindrical *cong* trunks and the *pi* discs, already mentioned elsewhere. The presence of jade in grave goods is certainly linked to the belief that it could prevent decomposition of the body after death. To this end, jade discs were also placed on the body of the deceased, to close the "five orifices."

The ritual bronzes did not have any part in daily life, for example, crockery for daily use was usually made of terra-cotta, though at the Shang sites a type of "proto-porcelain" made from china clay has been discovered, which indicates great technical skill in the building of ovens that could withstand temperatures in excess of 1830 °F. Bone was often used for common and ornamental objects, whereas shells served as money in business transactions, amply testified by the real "fortune" found in the tomb of the Marquise Hao, which was neatly ordered in rows of measurement units for the calculation of the "money" in use at the time. Quite advanced weaving included production of fabrics in silk and hemp. Agriculture, based on the cultivation of millet, barley, and perhaps wheat, was undertaken by free peasants and very probably by slaves, usually prisoners-of-war. At least until the Shang period, slaves were also used for human sacrifices to accompany the burial of important people.

32 left - This unglazed white pottery jar was made in the late 13th or early 12th century BC. The decoration imitates "thunder" (*leiwen*) motifs that appear on coeval bronze ware (FSG).

32 right - This jade pendant of the Shang period depicts a demon's face with very pronounced nose and ears (ROM).

33 - This ivory beaker with turquoise inlays and the handle shaped like a bird of prey was found in Tomb 5 at Anyang, the tomb of Fuhao or "Lady Hao." The decoration comprises *taotie* masks and spiral motifs, as found in bronzes of the period (MSC).

34

"SATELLITE" CULTURES AND THE SANXINGDUI DISCOVERIES

At the end of the 1920s, the government of the Chinese Republic financed the first organized archeological expedition to the Anyang area. The excavation brought to light a culture whose influence extended over a rather large area and so seemed to support the theory that Chinese civilization developed along a few fundamental lines, all of which can largely be traced back to the Yellow River basin, from where they spread all over the country. The hypothesis was eventually abandoned, after some resistance, following subsequent archeological digs that demonstrated that it was a random theory. As many experts emphasized, it was a vision of ancient history that was heavily influenced by political necessities: a young and fragile Republic (and more to the point diplomatically isolated, as China was after the rise to power of the Communist Party in 1949) felt the need to consider itself a compact unit that was territorially and culturally cohesive, where there was no room for local "particularities," and by sinking its roots into the most distant past it was able to legitimize this image. On the other hand, the strongly politicized use of historical data was not at all a new feature in Chinese history, even if archeological progress from the 1970s destabilized this vision once and for all, while conversely promoting the image of a polycentric civilization in which the different elements from each met and mixed. The "boundaries" of the great archeological areas which were relatively similar to their interior are subject to debate and continuous modifications. Generally, experts today tend to refer to "regional archeology," and so there is an "archeology of the northern regions," in turn divided into a series of local variations, and whose own peculiarities are recognized, as happens with the interior of Mongolia. The latter, as shown by the Zhukaigou excavations, was the center of the northern bronze cultures and a source of inspiration for the bronze cultures of the Ordos Valley between 1500 and 500 BC. Many cultural variations of a local nature were actually due to the complex coexistence of several different ethnic groups found in the southern area of Hua'nan, a place name that covers a vast region, extending from Fujian in the south, Guangdong and Taiwan in the east, the Xiangjiang and Xijiang rivers to the west, and the corresponding areas on today's borders of Hunan, Hubei, Anhui, and Henan in the north. In this region, for example, the Xin'gan Dayangzhou excavation demonstrates a bronze art that probably dates back to the last Shang period, but shows strong local characteristics in many of the decorative motifs (human and tiger heads), and in some types of objects that were part of a vast weaponry. Even the lower Yangtze basin has its own characteristics, as does the Shandong peninsula, and the Bohai region. Some southern cultures are unique, such as that of Chu, to which we dedicate a separate section, or the bronze culture of Yunnan province, known as the "Dian culture," which gave the province its ancient name. Here non-Chinese populations established production that developed from the 11th to the 1st century BC, which was a far more extensive period than that of classical China. This extremely varied production was characterized by the presence of many musical instruments, especially drums. One particular feature was an animal motif decoration, in relief or in the round, which is not found at all in bronze production in other areas of China. More than 40 species of animals are depicted: domesticated and wild animals, as well as groups of humans and animals together, with animal hunting or farming scenes. The heavily repeated depictions of cattle – embossed or in the round – certainly testifies to their importance, both in economic life and in ritual ceremonies.

If Yunnan undoubtedly constitutes a border region, where it is easier to imagine the existence of discernible cultures with very obvious specific features, then a central region such as Sichuan also shows precise cultures, confirmed beyond all doubt by the excavations which began in 1980, at the Guanghan Sanxingdui site. In 1986 two excavation pits revealed objects of extraordinary beauty, with a completely different ethnic background to the Shang tradition of the central plain. A group of life-sized human heads and an enormous statue (8.5 ft/2.5 m), thought to depict a priest holding an object, perhaps in the shape of a staff, perhaps in wood or ivory, emerged from amongst the finely crafted bronze, gold, and terra-cotta. Enormous eyes, prominent ears, and protuberant noses suggest "non-Chinese" models of reference, or perhaps it would be better to think about different models to those that were traditionally considered "Chinese" until recently.

34 - YUEXIANPU, IN THE COUNTY OF NINGXIANG, HUNAN, WAS WHERE THIS LATE SHANG *FANGZUN* ADORNED WITH RAM HEADS IN THE ROUND, AT SHOULDER HEIGHT, WAS DISCOVERED (MPHUN).

35 - THE *FANGDING* FOOD CONTAINER OF THE SHANG PERIOD, WITH ITS DEPICTION OF A HUMAN FACE, IS ALSO FROM NINGXIANG COUNTY. BRONZES OF VERY SOPHISTICATED WORKMANSHIP WERE PRODUCED IN THE SOUTH OF CHINA (MPHUN).

36-37 - This bronze mask with big ears and protruding eyes was found at the Sanxingdui site, Guanghan county, in Sichuan (SM).

37 left - This sculpture also presents those exaggerated "non-Chinese" traits, such as the pronounced nose and huge eyes, typical of the bronze heads discovered at Sanxingdui (SM).

37 right - Set on a tall base, this 12th-century BC bronze human figure from Sanxingdui probably depicts a priest (SM).

WESTERN ZHOU AND THE DEVELOPMENT OF A NEW ARISTOCRACY

If, as we have seen, the cultures present on Chinese territory lacked the unity of features and characteristics that archeology had attributed to them initially, it is nonetheless true that the birth of Imperial China is closely linked to what happened in the regions of the Yellow River basin and to the events of the transition from the reign of the Shang to the Zhou, to the fragmentation of authority that characterized the second part of the Zhou dominion, and the subsequent emergence of the small hegemonic state of Qin, whose sovereign would found the unified Empire.

The Zhou, an ancient people whom some experts believe were descended directly from the populations of the Yangshao painted pottery cultures, were probably connected to the Shang by links of "vassalage." Their territories were situated beyond the Shang domains, in direct contact with the "barbarian" populations of the west, the formidable Qiang, who were a constant source of concern for the Shang. This proximity led to the Zhou becoming skilled warriors and experts in the rearing and use of horses in battle. Unlike the Qiang, however, the Zhou were a resident farming population, as is underscored by the legend that says the first Zhou sovereign was called Houji, "Lord of Millet." The Zhou took power in the period between 1122 and 1028 BC (traditional sources are contradicted by modern historical and archeological finds) in circumstances described by a tradition that was destined to become a recurring feature in Chinese historiography, and which they themselves narrate, of noble and courageous warriors who overcame a corrupt and incompetent sovereign, surrounded by men of equally trivial worth. For instance, this is told by texts found in a Confucian classic, the *Shu jing*, or *Classic of Documents*, which is usually dated to the first period of the dominion of the triumphant conquerors. It is worthwhile emphasizing that the Zhou showed a marked sensitivity to the question of the legitimization of their own power, entrusting it to a staggering number of written texts, above all bronze inscriptions celebrating the virtue of the sovereigns and the strong bond of loyalty that tied them to local nobility. The first sovereigns established their capital close to Chang'an, now Xi'an, and this is the origin of the name "Western Zhou," by which they were known. The subsequent period of the "Eastern Zhou" would see the transfer of the capital to the city of Luoyi, which then became Luoyang (770 BC).

A significant watershed that marks the divergence of the Zhou's traditions from its predecessor is their different concept of power, of the role of the sovereign and the aristocracy. Traditionally, the Zhou originated from three sovereigns: King Wen (the Scholar King), King Wu (the Warrior King), and the Duke of Zhou, destined to become Confucius' paradigm when he wanted to exemplify the qualities of the wise and virtuous gentleman. In the Zhou period, the link between the sovereign and the "Supreme Ancestor" was modified considerably and had much less of a magical-mysterious connotation. The "Supreme Ancestor" did not disappear but was joined, even if in a subordinate position, by the ancestors of other *clans*, linked to the more or less direct family ties with the dominant Zhou clan. The immediate point-of-reference, so to speak, for the sovereign was Heaven, from which he received a "mandate" (*tianming*) authorizing him to rule on behalf of Heaven, of which he was the son. A divinity like Heaven, until that moment of an astronomic nature, was anthropomorphized but assumed more "universal" connotations than the more necessarily specific clan ancestor. At the same time, this anthropomorphization did not prevent the "mandate" conferred on the sovereign constituting a wider proxy, in whose implementation Heaven intervened very little and which the sovereign maintained simply by operating in accord with

Virtue. The power of proxy deviated much more from a concept impregnated with occult beliefs than in the past. The sovereign rid himself of the irrational and terrifying fear of ancestors, and replaced it with profound respect, as testified by the lavishness of ritual ceremonies. Essentially it was he who guaranteed directly the harmony between the macrocosm and human microcosm, and suffered directly the fury of Heaven if he incurred its wrath, losing his mandate by behaving in a way that did not conform to Virtue. Seen from a historical perspective, this conception appears very clever: if, for example, the sovereign was neglectful of his responsibilities to the State and forgot to attend to the regulation of the waters, essential in a country characterized by rivers, the waters would burst their banks, the population would suffer grief and famine, and this would show at the same time both the wrath of Heaven and the godlessness of the sovereign. It is easy to imagine that the social disorder caused by this state of affairs would lead to a delegation of power, which is perfectly justified within the limits of a "mandate" theory that does not recognize tout court the legitimacy of acts against established authority if they disturb social order and actually demands that authority, in order to be recognized as such, should be founded on Virtue.

Outside the capital, the sovereign delegated his power to those families whose nobility was proportionate to their antiquity, to their right to officiate at certain rituals, and to their direct relationship with the sovereign. The concession of a territory to govern (the reason for the use of the expression "feudalism" to describe this period in Chinese history) was underlined by the appropriate ritual ceremonies, which were frequently mentioned on bronze inscriptions sometimes made for these occasions. The feuds, *feng*, were divided into princedoms, *guo*, attributed with administrative powers and their own armies, even though they were formally subordinate to the Zhou sovereign and their courts were virtually replicas of the central Zhou court. The splitting up of the territory and the growing rivalry between the "central princedoms," *zhongguo* (with older traditions and more characterized by internal fragmentation), and the new peripheral princedoms, which were more united and militarily aggressive, constituted a fundamental point of weakness in the first Zhou period.

38 AND 39 - THE BRONZES OF THE EARLY WESTERN ZHOU PERIOD, SUCH AS THESE SPECIMENS PRODUCED BETWEEN THE END OF 11TH AND EARLY 10TH CENTURY BC, ARE GENERALLY VERY WELL PROPORTIONED (FROM THE LEFT: FSG, MSPS, FSG).

RELIGION AND ICONOGRAPHY IN ZHOU BRONZES

Experts divide Western Zhou bronze production into a first period from about 1050 to 970 BC, which was characterized by conflict in order to take possession of the cultural heritage of the preexisting dynasty, whose ritual practices they also adopted. The production of ritual goods in bronze was not at all strange to the Zhou, but the type made by them before the conquest was very different from that made by the Shang, with a prevalence of lobed *ding* or *gui*. The first production of Zhou bronzes following the conquest was quite faithful to the Shang model and often presented a relief zoomorphic *taotie*-type mask, present on the whole body of the vase. The front of the mask depicts a sort of wild face without a jaw and comprises two mirrored halves set on a short central vertical axis; in each of the two halves there is a depiction reminiscent of an imaginary animal seen in profile; the *taotie* alternated with animal depictions similar to dragons called *kui*. These decorations were in high relief and stood out on a background decorated with cloud (*yunwen*) or thunder (*leiwen*) motifs. The most complex part of the Zhou rituals, however, required an increase in the various types and a decrease in wine jars (to which the *gui* and *ding* types can be ascribed), in favor of those used for food. It was common to find inscriptions on the most valuable bronzes. In a Baoji tomb complex, in the province of Shaanxi, the development of bronze production is evident from the end of the Shang to the first Zhou period, with an increase of sculpted elements to enhance the magnificence of objects.

The middle period of Western Zhou, 970–870 BC, did not see any substantial changes in the vase repertoire, but it did present a completely new decorative style, with feathered bird motifs on vases which were usually smooth and rounded. It is believed that the disappearance of the *taotie* in favor of the new decorative model was due to the contact between the Zhou craftsmen and cultures from the southern regions of the country, which has been substantiated by the confirmation of models whose shapes were inspired by real or semi-real animals typical of southern production. The famous tiger-shaped pair of vases in Washington's Freer Gallery of Art is a fine example.

40 - This bronze tiger is one of a pair dating back to the 9th century BC, belonging to the Freer Gallery of Art, Washington, DC. It is an example of the trend for reproducing animal forms, typical in certain periods of Western Zhou (FSG).

41 left - The *fangding*, a rectangular *ding*, was used to cook foods. This example dates from the Western Zhou period (SHM).

The appearance of bells from Shaanxi is also ascribed to the middle Western Zhou period, together with other creations of different ethnic backgrounds that perhaps arrived along the waterways, such as the Han River or the Yangtze. Bells were already present in the Shang period but they were often characterized by the opening tending to point upwards and supported by a wooden strut in the hollow handle. Their use, however, was firmly established during the middle Western Zhou period and is probably linked to significant changes in ritual practices, with music in a role of fundamental importance, as testified by the collection of 14 bells of different dimensions found in the tomb of Wei Bo Xing, in Fufeng, Shaanxi province.

The late Western Zhou period (875–771 BC) is characterized by the presence of new types of bronze models and by the appearance of bigger and more numerous series of bells than in the past. In general, it was precisely the significant increase in the size of the bronzes, alongside a reduction and substantial exemplification of decorative motifs that characterize this period. There was no skimping on materials, while from an aesthetic point of view, the refinement of the decorations was replaced by the daunting size.

The dynasty during this time was in crisis and had evidently modified its own ritual practices in a significant way, above all in the metropolitan area, and seems to entrust the task of reaffirming its own authority to a visual suggestion based on the increasingly large size of objects of identical or similar type. The change in ritual practices was most probably linked to a weakening of the sovereign's prerogatives, since he was responsible for checking their correctness and ensuring that traditions were maintained. Several centrifugal tendencies threatened the stability of the Zhou king and from the middle period onwards some inscriptions indicate the decline of his authority. There are objects made to seal the transfer of land to a new owner, in exchange for the transfer of goods of a different type. In theory only the sovereign had the right to transfer lands temporarily in exchange for services. The birth of a "commercial transaction" outside of this scheme certainly told of a loss of central authority.

41 CENTER - THIS BRONZE DING, WITH A DENSE LEIWEN DECORATION, DATES TO THE EARLY WESTERN ZHOU DYNASTY (ICBCX).

41 RIGHT - THIS GUI, WITH BIRD-SHAPED HANDLES, WAS FOUND AT LIULIHE NEAR BEIJING AND BELONGS TO THE SAME PERIOD AS THE PREVIOUS BRONZES (MC).

42 AND 43 - DURING THE MIDDLE WESTERN ZHOU PERIOD NEW TYPES OF BELLS CAME INTO USE, SUCH AS THOSE OF VARIOUS SHAPES AND SIZES FOUND IN THE TOMB OF A CERTAIN WEI BO XING, AT ZHUANGBAI, NEAR FUFENG IN SHAANXI. THESE ITEMS ARE DATABLE TO APPROXIMATELY 880 BC AND ARE A TESTIMONY TO THE CHANGES THAT CAME ABOUT AT THAT TIME IN CEREMONIAL PRACTICES (MZF).

43

44

Traditionally, Chinese historiography divides the Eastern Zhou period into two stages (770–221 BC); the first one, called the "Spring and Autumn" period (*Chunqiu*), takes its name from the official records of the state of Lu, one of the potentates that emerged from the splitting of central power and the birthplace of Confucius. These chronicles cover a time span from 770 to 479 BC and with its three principal commentaries constitutes one of the "classical" written sources that describe the history of this troubled period. The subsequent period also owes its name to a historical work, the *Zhanguozi*, or *Record of the Warring States*, of the 3rd century BC. It is a convenient but sometimes problematic division, which was universally adopted, however, because it enjoyed deep-seated and regular use. In any case, during the period of the "Warring States", the Zhou sovereign completely lost his own role and half a dozen "states" bigger, richer, and more powerful than the others undertook a systematic policy of aggression and annexations of the smaller states. Traditional historiography delivers an image of a troubled and gloomy period, afflicted by continuous wars and invasions. This certainly corresponds to the truth, but at the same time it is precisely from this turbulent period that local cultures come forward and that regional traditions are established. There were significant developments in the technology of casting iron, which resulted in the increased production of improved agricultural implements and weapons, so an army was born, with well-equipped infantry and cavalry. New instruments for economic exchanges were developed, with coinage and the diffusion of coins. A form of "private property" was experimented with on the land, which promoted social mobility for peasants. A far-reaching debate was undertaken on moral and social values, establishing a concept of civilization without regard to the intervention of occult powers and based more on a positive Virtue, necessary and "immanent," capable of guaranteeing the correct functioning of society and its suitable hierarchical relations.

After the transfer of the capital to Luoyang, following the violent death of the Zhou sovereign brought about by an alliance between local nobles and leaders of the powerful Rong nomadic people, the Zhou monarchy failed to regain control of its territories. The last of the Zhou were deposed in 256 BC, by which time local nobles had been using the title of king for nearly a century. The powerful frontier state of Qin soon established itself across the regions conquered by the Rong, and precisely because it was always having to face barbarian tribes it organized a large, well-trained, and extremely well-equipped army, which had the most modern and lightest weapons of all those used in the surrounding kingdoms. Only the strong and magnificent southern state of Chu opposed the power of Qin and its shrewd administration. In 278 BC Qin finally stopped its expansion and the floodgates for the submission of the other six surviving states were well and truly open. However, when Zheng came to the throne in 246 further military campaigns were conducted with ruthless determination. A little less than 20 years later, having conquered "all land under Heaven," Zheng abandoned the title of king to take that of "First August Emperor." In the year 221 the first unified Chinese Empire was established.

In the arts, the Eastern Zhou continued the tradition of bronze production and simplified the process. While metropolitan traditions perpetuated a common ornamental language inherited from Western Zhou, the regional traditions were united by a stylistic direction that initially involved zoomorphic decorations being increasingly evolved towards an imaginary register. The transformation of the ornamental dragon was the typical motif in this respect. The rivalry between local courts favored the quest for refined detail, while some artistic centers were developing in the central-southern regions delimited by the Han and Huai rivers, and in the area where the extraordinary Chu culture was evolving (Hubei, southern Henan, Hunan, and Anhui), and in the areas of the Wu and Yue cultures, between Zhejiang and Jiangsu.

44 - CONSIDERABLE FREEDOM AND VARIETY CAN BE SEEN IN THESE TWO RICHLY AND ELABORATELY DECORATED BRONZE *FANGHU*. THE VERY IMPRESSIVE LEFT-HAND ITEM ON THE LEFT IS SURMOUNTED BY A CRANE THAT SEEMS TO TAKE FLIGHT. THE TWO EXAMPLES ARE DATABLE TO THE FIRST EASTERN ZHOU PHASE, THE SO-CALLED "SPRING AND AUTUMN" PERIOD (PM AND MPHEN).

46 - Towards the end of the Eastern Zhou dynasty, during the Warring States period, the style of the bronzes, often decorated with an abundance of inlaid gold and silver motifs, was completely different from that of the beginning of the dynasty (CI).

46-47 - This bronze *dui* (food container) inlaid with silver, of the 4th century BC, has splendid decoration, in keeping with the tastes of the day and with the use of bronzes outside of ritual practices (BM).

47 - This bronze pilgrim flask (*bian hu*), inlaid with silver, of the Warring States period dates back to about the 3rd century BC (FSG).

47

48-49 - This imaginary bronze animal inlaid with silver of the Warring States period was found in Houma (Shanxi) and is possibly a representation of the *bixie*, a winged feline with apothropaic function (MPHEB).

49 - This bronze animal carries a tray on its back for ritual offerings, and is datable to the Warring States period; it was found at Changzhi, in Shanxi (MPS).

In the northern cultures, above all from the 6th to the 5th century, and in particular in the area around Houma, close to Xintian, capital of the state of Jin (now Shanxi), winged animals and other figurines in the round were depicted with extraordinary detail, while a marked preference for naturalism emerged, expressed in three-dimensional bronzes of ducks, fish, reptiles, and tortoises, made with the "lost wax cast" method. Also in the north, we encounter the first example of Chinese architectural design, in the tomb of the fifth sovereign of the Zhongshan state (south-west of today's Beijing), who died in 308. A bronze plate inlaid with gold and silver shows a map of five royal mausoleums. Winged monsters in inlaid bronze with an apotropaic function protect the sovereign's sleep. It is useful to underline that this little and very refined kingdom did not have a Chinese population: it was inhabited by a small enclave of Bai Di, a people whose nomadic origin did not hamper their deep assimilation of Chinese cultural models, refashioned with stylistic features from their original culture. This illustrates that such classifications as "barbarian populations" (which we have applied for the sake of convenience here) are often very misleading and pose far more problems than they resolve.

Tomb art showed a transformation in the ritual conceptions linked to the burial of corpses, where most attention was dedicated to caskets, with several of them placed on top of one another, and favoring the use of lacquer, which had made a noteworthy appearance during the period of the Warring States, above all in the Kingdom of Chu, as testified by the tomb of Marquis Yi of Zeng (Hubei, around 433 BC). In fact, this tomb, with its imposing set of bells (*bianzhong*), recalls the absolute centrality of music in ritual ceremonies of the period.

Perhaps also due to the criticism by Confucian thinkers that funeral practices were over lavish, bronze grave goods, especially from the 5th century and above all in the north, were slowly reduced and partly lost their magnificence. Conversely, in the tombs of the Qin state, the first *mingqi* made their appearance. These were reproductions of objects from daily life, usually made of simple earthenware, which accompanied the deceased in the afterlife. The ultimate use of *mingqi* is unquestionably the First Emperor's awesome Terracotta Army.

50

50 - This splendid bronze *fanghu*, with handles shaped like a *kui* dragon, was amongst the grave goods in the tomb of King Cuo, fifth sovereign of the state of Zhongshan, at Sanji (near Pingshan in Hebei), and was discovered in 1977 (MPHEB).

50-51 A cylindrical bronze container with animal-shaped feet was found in the King's tomb. The Zhongshan ritual bronzes, influenced by the art of neighboring states of the central plain, show a great variety of styles and forms (MPHEB).

51 - This bronze *ding*, from the same burial place, has iron feet and three ring handles on the lid. A set of nine *ding* arranged in order of their size (or *lie ding*) was found in the site: they measure 7 to 20 inches in height (MPHEB).

THE GREAT SOUTHERN CULTURES: SPLENDOR AND RUIN IN THE STATE OF CHU

China has always considered itself a country from which civilization emanated towards the surrounding "barbarian" populations, and yet, in the course of its history, as in the course of the history of many other countries, "the frontier barbarians" often became an integral part of Chinese territory and developed high levels of culture and civilization. Indeed, even the state of Chu, in the Yangtze basin, was considered barbarian or semi-barbarian in the first Zhou period. However, a rapid expansion meant that it incorporated in its territories a series of northern states which bordered with the heart of the Zhou Empire, and it was able to expand its dominion to include states of ancient nobility such as Wu and Yue to the east. In other words, its expansion was no less than the total expansion of Western Zhou during its period of greatest splendor. The extraordinary wealth of Chu, together with a new recruitment system of functionaries that assured the efficiency of the administrative machine, as well as an army equipped with a fearsome infantry, meant that it soon became a very rich state, which was probably unrivalled anywhere in Chinese territory. It was characterized by a lively, stimulating cultural life, as testified by the sojourn there of a philosopher of the importance of Zhuangzi and by the extraordinary originality of one of the greatest poetic texts of ancient China, the *Li sao* (*The Lament*) of Qu Yuan (340–278 BC). While the fatal Qin conquest loomed, the exiled poet was in anguish because he had failed to persuade his own sovereign to heed his warnings. Qu Yuan laments his own desperate, useless loyalty, then he undertakes a truth-seeking journey towards Paradise, in search of his lost soul, where the sum of all the religious and cosmological beliefs of the Chu people (and probably of all the populations of southern China) are found, and which are less influenced by the rationalistic tendencies that had emerged with the affirmation of Confucianism. Qu Yuan committed suicide, overwhelmed by the pain caused by his country's destiny, but he nonetheless remains even now the icon of a loyal and devoted servant, and homage is still paid to him on the day of the Double Five (between April and May), with the dragon boat race originally conceived for recovering the poet's body and affording him the peace of a fitting burial.

Apart from the legend, something of the great wealth of Chu has survived to our times in the form of their sumptuous tombs with priceless lacquered grave goods (such as the Changtaiguan sites), with striking sculptures in the form of very abstract and highly symbolic monsters, often topped with deer horns. Chu has also left us with the first evidence of silk painting, which can be dated back to the 4th and 3rd centuries. These were funerary banners and were renowned for their sense of proportion and use of space, and their themes were linked to the journey of the deceased into the afterlife.

52 - THIS BRONZE *DOU* WITH LID (LEFT) AND A BELL (RIGHT) ARE FROM THE GRAVE GOODS OF MARQUIS YI OF ZENG, AND WERE FOUND AT LEIGUDUN NEAR SUIXIAN IN HUBEI. AN INSCRIPTION OF 31 CHARACTERS STATES THAT THE ARTIFACT WAS COMMISSIONED BY KING HUI OF CHU, IN 433 BC, FOR THE MARQUIS YI (MPHUB).

Many references have been made to different traditions, such as that of Chu, which moved away from the teaching of Confucius and take independent paths more consistent with their own history and with the customs and beliefs of the southern populations. Confucius (551–479 BC) remains, however, an inescapable reference point and not only for ancient China. Born in the northern state of Lu, in what is now Shandong, Confucius' father was an impoverished aristocrat who died shortly after his son's birth. Confucius was a virtuous son and excellent student who spent his adult life wandering with fluctuating success from one kingdom to another, accompanied by disciples attracted by his knowledge, offering his services to various members of the gentry. The doctrine he left us comprises a system of ethical-moral values which do not constitute a religion, other than a personal cult attributed to his figure which came about mainly after 59 AD when Emperor Mingdi decreed the obligation of making sacrifices in his honor. The Lunyu (The Analects), his principal work and the only one which can be attributed to the Master with certainty, does not deal with metaphysical, esoteric, or religious questions at all ("How can those who do not know how to serve men then serve the spirits?"; or "Is it possible to listen to the Master's voice on cults and customs and not on Nature and the action of Heaven?"), but expounds a hierarchical, non-egalitarian concept of society, governed through a series of universally recognized rules, the rituals (li) whose observance was guaranteed by a sovereign who practiced the virtue (de). This "general" virtue, for the sovereign as for the sage, was expressed in a series of "special virtues": benevolence (ren, or a sympathetic and united stance with regard to one's peers), altruism (shu), loyalty (zhong), faithfulness (xin), uprightness (yi), wisdom (zhi), and propriety of behavior and conduct (li). This last concept, often distorted and reduced to a mere self-righteous respect of form, actually had a profound significance and identified, in the relation between formal and external aspects of conduct and substantial values, one of the signs of a cohesive society supported by a good government. As a whole, society recognized within itself "five fundamental relationships": between father and son; between elder brother and younger brother; between husband and wife; between sovereign and subject (or minister); and between friends. Only the last of these was an equal relationship; the others were conditioned by moral obligations among which filial piety, xiao, occupied a very prominent place. The relationship between father and son had to conform to this and, by extension, so did that of the subject with the sovereign and that of the disciple with the master, although the first pair always maintained a certain superiority. The superior man, the junzi or gentleman, was not such by rank or wealth but by constant application to the study of the ancient classics and to moral discipline, which improved his nature, already predisposed to good. He used his position of power to serve society not for personal gain. This aspect of "service" has profoundly permeated the Chinese concept of power, at least at a theoretical level. It is a fundamentally simple thought, without any particular speculative depth, that firmly unites China with its own past and which inspires its present and future. It provides China's history with a peculiar centrality, fraught with consequences in subsequent events, due to the steadfast and almost uninterrupted dominion of the class of cultured bureaucrats who grew up with the Confucian classics.

53 - THIS WALL PAINTING DEPICTS CONFUCIUS WITH HIS PUPILS WHO FOUNDED VARIOUS SCHOOLS AFTER THE MASTER'S DEATH. THE CONTENT OF HIS CONVERSATIONS WITH HIS FOLLOWERS AND THE RULERS OF THE TIME ARE PARTLY RECORDED IN THE LUNYU (THE ANALECTS), WHICH IS THE NEAREST WRITTEN SOURCE TO CONFUCIUS'S TIME THAT EXISTS AND HAS MANY ENLIGHTENING ANECDOTES (UBCQ).

The political fragmentation of the Zhou favored philosophical debate, as often happens in periods of social crisis, and the search for new interpretations both on the previous speculative tradition as a whole and, in particular, on the teaching of Confucius (551–479 BC). When alluding to the Chinese speculative tradition, it is perhaps useful to say that some Western experts have been reluctant to apply the term "philosophy" to the development of ancient Chinese thought, because of the absence of a real speculative position in favor of thought strongly conditioned by pragmatic instances and hardly inclined to metaphysics and abstraction. These observations are only partly justified and, in any case, because they are arguments that often carry the conviction of a presumed "superiority" of Western thought, rather than a "diversity" compared to Chinese thought, they constitute a condition of little use as a basis for personal analyses. With the name "Hundred Schools" (bai jia) we refer to the different philosophical currents that emerged upon the death of the Sage of Lu. The term is not to be taken literally but to idicate the multiplicity of interpretative tendencies and thinkers who often start from a different interpretation of the Master's work.

Even before the appearance of the Hundred Schools, however, some thinkers were antagonistic towards the word of Confucius. This was the case with Mozi (or Modi, 479–381 BC), for instance, who lived not long after Confucius. He thought that humanity, at its origins, had no laws, not because, as the Master of Lu appears to sustain, humanity is intrinsically disposed to doing good, but because it follows its own personal interests. This utilitarian tendency is not in itself contemptible but it must be controlled by a strongly autocratic central power, which prevents the abuse of the weak by the strong and is the most advantageous solution because it guarantees general well-being. Such power, essentially, came from a sort of contract which the sovereign and the population signed in favor of the masses. The action of the rulers, to whom the individual right of action had been transferred in the name of good, which, being common would produce greater advantages in the end even for individuals, had to be evaluated on the basis of two criteria – efficiency (gōng) and advantages (li). The sovereign's power was, therefore, absolute, as was the discipline of chivalrous military "order." The disciples of Mohism abhorred the aggression of war but sustained the legitimacy of defensive action. They accused the Confucians of weakness and excessive indulgence in baroque rituals, but believed in the saving role of education. Conversely, they believed the Confucians lack of interest with regard to demons and supernatural powers to be blameworthy because they were thought to have a role which was not insignificant in rewarding those who proved to be useful to society, whilst punishing, on the other hand, the slothful.

Fundamental in the debate between representatives of the Hundred Schools was the question of human nature. For Confucius and, above all, for the interpretation of the Master's doctrine provided by the disciple closest to him, Mencius (372–288), humans are essentially good and need only to be improved through study, also indispensable for improving a propensity to Virtue (de). On the other hand Taoist tradition, and in particular the principal exponent of Taoism, Zhuangzi (369?–286 BC), regarded the very birth of the question on the goodness of human nature with great suspicion, and for the first time doubt appears and human beings lose their primordial innocence, thanks to which they could proceed along the natural way, the dao, guided by a sort of natural primordial virtue. Here Zhuangzi is asked how we should judge the hero: "Everybody considers the hero who sacrifices himself for his peers to be good, but this is not enough to save his life. In this case, is there really any difference between good and evil?"

The absence of a precise separation between good and evil definitely evolves in Zhuangzi and in the Taoists, from the dynamic concept of reality as a whole, whose manifestations (wan wu, the "Ten Thousand Things") are the result of the dialectic relationship between yin and yang (respectively "feminine principle – dark – malleable" and "masculine principle – light – hard"). This situation moved spontaneously along the dao, the Way, whose deep breathing the true sage should be

able to hear, acting in conformity with the natural flow of things, or indeed "not acting" (wu wei), at the moment when action tends to alter reality, and to then defend those alterations, intervening therefore in the natural and eternal mutability of the cosmos. This concept is accompanied by a certain disinterest for the administration of public matters – conversely central to Confucian notions – which certainly facilitates the absence of categorical concepts of good or evil. This disinterest, not unconnected to an anarchist inclination, in different periods of Chinese history made Taoism rather unpopular with those in power, and at the same time rooted it easily in many messianic ideologies that underpinned popular rebellions and revolts.

Revising the doctrines of Confucius and Mencius, Xunzi (298–238) was much less optimistic than the latter on the possibilities of human nature. It is naturally bad, because man is heavily influenced by emotions and passions; neither education nor coercive measures (such as the observance of the rules and rituals – li) are enough to redeem it. Wisdom, for which study is absolutely necessary, remains the prerogative of a small minority. Morality, based on the study of the classics and on the teaching of the masters, is not at all innate but can be acquired through study. This heterodox Confucian, of whom the legalist thinker Han Feizi was a pupil, laid the foundations for the affirmation of legalism derived from an offshoot of Confucianism and led to very different conclusions: not only is human nature bad, but to control it very rigid written laws and exemplary punishments are necessary. If Confucius believed that a virtuous sovereign did not need laws and that his authority was enough to guarantee what today we would call "consent," and with Xunzi the law was in any case useful for controlling human avidity, for Han Feizi it became the sole, objective guarantee an almost impersonal sovereign has for maintaining order, and whose power was represented only by the laws, from which even he could not escape. This notion of a more "modern" direction, which seems to go back to a sort of "certainty of rights," does, however, break with Confucian tradition, which says that in the State ruled by a good government, the subject respects the laws merely because he would be ashamed to do otherwise and therefore he fully recognizes himself in the virtuous authority of the sovereign.

The ming jia "school of names," otherwise known as the "school of Chinese Sophists," is important because it is all but unique in the speculative landscape of the time. If it shared with the Mohists a certain interest in logic, it also developed a marked interest for questions regarding language, which was expressed through a wide recurrence to the paradoxical in a specifically argumentative style (Hui Shi, 380?–300). One of the exponents of that school, Gongsun Long, was linked to the famous statement that "a white horse is not a horse" (Bai ma fei ma). Its issues moved in various directions: in particular, it examines the question of the relationship between general (or universal) names and things, and the problem of the relationship between the immobility of names and the continuous mobility and transformation of things. This second issue in particular reaches the heart of Confucian theory on the "rectification of names" (zheng ming), expounded in the Analects of Confucius. For the Master, contrary to what appears to be the case for Gongsun Long, the name retains something of the object to which it refers, therefore the object must correspond to the name that identifies it, in a concept which has not yet atoned for the primitive faith in the magical power of the word. Gongsun Long, however, views in a problematic way the increasingly obvious division between the object and the identifying name, opening up an epistemological issue rather than a moral one.

54 - The *Mengzi* ("Master Meng") is attributed to the 4th-century BC Confucian philosopher Meng Ke, whose name was later Latinized to Mencius (MSC).

55 - A study on the problem of evil and on human nature, considered by the author as intrinsically evil, is the work of Xun Qing or "Master Xun" (Xunzi).

THE BIRTH OF THE "BUREAUCRATIC EMPIRE"

The State of Qin's "Unification" Policy
page 58

The Fall of Qin and the Mausoleum
of the First Emperor
page 60

The Confucian Renaissance
and the First Han Empire
page 70

The Interregnum of Wang Mang
and the Fall of The Han
page 82

Eating, Living, Dressing
in Han China
page 84

Devoted Wives and Obsequious Children:
An Imperial Ideology
page 92

The Tomb of Mawangdui
and Concept of the Afterlife
page 94

Southern Cultures
page 98

THE STATE OF QIN'S "UNIFICATION" POLICY

Legend has it that in a remote period some time in the 3rd millennium BC, a granddaughter of the legendary king Zhuanxu fell pregnant after eating an egg that a swallow had laid next to her while she was busy weaving. The descendants of this child of divine origins became the lieutenants of the legendary emperors Shun and Yu, who established the Qin lineage.

History, however, states that a progenitor of the family was a man called Feizi, whose skills as a horse trainer brought him privileges and property when he was appointed to train chargers for the court. The region entrusted to Feizi was called Qin, and was originally to be found in what is now Gansu. This was at the dawn of the 9th century BC. The history of the family, until 361, was distinguished by the Qin's constant commitment to fighting back frontier barbarians and by their expansion policies, which damaged states created from the parceling of territories during the "Warring States" period (403–221 BC). By the 4th century power was initially contended by the so-called "Seven Kingdoms": Zhao, Han, Wei, Qin, Qi, Yan, and Chu. Gradually Qi in the north, Qin on the central plain, and Chu in the south came to the fore. The domestic problems suffered by Qi and Chu, alongside unscrupulous alliance policies and extraordinary military strength, meant that the state of Qin was able to secure the final victory and unify the Empire, in 221 BC.

Such an epic alone would justify the presence of Qin's progenitors in the myths and legends surrounding the foundation of China. But whatever the actual content of the legend itself (mentioned at the opening of this chapter, and quite complex in its developments), here we are more interested in considering the reasons why mythology has attributed the Qin with a "supernatural" pedigree to complement the very real early power possessed by the line, especially from the 4th to 3rd century BC. This need for a pedigree probably derives from the fact that culturally – and possibly ethnically – the Qin were part of the world of their "barbarian" neighbors, who settled on the Empire's frontiers. To take over neighboring states and, in 221, unify "all land under Heaven," they had applied a concept of the State and of power that was an offshoot of Confucianism, but had moved away from it radically, therefore breaking with tradition. The *Shiji* or *Historical Records* of Sima Qian (145–86 BC), whilst stating that the Qin progressively adopted the customs and administrative provisions of the Empire's other states, less "contaminated" by proximity to the frontiers, nonetheless miss no opportunity to mention their embarrassing crassness. The great historian was heavily influenced by the return of Confucianism in the Han period, and swings between his desire to keep his distance from the "traitors" and his appreciation of their greatness, which was an incentive to integrate them into a dominant cultural tradition.

Whatever the merits of Qin on the battlefield or in State administration, Sima Qian depicts their victory as the ascent of a bloodthirsty and vulgar dynasty. His *Shiji* speaks through a Wei nobleman who describes the victors as men with the "hearts of tigers or wolves, who know nothing outside of their own conduct … and virtue," describing how even Li Si, the future prime minister of the First August Emperor, wrote scandalized to his sovereign that the music of the Qin was a cacophony of sounds produced by beating terra-cotta jugs, jars, and animal bones, accompanied by a chant that was articulated as the sound "wu, wu!".

56 - THE COUNTENANCE OF THIS STANDING POTTERY FIGURE IS SET IN AN EXPRESSION OF DIGNIFIED COMPOSURE; THE STATUE IS ONE OF 12 FOUND IN PIT K0006, OR THE "PIT OF THE CIVIL OFFICIALS," IN THE QIN SHI HUANGDI MAUSOLEUM IN MODERN-DAY XI'AN (MET).

Certainly this less than generous evaluation was somewhat influenced by Qin deviation from orthodox interpretation of the Confucian tradition, not only from the strictly philosophical perspective, but also from the perspective of the political doctrine underpinning State administration. The crucial moment in their divergence from Confucian tradition came long before the unification of the Empire, and involved the Qin reform phase between 361 and 338 BC, which was inspired by the legalist philosopher, Shang Yang, also known as "Lord Shang." His thoughts are collected in a work known by his name (*Shang jun shu*, *The Book of Lord Shang*), but it comprises spurious texts that cannot be attributed to him. In any case, Lord Shang introduced radical reform in the sense of increased centralization of State administration, new land taxation that set aside the old system of distributing plots of land of equal size to peasants, and which consequently led to flexibility in the opportunity of transferring and purchasing land, with emphasis on the role of the "peasant-soldier," to the disadvantage of merchants (against whom a strong prejudice persisted even in later eras).

These reforms, culminating in a strong impulse to standardize weights and measures, the length of cart shafts, and eventually script, were later extended to the unified Empire. These were fundamental provisions to ensure equitable tax collection and the circulation of goods and people, just as the decrees that notified of imperial orders were based on a totally new ideological premise. If Confucian ideology placed a human endowed with virtue (*de*) to ensure correct State and social functioning, looking to the law almost with suspicion, as an instrument that intervened where the sovereign's moral authoritativeness failed, it was simply endorsing the deep crisis affecting the "moral" pact between the sovereign and his subjects, and the inefficacy of the "Mandate of Heaven." Shang Yang and the legalists who came after him, preferred to use precisely the law (*fa*) as an impartial tool of government, and to put the law in writing to avoid arbitrary interpretations, with an efficacy assured by a system of rewards and punishments. So, no more legitimization of power that came from the moral authority of the occupant of the throne and the respect that the subject afforded that authority, but a system in which the "social pact" was underwritten through rules issued from above, and no one, not even the monarch, could avoid them.

Laws were not obeyed, as the Confucians theorized perhaps somewhat idealistically, because of the "shame" that the virtuous person would feel in breaking the rules dictated by a just ruler, in a society made close-knit by a form of "consensus" not lacking in elements of modernity; quite the opposite, it would be the fear of inexorable application of the law that would cause its infringement to be shunned:

"… The method followed by the sage in organizing a country is not that of imitating antiquity or following the present, it is that of governing the needs of the times and in passing laws that take customs into account …

"Inflicting punishment. Slight transgressions must be given hard punishment; if slight transgressions are eradicated, no serious transgressions will arise. This is called abolition of punishment by punishment and if punishment is abolished, business will be successful." (*The Book of Lord Shang*)

58 - These 10 bronze arrows (composed of a shaft and a triangular arrowhead) are part of a crossbowman's kit and were discovered in the pits of the Terracotta Army that stands guard over the Mausoleum of Qin Shi Huangdi (MET).

59 - The inscription on a bronze weight or *quan* (left), of the Qin era, states the measurement, equal to 30 *jin*; an edict on the unification of measurements is etched onto a bronze plaque (right) found near Xianyang, capital of the Qin Empire (MMX).

THE FALL OF QIN AND THE MAUSOLEUM OF THE FIRST EMPEROR

The man behind the unification, Zheng, came to the throne in 246 BC. Initially, the influence of his companion-at-arms and prime minister, Lü Buwei, directed the Empire's legalist leanings away from extremes, taking Zheng's policies more towards general pacification politics. Conversely, the new minister Li Si (a disciple of Xunzi philosophy and brought to power by far more radical men) urged the monarch to complete unification of "all land under Heaven" or *tianxia*, also reinforcing imperial and legalist leanings, in opposition to the "pacifism" of his predecessor. After the foundation of the Empire, Zheng took the title of Qin Shi Huangdi, First August Emperor of the Qin, and he set up a special commission of wise men that was intended to refer back to the sacrality of previous dynasties, but at the same time he wanted to rise above the concept of Zhou majesty, which was expressed by the simple title of *wang*. As the fortifying walls between states were gradually demolished, retaining only those segments that coincided with the Empire's "outer" boundaries, and which then served as the foundation for the Great Wall, domestic opposition – upheld by the old governing class of functionaries and scholars of Confucian persuasion – was weakened in no uncertain terms. Although not even an "exemplary" provision such as the historically contentious sentence of burying alive 460 exponents had managed to wipe it out completely. In 213, the sovereign ordered the "burning of books," which should have eliminated all Confucian literature and saved only "scientific" texts, including prophetic and geomancy works. The book burning achieved greater symbolic value than anything concrete and the fire was seen, at the time and through history, as a real outrage against tradition. What is more, during the subsequent dynasty, it provoked a very lively and wide-ranging philological debate, with the establishment of two new schools of interpretation of the classics: the so-called "school of the old text" and the "school of the new text." Two decades passed before private libraries once more became admissible (191 BC). Books that survived the pyre were compared, but although the script reform applied during the Qin era was a watershed, it was not sufficient to resolve completely the issue of dating works, since texts in the "old script" (*gu wen*) had still be written even after the unification of the Empire. Uncertainties and gaps in various surviving editions were also compensated for by the memory of men of letters, for whom mnemonic study was a common and constant practice.

60 - IN THIS IMAGE, TAKEN FROM A HISTORY OF 17TH-CENTURY CHINESE EMPERORS, QIN SHI HUANGDI ATTENDS THE BURNING OF BOOKS AND EXECUTION OF A GROUP OF LITERATI, WHO WERE BURIED ALIVE (BNF).

61 - THIS COLORED SILK PAINTING, FROM AN ALBUM ALSO OF THE 17TH CENTURY, PORTRAYS THE FIRST EMPEROR, QIN SHI HUANGDI, ON ONE OF HIS TOURS ACROSS THE EMPIRE (BNF).

These same men of letters handed down to posterity the idea that Zheng came of obscure origins, possibly the illegitimate son of a court dancer who was already pregnant when she wed the emperor, and for that very reason branded by the stigma of being extraneous to "Confucian virtues." He was later a personally inept and gullible governor at the mercy of his ministers, who surrounded himself with necromancers, and was committed to seeking the "Islands of the Immortals," whilst indulging in esoteric rites that would ensure him eternal life. Nonetheless, the probable severity of these judgments was destined to wane in the light of the splendor of the First August Emperor's tomb complex, fulfilling any desire the sovereign nurtured of immortality.

The magnificence of the First August Emperor's political plan was already reflected in the palatial Xianyang complexes, on the south bank of the river Wei, not far from today's Xi'an, but its absolute completeness is seen in the tomb complex, which was constructed between 221 and 208 BC. Sima Qian provided precious accounts for archeologists, detailing the profusion of men and material, and the terrible fate of the artisans, imprisoned forever in that tomb so that its secrets could not be revealed. The barrow is now about 162 ft (50 m) in height (but there is disagreement about the measurements), and protects the sovereign's actual tomb, which is as yet unexplored. The sections best known to the public of the enormous excavation area around the barrow are those brought to light in 1976, containing the warriors of the Terracotta Army, situated nearly 4000 ft (1200 m) east of the barrow. It is estimated that they hold about 7000 statues of warriors, whose facial features, hairstyles, and weapons all differ. Then there are 600 terra-cotta horses, over 100 wooden war wagons, as well as

a profusion of bronze weapons. The soldiers were originally polychrome and are larger than life-size of the people of that period, to increase the overall sensation of invincible power that the army was supposed to create, even though it was obviously meant to be hidden from human sight, arranged down the long corridors, separated from one another by earth banks that supported the wooden trabeation holding up the roof. The three trenches occupied by the army (the nearby fourth trench is empty) are just a part of the immense burial area. The other pits excavated include the "pit of bronze chariots," where two exquisitely beautiful models were discovered, the "pit of civil officials," the "pit of western stables," the "pit of bronze cranes," which probably depicted a lake or swamp habitat and which has revealed birds of incomparable delicacy, such as the crane with its beak gripping a worm that wriggles helplessly, the "pit of acrobats", with large, muscular figures, and the "pit of imperial stables", with figures of grooms kneeling before the skeleton of a horse, the relic of one of many sacrifices, including human, in a tribute to the August Emperor for his final journey. The First August Emperor's final resting place is probably a realm of even more surprising treasures, but its depths have yet to be excavated.

62-63 - Pit 1 of the Mausoleum of Qin Shi Huangdi covers 153,500 square feet (14,260 sq m). The warriors are lined up in a "rectangular formation": three rows of archers are at the front and behind them stand the light infantry, who acted in support of the heavy infantry, distinguished by their plate armor (MET).

64 - This warrior with his eye-catching mustaches wears a neckerchief and his hair has a clear middle parting (MET).

65 - The elaborate headgear – called *he* – identifies this figure as a general: a commander had to be clearly visible during battle (MET).

66

66 - This mounted warrior, found in Pit 2, was wearing leather headgear and rode his charger on a plain saddle without stirrups (MET).

67 - The crossbowmen wear a short cuirass and short skirt. Their hair is tied up in a topknot and they gaze straight ahead (MET).

68

68-69 - This is a front view of one of the two chariot models (n. 2) found in the "pit of bronze chariots," and it shows the elaborate yoking system of the four splendid horses (MET).

THE CONFUCIAN RENAISSANCE AND THE FIRST HAN EMPIRE

The First August Emperor died in 210 BC, in mysterious circumstances and a long way from the capital, where his body was taken using a cart carrying dried fish in order to cover the stench of the corpse. The battle for the succession was bitter, with much court intrigue, and the Second August Emperor was faced with a hostile army supporting his brother Zhao Gao (excluded from the succession), a mass of peasants worn out by work on his father's nonetheless marvelous public works, and the scholars who certainly had no great love of the Qin. The fall of the Qin dynasty was due mainly to their fearsomely draconian laws. A handful of soldiers running late on the schedule of their march towards the frontier of today's Anhui, knew they would be executed for their late arrival, so preferred to rebel. The revolt spread to the regions of the central plain, attracted a great many peasants and after many bloody battles, even amongst the leaders of the rebellion, one figure emerged – Liu Bang. He was an NCO of peasant origins who defeated Xiang Yu – his final adversary, who had been responsible for the pillage and burning of the capital – in 202 BC. Liu Bang then proclaimed the advent of a new dynasty that he christened Han, after a river on the central plain. His choice embraced great symbolic value and indicated the

tration, although he flanked the existing governors and districts with the *guo*, territorial divisions probably born of the need to meet demands from his closest allies and companions-at-arms. Nonetheless, as time passed, these were gradually brought under the direct control of the imperial authorities. The government remained soundly centralized, as it had been with the Qin. Under the Emperor there were the so-called *san gong* or "Three Dukes," including the "Grand Councilor," who was basically the prime minister. They were flanked by the *qiu qing*, "Nine Dignitaries," who had specifically served the imperial house under the Qin and later supervised the various aspects of state administration. As time passed, the function of the Grand Councilor was limited by the "imperial secretariat," which was more or less controlled by the sovereign in person.

As far as the occult was concerned, Liu Bang (who took the name of Gaozu as emperor) placed his dynasty under the aegis of the same symbolic protective "element" as his predecessors, that of water. Thus he confirmed his intentions of continuing a certain esotericism present in Qin cults. However, while he reinforced the repression of brigandage, as well as proceeding with a certain redistribution of land amongst the peasants, which his rival Xiang Yu had started, with the return of some social well-being he also earned the support of the great landowners because they enjoyed greater protection of their property, which had often been greatly increased during the Qin period. At the same time, the sovereign promoted a great amnesty, which allowed a large number of disbanded rebels to return quietly to farm work, reduced the amount of forced labour, enacted a less severe conscription policy, and made a significant reduction in income tax.

total break with the oligarchies and great states of the past. At the same time, Liu Bang continued to express a very clear contempt of the men of letters. He himself was of humble origins, ignorant but strong-willed, courageous, and endowed with some political insight, and he considered the Confucian "sages" to be a rag-bag of time-wasting pedants:

"….he disliked the literati. Any guest who arrived wearing the headgear of the man of letters would have that hat rudely removed and he would urinate in it; when he spoke to them it was to insult them heavily." (*Shiji*, Historical Records)

Moreover he retained the Qin style of territorial adminis-

70-71 AND 71 TOP - THESE DETAILS OF A 17TH-CENTURY SCROLL, PREVIOUSLY ATTRIBUTED TO ZHAO BOJU (CA. 1120–62), SHOW THE FIRST EMPEROR OF THE HAN GAOZU ENTERING THE CENTRAL PLAIN DURING THE CONQUEST OF THE EMPIRE. THE PAINTING IS CLASSIFIED AS A "LANDSCAPE IN BLUE AND GREEN" (MFA).

71 BOTTOM - A NATIVE OF JIANGSU AND FROM A FAMILY OF HUMBLE ORIGINS, LIU BANG SKILLFULLY MANAGED TO FREE HIMSELF OF XIANG YU, TO WHOM HE HAD BEEN ALLIED. IN 202 BC HE ESTABLISHED THE HAN DYNASTY AND THIS WAS THE FIRST TIME THAT A MAN NOT OF THE ANCIENT ARISTOCRACY SUCCEEDED IN RISING TO THE RANK OF EMPEROR (MSC).

The capital was situated south of destroyed Xianyang, in a district called Chang'an, and in just four years, from 194 to 190 BC, the city that was constructed was destined to become one of the most important metropolises of the entire Empire. In later years it was its position that led to the designation of the term Western Han to define the first Han imperial phase. Gaozu did not survive to see even the start of the works. He died the year before and left an Empire at peace, after a last enormous effort to ensure its security. The northern boundaries were menaced by the nomadic Xiongnu peoples and the sovereign tried in vain to defeat them in battle. Unable to achieve a military victory he therefore pursued a political approach, using negotiation and dynastic marriages which for at least a few decades provided relative peace. The lives of many young noblewomen were sacrificed to the pitiless requirements of statecraft, but at least one left the heartfelt echo of her hopeless song to posterity.

Liu Xijun, the bride of the Lord of the Wusun in about 105 BC wrote: "My people have married me / In a far corner of Earth: / Sent me away to a strange land, / To the king of the Wusun. // The round tent is my palace, / Its walls are made of felt, / Dried meat is my only food, / Koumiss is my drink. // Endlessly I dream of my country, / And my heart is all bruised. / Oh to be the yellow swan / That returns to its homeland!" (*Bei qiu ge*, *Sad Song of Autumn*).

One of Gaozu's sons, Wendi (r. 180–157 BC), ensured a long period of prosperity for the Empire, while with the restoration of old texts the Confucian administrative class, as we have already seen, began to rediscover "tradition" and classify doctrine. The philosopher, politician, and statesman, Dong Zhongshu (ca. 195–115 BC), provided Confucianism with the link between social order and the natural order of the universe, which was not immediately clear in the formulations of previous thought and the absence of which left room, even theoretically, for Qin legalism. The sovereign, rather than answering to the people, became liable to Heaven and was called upon to act in compliance with the laws of the latter, governed by Tao. In other words, the Universe, made up of five elements sharing a dialectic relationship so as to guarantee the eternity of the life cycle, constituted an organic whole supported by Heaven, which the emperor, son of Heaven, had to obey: "Men must comply with the sovereign and the sovereign must comply with Heaven" (*Chunqiu fanlu*, *Rich Dew of Spring and Autumn*). So imperial authority had heavy limitations, even when it was masked by the law's presumed "objectivity." In this new reading of tradition and the function of power, endowed with a bond with the sacrosanctity of the universe that was clearly and peremptorily formulated, the legalist period of the Qin was seen as an execrable "mishap," which was not worth taking into account and was better repudiated while accentuating its darker side.

72 - THE CONFLICT WITH THE XIONGNU WAS A CONSTANT FACTOR OF THIS PERIOD. THIS ORNAMENT WITH A GOLD AND TURQUOISE EAGLE IS TAKEN FROM A HEADDRESS DATED JUST PRIOR TO THE HAN DYNASTY, AND WAS MADE BY THE HU, A POPULATION SUBDUED BY THE XIONGNU AND INCORPORATED INTO THEIR FEDERATION (MMI).

73 - THIS GILDED BRONZE LAMP, SUPPORTED BY A YOUNG GIRL WITH DELICATE FEATURES, WAS FOUND IN THE TOMB OF DOU WAN, WIFE OF PRINCE LIU SHENG, AT MANCHENG IN HEBEI. THE LAMP WAS MADE DURING THE WESTERN HAN DYNASTY, USING AN EXTREMELY SOPHISTICATED CASTING TECHNIQUE (MPHEB).

73

Under Emperor Wudi (r. 140–87 BC), China evolved as the *magistra vitae* of all Oriental Asia. The Emperor reinforced the Confucian *tianxia* concept, initiating a cult for the figure of Confucius that many centuries later was misunderstood by Westerners, who thought that Confucianism was a form of religion. In economic matters, the sovereign imposed a state monopoly for a series of essential commodities, such as salt, iron, and alcohol, but this brought criticism from the more orthodox Confucians who considered that these provisions threatened the central position of agriculture in the Empire's economic policy: "… the monopolies are a system of competition of an economic nature between the state and the people, which will undermine the latter's natural honesty and will foster selfishness, with the result that only the few will continue to dedicate themselves to fundamental occupations, and many will rush into secondary work [commerce and manufacture]." (*Yan tie lun*, *Discourses on Salt and Iron*)

In reality, the sovereign, who involved his armies in great and

very costly campaigns, saw state control of several manufacturing and trade activities as the only means to provide resources without too heavy a tax burden on the peasants. Indeed, Wudi committed to a series of military campaigns in the north-east not only with the intention of defeating Xiongnu once and for all, but also on the basis of precious information brought back by the envoy Zhang Qian, following a lengthy and spirited journey to those lands, who had recognized the region's great trade significance. Wudi's expansionist efforts represented the golden age of the Han dynasty, but equally and paradoxically laid the foundations for its ruin. The economic effort was immense and the goods coming from the annexed regions were essentially luxury goods, having little influence on most people's lives. The class of functionaries had been extended enormously and monopolies had brought a certain amount of corruption. A series of puppet sovereigns had succeeded Xuandi (r. 74–49 BC), son of Wudi, and had worsened the situation, actually transferring power to the hands of the various "Empress Mothers," while an inefficient system was no longer able to ensure a state fixed-ceiling price policy by direct, prudent purchase of cereals in the regions where they were cheaper so they could be resold where costs were lower. With a growing economic crisis and a precarious political and institutional situation, Wang Mang managed to take power in 9 BC. This member of the powerful Wang family was either related in some way or other to the various child emperors, or possibly he was involved as a tutor. The interregnum of Wang Mang, who went down in history with the rather unflattering designation as a "usurper," brought to a conclusion the first Han Empire. Wang Mang's star was short-lived but after him the restored Empire assumed quite different characteristics and saw the gradual crumbling of absolute faith in the Confucian ideological principles that had been the underpinning of Western Han.

74-75 - QIU YING (CA. 1494–1552), AN ARTIST OF THE MING PERIOD, PAINTED THIS IMAGINARY PICTURE (IN THE "LANDSCAPE IN BLUE AND GREEN" STYLE) OF WUDI IMPERIAL PARK – COMMISSIONED BY THE EMPEROR WUDI JUST OUTSIDE THE CAPITAL CHANG'AN – ON THE BASIS OF A LONG COMPOSITION (FU) BY THE POET SIMA XIANGRU (179–117 BC) THAT HAD ALSO BEEN COMMISSIONED BY WUDI (FSG).

75 TOP - THIS MURAL, DEPICTING THE ENVOY ZHANG QIAN TAKING HIS LEAVE OF THE EMPEROR WUDI TO EMBARK ON HIS JOURNEY TO CENTRAL ASIA, WAS PAINTED SEVERAL CENTURIES LATER, IN ONE OF THE MOGAO GROTTOES NEAR DUNHUANG IN GANSU. IN THE COURSE OF HIS LONG EXPEDITION, FROM 138 TO 126 BC, ZHANG QIAN WAS CAPTURED BY THE XIONGNU AND MANAGED TO ESCAPE ONLY AFTER 10 YEARS, BRINGING HOME WITH HIM IMPORTANT INFORMATION ABOUT THE LANDS OF THE WEST.

75 BOTTOM - IN THIS LATE PAINTING, TAKEN FROM AN ALBUM NARRATING EPISODES OF THE LIVES OF CHINESE EMPERORS, WUDI IS PORTRAYED WELCOMING A LITERATI (BNF).

76-77 - Today this famous horse from Leitai (Gansu), with one leg placed on a swallow, traditionally attributed to Eastern Han, is dated to the Western Jin dynasty (265–317) (MPG).

77 - The two bronze horsemen date from the Han period, when great quantities of bronze and pottery miniatures were placed in graves (MPG).

78

78 - *Hu* wine jars with lids, such as these dating back to the Western Han period, were made in terra-cotta painted with colored pigments imitating not only coeval bronze wares, of which they reproduced the inlaid motifs, but also similar lacquered objects with multicolored decorations (MSPS, left and MPHEN, right).

79 - This mountain-shaped bronze incense burner (*boshan lu*) with gold inlay comes from the tomb of Prince Liu Sheng, at Mancheng, and is dated pre-113 BC (MPHEB).

80 top - The tomb of the King of Nanyue, in Guangzhou, has provided objects of great interest for understanding regional art of the Western Han period. More than 1000 grave objects were found there, many in gold, such as this bowl (MTRN).

80-81 - The corpse of the King of Nanyue was protected by a robe made out of thousands of jade platelets, since it was thought that jade preserved the body and made it imperishable. This kind of jade robe was found in other tombs of Han dynasty aristocrats (MTRN).

81 top - This tomb, discovered in 1983, is that of Zhao Mo or Zhao Hu, second King of Nanyue, who reigned between 137 and 122 BC, after succeeding his grandfather Zhao Tuo, the first sovereign. Zhao Mo was also known by the posthumous name of Wendi, as in the script on the reverse of his gold seal, which is decorated with a sinuous dragon on the front (MTRN).

THE INTERREGNUM OF WANG MANG AND THE FALL OF THE HAN

Despite being known as a usurper, Wang Mang probably had extraordinary qualities, but he lacked the sort of political ability needed to "create consensus" with the various power groups essential to the success of a sovereign.

Undertaking a valiant agrarian reform to limit the extent of the large landed estates, he failed to realize that he was working against the social class that provided the vast majority of imperial functionaries, who would then have had to implement this actual reform. Moreover, there were other, equally significant reforms, for instance the establishment of "public granaries" that would fix a ceiling price for cereals, applying a shrewd buy-sell policy, or the mint monopoly accompanied by low-interest state loans, conceived to limit money-lending that would simply have come under the speculation of state functionaries. Since the functionaries perceived the reforms as being against their own interests, they boycotted them. A series of military defeats inflicted by the Xiongnu and a frightful sequence of natural calamities, which reinforced the popular conviction that the sovereign had lost the "Mandate of Heaven," all led to the great peasant revolt of the "Red Eyebrows" and the end of Wang Mang, who died in 23 AD.

The furious battles that ensued devastated the country and left victorious a prince of the deposed Han, who reestablished the dynasty in 25 AD and moved the capital east to Luoyang.

The politics of the Western Han were typified by a new phase of expansion towards Central Asia, thanks chiefly to General Ban Chao, which continued for the entire 1st century, leading the world's two great powers of that time – China and Rome – to acquire mutual, albeit imprecise, knowledge. The Romans may well be the "Da Qin" mentioned in the *Hou Han shu* (*Book of Later Han*), whose capital is studded with sumptuous palaces: "In the city there are five royal palaces … They have glass columns and goods …."

Conversely, the Chinese may be Pliny's "Seres," the peoples who produced silk, although there are very legitimate doubts regarding their real identity, since Pliny describes them as taller than average, with red hair and blue eyes.

Whatever the case as far as knowledge of Rome is concerned, the fact remains that China pushed westwards further than ever before, into lands and meeting populations, such as the Parthians, that the Romans knew very well. All thanks to the ability of Ban Chao and restored political stability. The first three sovereigns, Guangwudi (r. 56–57), Mingdi (r. 57–75), and Zhangdi (r. 75–88), rebuilt and consolidated the power and prestige of the new dynasty, however, after them and towards the end of the 1st century, the pernicious phenomenon of the "child emperors" emerged once more, with particularly disastrous consequences in a heavily centralized system of government. The weakness of central power in the absence of any real government policy once more threw the country into poverty, and the peasant rebellion of the "Yellow Turbans" marked the end for the Han and the start of a period of political and social upheaval. Nonetheless, even in this troubled period there were far-reaching contributions to the future development of Chinese civilization, not least of which was Buddhism.

82 - GENERAL BAN CHAO (32–102) WAS ONE OF THE INSTIGATORS OF THE EXPANSION WESTWARDS THAT OCCURRED DURING THE EASTERN HAN PERIOD. ENDOWED WITH EXTRAORDINARY MILITARY SKILLS, HE SUCCEEDED IN SUBDUING ALL THE POPULATIONS OF THE TARIM BASIN (MSC).

83 - MINGDI (58–75) WAS ONE OF THE SOVEREIGNS WHO SUCCEEDED IN CONSOLIDATING THE POWER OF THE RE-ESTABLISHED EASTERN HAN DYNASTY. IN THIS PAINTING – OF MANY CENTURIES LATER – HE IS PORTRAYED CONFERRING HONORS TO TWO ELDERS (BNF).

EATING, LIVING, DRESSING IN HAN CHINA

The sumptuous and complex court life of the Han era is perfectly illustrated by the lavish grave goods left by a number of nobles and dignitaries, which reveal not only the overall concept of the afterlife, but also suggest an earthly lifestyle that was extremely refined, both locally and regionally. "Regionalism" constituted one of the new sources of wealth and variety in the Han period, accentuated by external contributions. New technology, ideas, and religion, as well as new and different types of commodities, such as jewels, glassware, textiles, wool, felts, nephrite (thanks to the Empire's unprecedented expansion towards Central Asia) generated profound change, though this change came slowly. Many developments came about only after the fall of the first great Empire in Chinese history. Concepts of art also modified gradually and seamlessly with the past. In general terms, it was possible to observe a shift from ornamental art, with a prevalent use of fantastic motifs, to a style that willingly measured up to the demands for a depiction of reality, or in any case a type of fantasy that appeared more humanized. This process can be clearly seen in the transformation of the decorative motifs used in textiles (silk weaving and processing with damask motifs on a monochrome background had existed since the Shang dynasty). During the Han period the geometrical elements were gradually replaced by figurative themes, sometimes accompanied by the introduction of characters indicating good wishes (happiness, longevity, many children). Surviving examples, together with extremely famous lacquer items, were found in the grave goods of the Marchioness of Dai (who died in about 168 BC), at Mawangdui, near Changsha, in Hunan province. As with precious fabrics (severe sumptuary laws governed peasant garb, which was in cotton or hemp and never dyed), lacquer dishes were also only found in wealthy homes and point to culinary customs of great refinement. In the four centuries spanned by the Empire, the number and type of dishes multiplied significantly, along with the variety of cooking techniques. One of the underlying principles of Chinese cuisine began to become definitive, that of the harmonization of the so-called "five flavors" of sweet, sour, spicy, bitter, and salty. Pasta appeared, whilst protein for the less wealthy was supplied chiefly by soya beans. The journeys into the regions of Central Asia of Zhang Qian and the merchants who emulated him resulted in the introduction of "luxury" foods and spices that were formerly unknown in China and destined in some cases to acquire rapid domestication, for example, grapes, sesame, coriander, lemon, pomegranate, spinach, black pepper, and pumpkin. Although the poor were eating "husks and chaff," the poet prince Cao Zhi, of the 3rd century, described the details of a banquet washed down with "…ten thousand *dou* of superb wine, finely-sliced carp, juicy shrimp, turtle in sauce and roasted bear paw." (*Mingdu pian, On the Famous Capital*)

84 AND 85 - IN THE TOMB OF THE MARQUISE OF DAI AT MAWANGDUI, SPLENDID LACQUER ITEMS HAVE BEEN FOUND IN AN EXCELLENT STATE OF PRESERVATION, WITH BRILLIANT DECORATION MOSTLY IN REDS AND BLACKS, TESTIFYING TO A LIFESTYLE OF LUXURY AND ELEGANCE (MPHUN).

85

86

These convivial encounters, often organized after magnificent hunts, were enlivened by music and dance. This custom was described in written sources and depictions of groups of dancers and/or musicians have been found in grave furnishings such as those brought to light in 1999 in a tomb at Yahehuayuan, near Xi'an. The dancers depicted in this clay artifact also show what was considered the ideal of female beauty in the first phase of the Empire: slim, pretty women, with long tresses gathered behind their necks. Over the centuries figures got heavier and acquired the overize solemnity of Tang (618–917) women. The preference for the performing arts of music and dance links to the strong interest in music that already existed at the time of the Emperor Wudi, who established the *Yuefu*, a government office specially dedicated to collecting "poetry" and "nocturnal chants" (*ye song*). The office, as we know from the *Han shu* (*History of Han*), was entrusted to Li Yannian, a musician and singer himself, who came from a family of musicians and was one of the first music scholars and composers known in Chinese history.

Details about Han dwellings are known thanks to the *mingqi*, or "objects of the soul," which accompanied the deceased into the afterlife. The depiction of dwellings and granaries in terra-cotta that was sometimes glazed is the oldest and most frequent type of *mingqi*. It illustrates an interest in daily life and materials which in the Han period also had precise links with religious concerns about the afterlife. We can see illustrations of turreted homes and palace watchtowers, with several floors tapering upwards, with narrow sloping roofs covered with curving tiles, usually set within a court protected by boundary walls. There are also single-story peasant homes made from mud and earth, with courtyards where there are folds for domestic animals, which are often also carefully depicted.

86 - Amongst the *mingqi* (reproductions of various subjects), present in Han period burials, there are many figures of musicians, such as this very realistic pottery item (MPGU).

87 - Tomb figurines could also be made out of wood, such as this group of musicians found in the tomb of the Marquise of Dai at Mawangdui, near Changsha, in Hunan (MPHUN).

88-89 - Six maidens with long-sleeved robes dance to accompany the deceased in his journey to the afterlife. These elegant pottery MINGQI date back to the Western Han era and are decorated using colored pigments (MSPS).

89 - Few traces remain of the colors that were used to enliven the willowy figures of these two terra-cotta dancers of the Western Han period, while the rhythm of the dance is expressed vibrantly through their flowing robes (MSPS).

90

90 - This miniature pottery tower, found in the village of Mazuo in Henan, is splendidly decorated with colored pigments, and is almost five feet tall; it was made during the Eastern Han dynasty in the 2nd century AD (MPA).

91 left - Pottery models, such as this one of a fortified dwelling inhabited by a rich family of the Eastern Han period, have been found in many Han burial places. They provide important information on Han architecture (MSC).

91 right - This glazed terra-cotta model of a tower of the Eastern Han dynasty is truly spectacular for the extraordinary detail in its depiction of its walls, parapets, and finely decorated roofs (MPHEB).

The Confucian restoration during the Han period laid particular emphasis on "filial piety" (*xiao*) as one of the moral qualities that distinguished the virtuous gentleman (*junzi*).

The Classic of Filial Piety (*Xiao jing*) became an essential part of the studies of all scholars. Respect for parental authority, especially for the father figure, was celebrated not only in literature but also in the production of artistic items. One particularly significant item in this context is a tombstone found in Wu Liang's mausoleum, erected in 151 AD at Jiaxiang, in Shandong province. The bas-relief decorating the tombstone narrates the famous story of Laizi, a shining example of the most valued of Confucian virtues, who at over 70 years of age continued to act like a child as he wished to persuade his parents that theirs was not a particularly advanced age, so that they would not be saddened by growing old. In the Han period, and possibly even more so in the Western Han period, the respect for filial piety was underpinned by a vision of the family as the fundamental unit of social organization, reproducing in miniature amongst its members the same hierarchical relations and the same obligations that should exist between the loyal subject and the virtuous sovereign. In this vision, the woman played a totally marginal role, but if Confucius had reserved very few – and hardly complimentary – words for women, the "ancillary" function of the female figure is underscored and emphasized in the Han period. The subaltern role was in no way disputed, and was actually recognized as a form of "dignity" that until that moment was unknown. The erudite Liu Xiang (79–8 BC) dedicated his extremely famous volume called *Lienü zhuan* (*Traditions of Exemplary Women*) to 125 women of antiquity. Their lives were exemplary because they behaved in total compliance with Confucian ideals. They were exemplary mothers, virtuous wives, shrewd and frugal administrators, chaste and modest widows, and where destiny reserved for them the shame of a violence they could not oppose, it was above all admirable – actually opportune – for them to sacrifice their own existence to wash away the shame of the outrage they had suffered. Women had no legal standing, like children, so if they had to appear in court they were represented by their fathers, husbands, or oldest sons, even if they were adults. Even those rare figures who ventured into what was usually male territory, such as the wise Ban Zhao (ca. 48–116 AD), daughter of a famous family of historians and an historian herself, were unable to escape the restricted roles given to women. In the pages of *Nü jie* (*Lessons for Women*), Ban Zhao remembers her contemporaries:

"Humility means deferential bearing and actions, always putting others before oneself, setting aside the thought of worthy actions to underscore one's own failings, bearing insults and unjust treatment in the correct measure …."

DEVOTED WIVES AND OBSEQUIOUS CHILDREN: AN IMPERIAL IDEOLOGY

92 - SERENITY AND SENSE OF OBEDIENCE EMANATE FROM THE COMPOSED AND ELEGANT EXPRESSION OF THIS FIGURINE OF A YOUNG SERVANT OF THE WESTERN HAN DYNASTY (HM).

93 - THIS UNDULATING AND ELEGANTLY STYLED JADE PENDANT ALSO SUGGESTS AN IDEAL OF FEMININE BEAUTY INSPIRED BY A GENTLE AND ALMOST RAREFIED CHARM (MTHD).

THE TOMB OF MAWANGDUI AND CONCEPT OF THE AFTERLIFE

Some scholars believe that the ancient southern origin of the Han founder might justify, at least in part, the notion of a world and an afterlife populated by obscure – at times terrifying – powers, flanked by heartening and merciful divinities, such as the Queen Mother of the West, lady of Paradise. They were very popular in a religious context that went on to evolve a precise association between actions in life and their rewards after death, assured by the "accountant" divinities that resembled increasingly the functionaries of the Empire in the world of the living and who were affected by an outright "bureaucratization" of their functions. It was an eloquent sign of the times that the world of the living encroached on that of the dead, and that the champions of Confucian orthodoxy, such as Emperor Wudi, placed their trust in their necromancers to conjure up the spirit of a concubine much loved and prematurely lost. The pronounced esoteric beliefs of Han China intertwined with the sturdy defense of Confucian orthodoxy. Perhaps it is no coincidence that the dynasty was finally wiped out, in the early 3rd century AD, by the surprisingly vicious "Yellow Turbans" peasant revolt, which combined justifiable claims for a more equitable land distribution and goods, with an ideology of a messianic and millenary nature.

The ideological and religious panorama was therefore complex, for although Confucius had said that "spirits" should not be taken into account, conversely they were occupying a central position in Han philosophies, especially with regard to the afterlife. It was believed that on the point of death the aerial, spiritual soul of the individual, called *hun*, futilely called back by the lament of the deceased's family, began its ascent Heavenwards. The body, however, continued to be the home of the *po* soul, for whose sustenance and ease offerings and goods were left in the tomb of the deceased, waiting for this more chthonic and heavy soul finally to reunite with its more aerial, spiritual mate.

Showing the strong influence of southern style concepts from the state of Chu, the so-called "Mawangdui banner," discovered in 1972, has a characteristic T-shape, present in an iconographic program that, while still the subject of contradictory interpretations, nonetheless exemplifies in a quite striking way, the beliefs that revolved around the world of the dead, and clearly demonstrates the definitive affirmation of a dualistic and dialectic (not dichotomic) vision of the universe, in which a multiplicity of manifestations of reality, the "Ten Thousand Things" (*wan wu*), are produced by the inter-

action of yin and yang, respectively the female and the male principles. It describes the ascent to the heavens of the Marchioness Dai, amidst zoomorphic figures, who found their counterparts in bronze grave goods, sometimes in inlaid gold, jade, terra-cotta, wood or stone, sometimes with hybrid features and a threatening look, for example, the winged felines called *bixie*, normally with an apotropaic function, that stood guard over the tombs. Marchioness Dai's banner shows her ascent to the heavens facilitated by two dragons intertwining in spires across a jade circle (*bi*). Jade plays a very important role in Han funeral rites in the aristocratic sphere. Since it was believed that this substance preserved the body from decomposition. Jade was used to make a sort of tomb "pajamas," a kind of shroud that covered the deceased's entire body, comprising separable sections (limbs, trunk, head), each made with small jade platelets and seamed with metal or gold filaments. One of the loveliest examples has come down to us, discovered in 1995 at Shizishan, in the province of Jiangsu and made for a Chu monarch in the 2nd century BC, although its gold threads were stolen by tomb raiders before it was recovered by archeologists. The "jade shroud" custom, which did not survive the Han dynasty, brought forth objects of great refinement, confirming the preoccupation for conservation of mortal remains that is typical of a rich, opulent and mature society, which explicitly declares its attachment to the physical and carnal aspects of existence. This tendency for physical and material welfare may also explain the so-called "money trees," which appeared in the Eastern Han period, in south-west China. These are probably good luck objects and show "branches" loaded with coins, at the top of which there is sometimes a Queen Mother of the West, almost a guarantee of the benevolence of the gods, as is the case with the tree brought to light at Guanghan (Sichuan).

94 - The famous "Mawangdui banner" portrays the ascent to the heavens of the spouse of the Marquis of Dai, visible in the center of the composition, on a platform surmounted by a rich canopy (MPHUN).

95 - In red lacquer and with good luck motifs, almost a hymn to eternity, the third of the four sarcophagi that held the body of the Marquise of Dai – Xin Zhui, wife of Li Cang – in Tomb 1, Mawangdui (MPHUN).

96

96 AND 97 - THE SUMPTUOUS GRAVE GOODS OF THE MARQUISE OF DAI WERE MANY AND LAVISH. AMONGST THESE, BESIDES THE SPLENDID LACQUER ITEMS, THERE ARE MUSICAL INSTRUMENTS, FOOD OFFERINGS, ROBES IN SILK AND SMALL WOODEN FIGURINES, INCLUDING A FEW MUSICIANS AND SINGERS (LEFT), ALSO WEARING SILK GARMENTS. ALSO PRESENT, THE SERVANTS (RIGHT) THAT ACCOMPANY THE DECEASED ON HER JOURNEY TO THE AFTERLIFE (MPHUN).

98

98 - The extraordinary bronzes of the Dian culture, which evolved between the 4th and the 1st centuries BC, in the modern-day province of Yunnan, speak of the rich and vivacious world of the southern cultures. This container for shells is surmounted by a gold horseman (MPY).

98-99 - Two rampant felines serving as handles seem to turn menacingly towards the lively scene that unfolds over the top of this bronze container produced by Dian artisans, whose works abound with feline and quieter bovine figures (MPY).

99 - A peaceful scene of rural life can be admired on this bronze of similar origin, whose body is embellished by a refined engraved decoration. Containers for cowries (shells used as currency) are a cultural characteristic of the Dian reign (MBLY).

During the Western Han dynasty, especially under Wudi, the Chinese reestablished their control of regions inhabited by the "southern barbarians," who lived in Fujian, Guangxi, and Yunnan, and got as far as today's Vietnam. In these areas the independent cultures that developed were very often quite splendid. This was the case with Dian culture, which extended over an area whose centre was today's Yunnan, reaching into Guangxi, Guizhou, and touching the southern part of Sichuan out as far as the opposite side to Vietnam and Laos. Dian culture was the expression of a military aristocracy of knights who were ignorant of the use of script but who produced extremely refined material goods, including drums, excavated as early as the 1950s at Shizhaishan, in Jinning county (Yunnan), and with magical-religious functions, connected to political power and to fertility.

3

THE PERIOD OF DIVISION

State Fragmentation and
the Decline of the Empire
page 102

The Northern and Southern Dynasties
page 106

The Ideological Crisis and the Reply of the Literati
page 108

The Advent of Buddhism
page 112

The Great Rock Temple Complexes
page 114

STATE FRAGMENTATION AND THE DECLINE OF THE EMPIRE

The period between the fall of the Han and the reunification of the Empire by the Sui dynasty in AD 589 is one of the most turbulent and complex in Chinese history. The need to control the "Yellow Turbans" rebellion led to the emergence of a series of generals who could rely on growing power and secure status, and were supported by armies more loyal to their own leaders than the dynasty. This was the case with Cao Cao and his son Cao Pi, who definitively defeated the Han, thus founding the Wei dynasty in northern China that established its court in Luoyang, at that time the capital of Eastern Han. The new dynasty did not control the northern region of the Empire. The new state of Wu emerged in the central-southern area of the Yangtze valley, supported by an agreement in previous centuries amongst influential families who had settled in what was considered border territory, and characterized by the powerful presence of an indigenous culture. In the western regions of the Empire, a member of a dethroned branch of the Han imperial family, Liu Bei, founded the Shu dynasty and presented himself as the "legitimate" representative of the dynastic continuity, in a geographical area corresponding to the present-day region of Sichuan, peripheral somewhat to the heart of the Empire. His death saw repeated and failed attempts at reunification by the regent, Zhu Geliang, an individual who symbolized devotion to the Han dynasty and loyalty to the ruler, not to mention a capacity for foresight, adaptation, and development of a flexible political

101 - THIS TERRA-COTTA FEMALE HEAD COMES FROM THE YONGNINGSI SITE OF LUOYANG, THE GREATEST TEMPLE TO BE CONSTRUCTED BY THE NORTHERN WEI (386–534) SOVEREIGNS AFTER THE CAPITAL WAS MOVED FROM PINGCHENG TO LUOYANG (IAACSS).

102-103 - THIS PAINTING BY AN ARTIST OF THE MING PERIOD, SHANG XI (EARLY 15TH CENTURY), DEPICTS AN EPISODE FROM THE *ROMANCE OF THE THREE KINGDOMS*, WITH GUAN YU (160–219) – A DISTINGUISHED COMMANDER WHO WAS THE OBJECT OF A RELIGIOUS CULT – CAPTURING AN ENEMY GENERAL (PM).

103 - A GREAT SENSE OF COMPOSURE IS SHOWN BY THIS EASTERN JIN DYNASTY (317–420) TERRA-COTTA WARRIOR WITH COLOR PIGMENTS, FOUND IN THE FUGUISHAN AREA OF NANJING (NM).

strategy, attentive to the needs of *Realpolitik*. He, and all the protagonists of this troubled – and in many ways extremely cruel period – would later become popular in China thanks to the epic *Romance of the Three Kingdoms*, one of the masterpieces of Chinese literature, written in the 14th century by Luo Guanzhong. Traces left by this epic can even be heard in the everyday language of contemporary China: someone who deserves admiration for their intelligence, insight, and ability to adapt to circumstances, is addressed as Zhu Geliang. The *Romance of the Three Kingdoms* recounts much more than a sequence of events. Although subsequent Confucian historiography would tend to suppress unequivocally and harshly its representation of characters (the famously ferocious tyranny accompanying the figure of Cao Cao, "guilty" of attempting to overthrow established power), its essence has a psychological complexity that reflects that of the times. Thus, the anti-hero who, in reality as in the novel, was also a great poet, prone to rage yet torn by a sense of guilt, ready to use force to succeed in his own designs, was also aware of "another" destiny, from which no one can escape and which thwarts all human endeavor. He was not afraid to be cruel, but took for granted the confused consciousness of the futility of things, showing a new type of awareness, introduced by Buddhism and combined with the atavistic fear of spirits and magical powers to which the final designs of fate are entrusted. So it should not be a surprise that this ferocious warrior paused to produce lines such as these:

"… The old war-horse may be stabled, yet still longs to gallop a thousand *li*; the noble-hearted man is in the twilight of his years, but his proud heart is not yet finished." (*Bu chu dong xi men xing*, Leaving from The Eastern and Western Gates)

At the end of his days, the heart of the great leader-poet foresaw a period in which he warned of uncertainty. In less than 50 years, from 220 to 265, the map of power was radically modified and the borders of the Han Empire vanished. This dramatic period saw great masses of peasants lose their independence and fall back into serfdom, at times nearing slavery. With the disappearance of Zhu Geliang from the military theater, the "loyalist" state of Shu would be absorbed by Wei. In turn, the Wei, after various court struggles, came under the supremacy of one powerful aristocratic family, the Sima, who proclaimed, in 265, the birth of the Jin dynasty which conquered the Kingdom of Wu in 280. But a tax reform, although promoting the farming of uncultivated areas because of the system of so-called "military colonies," at the same time created unsustainable financial pressure on peasant families, sanctioned intolerable privileges for functionaries, encouraged discontent amongst the aristocratic families from the recently conquered kingdoms, and weakened the central power, which was incapable of opposing the growing pressure from the "Northern Barbarians." In 316, the dynasty surrendered and the richest families were pushed beyond the Yangtze River by the armies of the barbarian tribes. In these regions and in the new capital of Nanjing, they continued to be a bulwark of Chinese tradition, founding a new dynasty – the Eastern Jin – which nevertheless was unable to give unity to the Empire.

104 - Animal forms were common in Yue celadons. The surface of this Yue pottery bear, dating back to the Western Jin dynasty (265–316), is detailed with deep incisions to simulate fur (ROM).

105 left - This ewer with spout in the shape of a chicken head has a dark glaze and was produced in Zhejiang, at Deqing, one of the kilns active in the Yue tradition at the time of the Eastern Jin (317–420) (ROM).

105 right - The most ancient specimens of *gucang guan* (funeral urns surmounted by architecture and figures of humans and animals) in Yue pottery were produced in about the mid-3rd century, during the Eastern Jin period (MG).

THE NORTHERN AND SOUTHERN DYNASTIES

Bad political choices and internal struggles, lasting almost 18 years and known as the "Rebellion of the Eight Princes," undermined the power of the Western Jin. Over time this situation encouraged the ambitions of the border populations, never truly converted to the tax policies established by their powerful neighbors. The Xiongnu tribal confederation, particularly threatening to China along the northern borders, did not disperse until later, leaving room for other nomadic populations of Turkish origin. From 304 to 340, the northern regions of the Empire were constantly shaken by wars for supremacy amongst local families and populations, also of "barbarian" origin. The name by which the period is known, "Sixteen Kingdoms," bears out its deep instability. The uncertainty and wretchedness of the period is echoed in the tension that runs through the verses of this anonymous poet, reaching out in the night to hear the voice of her faraway love, whom she has only imagined she can hear:

"In the infinite night, I cannot sleep
Why, moon, do you give such brightness?
I seem to hear a voice that calls
With a nod, I answer the emptiness in vain."

Chinese historiography also refers to this period as the "Northern and Southern Dynasties" (Nan bei chao). One situation can be seen as destined to repeat itself in different phases in Chinese history. The South, richer and more cultured, considered itself heir to the "classic" tradition, while the North was crisscrossed by diverse populations, frequently unrelated from a cultural point of view. Nevertheless, their cultural contributions would be crucial in giving substance to the most indigenous traditions with new and essential elements. Far from being a trivial "geographical" expression, Nan bei chao designated a difference between North and South that in some ways can still be seen.

In the North, the different nomadic tribes established kingdoms as new as they were ephemeral. Among these was the state founded by the Di, a people of Tibetan origin who originally settled in the Gansu region. Their single, yet remarkable, sovereign, Fu Jian, was the first to promote a new foreign religion in northern China, Buddhism. The Tuoba, a tribe of Turkish origin, nominally conquered by Fu Jian, gave rise to a new Empire in 398, gaining the allegiance as well of many nomadic Xiongnu and Xianbei tribes. The Chinese accepted their new conquerors with little hostility and

the latter, shrewd enough to utilize Chinese bureaucracy for administration, showed a remarkable tendency for assimilation into Chinese culture. The question of cultural assimilation and the relationship with "Chinese mastery" in the northern region was becoming crucial. The most Sinicized "barbarians," over time, came to oppose a concept of the State based only on the power and supremacy of a warrior caste. This process of "integration" would double the power of the Tuoba, at this point settled into power under the name of the Northern Wei dynasty. In fact, the military and warrior aristocracy barely tolerated this progressive Sinicization of customs, further encouraged by a patent policy toward mixed marriages, as well as the growing prestige of the civil bureaucracy of Chinese extraction. Added to this malcontent was that of the common people of Tuoba origin. The transfer of the capital from Pingcheng (the present Datong) to Luoyang at the end of the 5th century determined a definite economic shift towards an agriculture-artisan-commercial axis that would exclude the Tuoba nomads, who were mostly shepherds and raised livestock. A series of rebellions brought power into the hands of Yang Jiang, a high-level functionary who founded the Sui dynasty in 581.

Meanwhile, in the South, the immense fortunes originating from the great families escaping the North enabled the development of farming of vast southern areas where the land was definitely more generous. But the attempt at reconstructing the economic fabric did not take into account the profound political instability. The Eastern Jin was quickly replaced by the Liu Song dynasty, founded by a general originally in service to the old dynasty, who previously had even managed to extend his dominion to several northern regions. However, the fragility of power was endemic and fed by the constant tension that pitted the ranking families, frequently of northern origin and, in alternating succession, influential in the court, against the local populations who were unhappy about their marginal position with respect to the seat of government. Added to this was the weakness of the armies. Whereas the Eastern Jin had maintained the system of "military families" who, in exchange for territorial and financial privileges, guaranteed the soldiers for the army, aristocratic families in the South preferred to entrust themselves to unreliable mercenary troops. The last southern dynasty, called Chen, finally surrendered to the new, relatively large and powerful political entity established in the North, the Sui dynasty.

106 - FRAGMENT OF A STONE BASE DATING BACK TO THE 6TH CENTURY, PRODUCED IN THE NORTH DURING THE NORTHERN WEI DYNASTY (386–534). THE FIGURES SCULPTED ON IT ARE *SHENWANG*, IN OTHER WORDS, "SPIRIT KINGS" (MG).

107 - THIS ELEGANT TERRA-COTTA FEMALE FIGURE WAS MADE IN THE SAME PERIOD AND COMES FROM HENAN (MG).

THE IDEOLOGICAL CRISIS AND THE REPLY OF THE LITERATI

The dramatic nature of the historical events would be accelerated by intellectuals in the process of losing trust in the Confucian-style ideological model, unable to guarantee the continuity of the imperial system in peace and prosperity. Dismay at the growing crisis in all governmental structures and the system of exams, reduced to a mere instrument for defending and guaranteeing functionary family privileges, was accompanied among intellectuals by the search for a more personal and private dimension, marked by a growing interest in those mysterious and esoteric themes that Confucianism had *de facto* eliminated for its own rationalistic horizons. The group of poets, literary figures, and painters, known as the "Seven Sages of the Bamboo Grove," were brought together by the clear call for a return to nature. The deep transformation of the cultural climate appears through the common elements of this group, and was more interesting because of this than their individual intellectual biographies. The seven met near the city of Luoyang, in a bamboo grove, where they could admire the tranquil landscape, play the *qin* and compose verse, gather

medicinal herbs and attempt experiments in alchemy; in short, live for a limited time the ideal life of the Taoist hermit, later to return to the more comfortable life in Luoyang.

The interest in alchemy and techniques capable of guaranteeing immortality also contributed to the development of science, as shown in the medical-alchemical-galenical essays called *Baopuzi* or "The Master Who Embraces Simplicity," from the pseudonym of the author, Ge Hong (250–330), one of the main neo-Taoist philosophers.

Also connected with the cultural environment of the "Seven Sages" was one of the most eminent Chinese literary figures of the 4th and 5th centuries, Tao Qian (365–427), otherwise known as Tao Yuanming, born into a family of impoverished functionaries. He showed clearly the unease of the high-principled Confucian, much of this through his troubled biography, his intolerance for a career in public offices and the conspiracies arranged there. His work shows his yearning for the rustic life through compositions with calm, almost "Arcadian" tones, together with an apprehension regarding the present. This all finds superb expression in his "dream" of an initiatory journey to a village as yet untouched by the decadence and corruption of the present, the "City of the Peach Blossom Valley" (*Taohua yuan ji*, Story of the Peach Blossom Valley).

While "high" literature transmits the deep malaise of an uncertain and perhaps frightened ruling class, several popular texts confirm how the introduction of "non-Chinese" elements modified the way of feeling and perceiving society, including the role of women. The liberty enjoyed by the women from the nomadic northern tribes comes through clearly in the *Ballad of Mulan*, the tale of an intrepid young girl who leaves for battle in the place of her ageing father, since there are no other men in the family. Her adventures have inspired theatrical renditions since ancient times and, more recently, even a successful cartoon film. Mulan sighs while she weaves the tale but her sighs are not dedicated to a faraway love: "They ask Daughter who's in her thought, / They ask Daughter who's on her memory. / No one is on Daughter's thought, / No one is on Daughter's memory. / Last night I saw the army notices, / The Khan is calling for a great force. / The army register is in twelve scrolls, / and every scroll has Father's name." She is an active female figure, aware of the events in the world around here, able to read, with prospects that are not closed within the memory of an amorous experience; in other words, a woman very different from those previously celebrated in Chinese literature.

108-109 - Sun Wei, a Sichuan artist working in the late Tang period (618–907), depicted in a horizontal scroll (seen here in detail) the *zhu lin qi xian* or "The Seven Sages of the Bamboo Grove"; the expression of intense spirituality is very successfully captured (SHM).

The southern court near Nanjing, though torn by internal struggle, presented itself as an element of "continuity" in tradition. Here the revival of painting represented, in aesthetic terms, another possible artistic response to the crisis of pre-existing cultural models that naturally also involved the concept of art and its social function.

Two of the greatest Chinese painters of all time appeared during the 4th century: Wang Xizhi, a calligrapher for the most part who lived from the early 300s to the late 360s, and the eccentric Gu Kaizhi (341–402) who was unconcerned with rules and regulations. A century later Tai Kui was destined to hand down his stylistic lessons through the stone relief carvings in the "Longmen Grottoes." Only later copies of their paintings have survived, but both the calligraphy and painting clearly show their desire to answer the dark pace of history with a search for absolute elegance, while the affirmation of landscape painting may belong to that return to nature, albeit elegantly reinterpreted, that enchanted many poets from the period. *Admonitions of the Court Instructress*, the most famous copy by Gu Kaizhi, is today found in the British Museum.

The prevalence of line and the fine, sinuous stroke of the statuesque rendering of faces and tall, slender bodies, would be revived in the Longmen rock cycles. At the same time, the lesson of these painters, who left no contemporary traces, is present in several tomb furnishing decorations, such as the tempered screen in Sima Jinlong's tomb, near Datong.

This style of painting, though indicating in some way the continuation of tradition, was nevertheless a completely new way of thinking in terms of fundamental techniques and theories from which future painters would never depart. Around 500, Xie He published his *Six Principles*, a milestone and departure point for each subsequent debate on painting, destined to give rise to interpretive theories that still survive. Their translation sounds something like this:

Vitality, thanks to spiritual resonance;
"Structured" or "bone" method or the way of using the brush (this literally recalls "bones," with reference to the intrinsic congruity of every object endowed with a bone structure that holds it together);
Correspondence to the object in depicting form;
Suitability to type or the application of color;
Appropriate arrangement of elements;
Transmission of the legacy of the past in creating copies.

A profound inner turmoil was provoked among artists. The radical weakening of the teachings of Confucianism allowed the emergence of new aesthetic thought on the function, methods, and forms of all artistic expression. Around 480 the first real treatise on aesthetics appeared, written by Liu Xie with the title *Wen xin diao long* (*The Literary Mind and the Carving of the Dragon*); "carving of the dragon" here refers to the Chinese act of decorating an artistic work for the simple pleasure of beauty. The writer Xiao Tong (501–531) would go so far as to create an anthology of literature, the *Wenxuan* (*Literary Selections*), based on completely personal aesthetic and ethical criteria, and not on the didactic function of works of art advocated by Confucian ideology.

110 - Two versions exist of the scroll *Admonitions of the Court Instructress*, attributed to Gu Kaizhi. The older version is in the British Museum and is a copy from the Tang period (BM).

110-111 - The master's influence is evident in the 5th-century lacquered wood screen from the tomb of Sima Jinlong, which narrates the lives of famous women taken from the *Lienü zhuan* (*Traditions of Exemplary Women*) (MCD).

111 bottom - This close-up is part of a painting attributed to Gu Kaizhi (341–402), *The Nymph of the Luo River*, which became famous through a later copy (PM).

THE ADVENT OF BUDDHISM

The ascent to power of the Tuoba-Wei coincided with the diffusion of Buddhism in China. The great support given by the new sovereigns to this foreign religion was expressed in the financial wealth lavished by the court on the construction of grandiose stone temples. Recent research has shown, however, that private commissions and widespread economic support were the basis for this extraordinary flowering of places of worship and monasteries, testifying at the same time to a generalized adherence to this new religion. Around the end of the 5th century, northern China had just under 6500 temples and a monastic population of over 77,000.

What were the reasons for the success of this foreign religion? Certainly, the crisis in Confucian ideology had left an enormous vacuum to fill and Taoism was not completely "equipped" for this task. It still did not posses an organized clergy capable of widespread proselytizing and its message was probably less immediate. More interested in alchemical research into the attainment of immortality than the offer of a concrete hope of future "remuneration" after a virtuous life, it did not stimulate in any way the search for inner perfection, nor did it offer a satisfying response to existential problems of great importance, above all during a period of crisis, such as the ultimate meaning of suffering or the specific individual destiny of every human being after death. Buddhism, in its "easier," more merciful version, the school of the "Great Vehicle" or Mahayana, allowed anyone to see the possibility of reaching "enlightenment," thanks also to the compassionate intercession of the Bodhisattva, Buddha who had renounced entrance to Nirvana in order to mingle with men and help them on their path toward perfection, the cessation of all punishment, and everlasting peace. What is more, with its rich pantheon, and lively and powerfully descriptive iconography, this religion was able to fire the imagination and fantasy of even the humble and illiterate. While those who could write were frequently attracted by the new intellectual and spiritual experience offered by the techniques of meditation. Many had earlier considered Buddhism a variation of Taoism, in part because the earliest translations of the sacred texts made broad recourse to Taoist terminology. The monk Kumarajiva (350–413), originally from Central Asia, was the first to confront the problem of the correct translation of the sacred texts, establishing himself as head of a school of translators with several hundred monks, located in Chang'an (present-day Xi'an). In the meantime, intrepid monks such as Faxian undertook long journeys (399–414), to bring the classics of the new religion to China.

Political reasoning also contributed to making Buddhism the triumphant religion in this era of division. Although foreign to the Chinese, a fact that made it appealing to the Tuoba warrior aristocracy who were always suspicious of the prospect of excessive assimilation into Chinese ways, Buddhism was not identified by the Chinese as a religion of their Tuoba conquerors, because it came from a land with a culture foreign to them. It became, therefore, the ideal instrument for political unification.

112 - THIS GILDED BRONZE GROUP, DATED 518 AND PRODUCED DURING THE NORTHERN WEI DYNASTY, DEPICTS WITH FLOWING CONTOURS THE BUDDHAS PRABHUTARATNA (OF THE PAST) AND THE SAKYAMUNI (MG).

113 - IN THIS DUNHUANG MURAL, THE BAGGAGE OF THE TRAVELING MONK – ACCOMPANIED BY A TIGRESS AND HOLDING A FAN – HAS VARIOUS OBJECTS HANGING FROM IT, PROBABLY RELICS.

意為亡弟知球三七
齋畫造慶讚供養

THE GREAT ROCK TEMPLE COMPLEXES

The most magnificent examples of the Buddhist presence in China between the 4th and 6th centuries has to be the great complexes of stone temples that were constructed in northern China, beginning around the 5th century. Evidence from earlier periods is limited to a few figures of clear Central Asian origin, in gilded bronze or stone, such as the Buddha dated 338 now in the San Francisco Asian Art Museum.

The tradition of temples carved into rock comes from India. From there it reached Dunhuang, an oasis located on the north-west border of the Chinese province of Gansu, where the temple system dates from the 4th to the 14th century, with a clear predominance of temples constructed during the Tang era (618–907). Here, the grottos from the Wei era are also clearly inspired by the Central Asiatic model. In the centuries to come, Dunhuang would become an important stop for caravans along the silk road. The Tuoba, after their conquest, transferred their capital to a place called Yungang, where around 30,000 families of artisans worked on a new complex, creating up to 40 grottos. The most imposing caves are those opened during the first phase of the complex's construction, between 460 and 494, before the transfer of the capital to Luoyang. Subsequent caves, however, frequently only small niches, show clear influences from the art of Gandhara. Although the Chinese government founded an institute for the preservation of the complex of caves in 1955, this did not stop the Red Guards from causing extensive damage to the statues and paintings, brought on by the Cultural Revolution's vandalistic fury. Climate changes also played a role in altering the original landscape. Yungang means "hill among the clouds" but today the landscape is arid and semi-desert. The iconographic program of the grottos shows the evolution of an initial style characterized by powerfully liberated forms of sensuality from the Central Asiatic tradition. Chinese taste gradually came to alter and modify the initial program, introducing colored caryatids, flowering branches, and zoomorphic motifs of Central Asiatic or Persian origin, reinterpreted according to Chinese tastes. At the end of the 5th century, the process of Sinicization became more marked and elegant draped clothing accompanied longer, less-imposing figures.

The slow passage from a more "statuesque" interpretation to a more linear reading of the figure became evident and occurred in the Longmen Grottoes, a few miles from the new capital of Luoyang. Thanks also to the malleability of the stone here, a progressive refinement can be seen even in the outlines of the faces. The grotto of Binyangting, completed in 523, constitutes the most advanced expression of the new style. The iconographic program, with the Buddha set apart between two disciples, the representation of a famous theological debate between two monks on the lateral walls of the grotto, the figure of the emperor and empress (the latter now in the Nelson-Atkins Museum of Art in Kansas City), all testify to the progressive movement of relief techniques toward those of painting. Scholars now agree that this iconographic choice owes a great debt to the pictorial concepts established at the court of Nanjing, capital of those regions in the south of the country that, during the brief intervals of peace and prosperity, especially during the course of the 6th century as we mentioned earlier, promoted the revival and reaffirmation of those forms of art dearest to the literary world.

Although Chinese historiography of subsequent centuries paints the history of this period as an era in which the "Mandate of Heaven" found no faithful caretaker, in fact precisely the absence of a powerful central authority, along with the contemporary presence on Chinese soil of different ethnic groups and cultures, made these four centuries a period heralding great innovations and new syntheses in every field of culture and the arts, preparing the land for the great cosmopolitan splendor of the Tang Empire.

114 - THE MOGAO GROTTOES MURALS, NEAR DUNHUANG, WERE COMPLETED IN A SPAN OF APPROXIMATELY 1000 YEARS. THE BODHISATTVA GUANYIN, IN CAVE 57, DATES FROM THE EARLY TANG PERIOD.

115 - THE SEATED GILT BRONZE BUDDHA (338) IN THE ASIAN ART MUSEUM COLLECTION GOES BACK TO THE LATER ZHAO (319–350), A DYNASTY OF THE "SIXTEEN KINGDOMS" PERIOD (AAM).

116 - This suggestive hunting scene was painted during the Northern Wei period on the walls of Cave 249 at Dunhuang.

116-117 - The colossal Buddha of Cave 13, at Yungang near Datong in Shanxi, goes back to the same period. The right arm of the figure, who is sitting cross-legged, is supported by a smaller statue.

118-119 - At Wangjiafeng near Taiyuan, in Shanxi, the tomb of Xu Xianxiu – who reigned over the Northern Qi (550–77) with the name of Wu'an – contains a painting of a procession with servants, carts, and horses, of which a detail is seen here. The work shows Central Asian, Persian, and Indian influences.

A COSMOPOLITAN EMPIRE: THE GOLDEN AGE OF THE TANG

The Sui Unification and
the Great Public Works
page 122

The Development of
the New Empire
page 126

The New Institutional Order
page 130

Chang'an as Capital, Cosmopolitan Culture
and The Splendor of the Arts
page 134

The Golden Age of Buddhism
page 148

The Regionalization of Power
and the Fall of the Tang
page 150

THE SUI UNIFICATION AND THE GREAT PUBLIC WORKS

From out of the hotchpotch of dynasties that had typified the period of division came the Sui dynasty (581–618), which was founded by General Yang Jian (541–604), who was a leading figure of northern warrior aristocracy. Yang Jian overturned the last monarch of the Northern Zhou dynasty (whose domain extended across all north-western China) and set up his capital at Chang'an. Once on the throne, Yang Jian depicted himself as the legitimate heir to the Han tradition, nurturing an ambition to conquer the South, unify the country and revive the imperial ideal. He pursued his objective with great determination and was successful in 589, with the annexation of the vast southern state of Chen, governed by the South's last dynasty. The capital of Jiankang (near what is now Nanjing) was razed to the ground, but the sovereign and his family, the aristocracy, members of the court, and functionaries received surprising clemency.

The attempts by Yang Jian – who was known as Wendi (r. 581–604) – to secure the support of the southern elite, and to pacify and integrate all of the Empire's territories south of the Yangtze, proceeded in parallel with efforts to consolidate his own power along the northern frontiers. In the North, pressure was being exerted by a powerful tribal confederation that stretched from the furthest western boundaries as far as Manchuria, and was led by the Turks (Tujue). The Emperor succeeded in weakening this confederation with an effective political and diplomatic strategy.

At the same time, Wendi aimed to create a State ideology to legitimize his own power and establish himself as the successor to the Han Empire. So, in a genuine spirit of inclusion and reconciliation, he activated a precise policy towards both Confucianism, whose ritual symbolism embodied the continuity of the imperial notion, and Buddhism, a religion that enjoyed a great following and was able to provide the new universal sovereign a no less significant form of legitimization and consecration. In this way he confirmed his adhesion to the principles of Confucian ethics, in particular to the virtue of filial piety (*xiao*), and to a number of rituals linked to this tradition, simultaneously restoring relations with the Buddhist religion. He fostered its development with donations and promoted the improvement of conditions for its clergy.

The desire to reestablish a centralized Empire was expressed in a series of reforms that were intended to bring the armed forces and the various branches of bureaucracy under direct control of the central government and, at the same time, reinforce the sovereign's power. For this purpose there were modifications to the methods of military organization and recruitment, and the procedures for appointing civil functionaries at various levels by means of an examination system, although many candidates were still appointed on the basis of hereditary criteria. Members of the administration were asked for increasingly high levels of efficiency, thanks to improved control and supervision

of their actions. Moreover, a new code was enacted that was a synopsis of the juridical traditions of North and South, thus laying the foundations for what would be the Tang legal system. Drastic reforms were also made to taxation, with the introduction of a system based on three types of tax (cereals, textiles, and corvée), whilst lands were registered, classified in various categories, and justly redistributed. However, it was not possible to apply the new laws with uniform success throughout the Empire.

121 - AS CAN BE SEEN IN THIS PLUMP POTTERY LADY, THE STYLE OF DRESS PREFERRED BY HIGH-BORN LADIES AT ABOUT THE END OF THE 7TH CENTURY LEFT THE NECK BARE. THE FOREHEAD CHIGNON HAIRSTYLE IS OF FOREIGN ORIGIN (MSC).

122-123 AND 123 - *THE THIRTEEN EMPERORS*, ATTRIBUTED TO YAN LIBEN, COURT PAINTER OF THE EARLY TANG, PORTRAYS THE SUI EMPERORS, YANGDI AND WENDI (LEFT), AND EMPEROR WENDI (RIGHT), WHO REIGNED 560–66 DURING THE CHEN DYNASTY (557–89) (MFA).

Notwithstanding Wendi's explicit desire to renew and pacify, a number of revolts in the southern regions flared up during his reign. They were quashed by his son Yang Guang, who went on to succeed his father in 604. During the years when he was governor of the new capital Jiangdu (now Yangzhou), which he founded, Yang Guang supported the Buddhists in the South, encouraged the diffusion of Taoism, and promoted the study of the Confucian classics and the development of arts and literature. All of which contributed significantly to the difficult task of integrating the southern regions into the new Empire.

Later he went on to build a second capital on the central plain, at Luoyang, following in the footsteps of his father, who had rebuilt Chang'an. In 605, when he became emperor, Yang Guang (known by the posthumous name of Yangdi, r. 604–617) started one of the most impressive public works in all Chinese history, with the construction of the main section of what became the Grand Canal: a network of waterways that crossed the country, covering over 1000 miles and connecting various rivers and several major settlements, with the result of finally creating a link between North and South.

To protect the northern boundaries from the Turks, and the pressure exercised by the Korean kingdom of Koguryo (which stretched from eastern Manchuria to North Korea) – two forces he feared might ally against him – Yangdi consolidated several sections of the Great Wall, but that was not enough to ward off the risk coming from the north. Despite a vigorously pursued foreign policy, leading to maritime expansion, and the determined action to make tributaries of countries on the southern border, the Emperor was unable to cope with the threat posed by the Korean kingdom, which turned out to be an insurmountable barrier upon which his ambitions shattered. The three failed expeditions against Koguryo (in 612, 613, and 614), alongside the dissatisfaction caused by the forced work campaigns, in which millions of subjects were obliged to participate in order to complete the Grand Canal and other grand public works, ruined the dynasty. Yangdi earned the loathing of his people and of many historians, who far too easily labeled him a cruel megalomaniac, devoted to luxury and responsible for all the catastrophes of the Sui Empire. On the other hand, it was common practice for official historiography to label the last sovereign of a dynasty as a hated tyrant, so as to justify the succession to the new dynasty.

The disastrous flooding of the Yellow River in 611 hastened the end of the Sui Empire, brought about by the conspiracy of aristocrats and people's rebellions. In 618 Yangdi was assassinated in Jiangdu by the son of one of his most trusted generals. Although the second and last Sui dynasty emperor did not leave a good impression, his father's reign was recovered by historians of the subsequent Tang period, who nurtured the legend of a parallel between the Sui dynasty and that of the Qin, and between Wendi and the First Emperor, Qin Shi Huangdi. Both dynasties were founded by men of strong ambition and exceptional ability, who had reunified national territory after centuries of divisions, fostering periods of great prosperity, such as those of the Han and Tang.

124 - THIS 7TH-CENTURY WHITE PORCELAIN RHYTON, WITH LION HEAD, WAS INFLUENCED BY CENTRAL ASIAN AND PERSIAN METAL MODELS, AS IS ALSO EVIDENT BY THE BEADED BORDER RELIEF DECORATION ON THE SILVERWARE (BM).

125 - THIS SILK PAINTING (18TH CENTURY) DEPICTS THE SECOND SUI EMPEROR, YANGDI, WITH HIS RETINUE, ABOARD A GREAT BOAT, DURING ONE OF HIS FREQUENT TOURS OF THE EMPIRE (BNF).

THE DEVELOPMENT OF THE NEW EMPIRE

The Tang dynasty (618–907) was founded by Li Yuan, who came from an aristocratic family of the North and was commander of the important garrison at Taiyuan, in modern-day Shanxi. In 617, with shrewd negotiations, he assured himself the support of the Eastern Turks, whose power center was in Mongolia. Li Yuan then carefully planned an uprising and occupied Chang'an, appointing as emperor a grandson of Yangdi. The year after, following the assassination of the last Sui sovereign, he himself took the throne, and went down in history with the posthumous name of Gaozu (r. 618–626). In just a few years he reconquered imperial territory that had been split into several large potentates controlled by generals and members of the Sui aristocracy. In 624 the difficult reunification task was almost complete, but after just two years the sovereign abdicated in favor of his son Li Shimin, who had become heir to the throne after eliminating his older brother, the legitimate heir.

Despite this stormy start, the reign of the new emperor, known by the name of Taizong (r. 626–649), was always considered one of the greatest in Chinese history. Under his rule China became a great world power, whilst the sovereign was depicted as a model to imitate, especially for his ability to surround himself with the best men, with whom he usually established exemplary relationships.

In 630 Taizong achieved a decisive victory over the Eastern Turks (whom his father had kept under control using his diplomatic skills), who had pushed forward in just a few years to a mere 60 miles from Chang'an. Then Taizong turned his attention westwards, to modern-day Xinjiang, an area dominated by the Western Turks, whose sphere of influence stretched west as far as Persia and whose unity at that time was undermined by domestic rebellions and conflicts. There followed a phase of extraordinary expansion in Central Asia, which led to subjugation of the Western Turks, submission of various populations, including the Tuyuhun from the Lake Kokonor area, and the Tangut, who lived to the north-west, and annexation of the kingdom near today's Turfan. Diplomatic relations were also established with the powerful confederation of Tibetan tribes, whilst the capital, Chang'an, was the destination of increasing numbers of delegations from various Asian countries. The Chinese Empire now bordered Persia and was in control of the caravan routes of Central Asia, whilst to the north it touched on the regions of Mongolia and Ordos. In 645 and 646 Taizong tried to challenge the kingdom of Koguryo with two successive campaigns, but both failed. He died while preparing his third attack, planned for 649. Korea was therefore the only realm that successfully resisted the sovereign's expansionist aims.

126 - In this detail of the painting titled *Emperor Taizong Greeting Tibetan Envoys* or *The Imperial Sedan Chair* – attributed to Yan Liben, but probably a copy from the Song period – the artist captures all the majesty of Taizong, who is portrayed as an authoritative figure towering over his retinue (PM).

127 - A 9th-century mural discovered in Cave 9 (today's Cave 20) at Bezeklik, not far from the Turfan oasis in Xinjiang, depicts several princes of the Uygur Kingdom of Gaochang. Around this period Uygur sovereigns converted to Buddhism (MIK).

During his reign, Taizong put into practice a shrewd religious policy and under him the "Three Doctrines" (sanjiao) of Confucianism, Buddhism, and Taoism became the foundation of State ideology. After supporting Taoism, as his father had done before him, in the last few years of his life he was drawn to Buddhism, mainly through his admiration for the pilgrim monk Xuanzang, who was a translator of Buddhist scriptures. The Emperor admired Xuanzang's vast knowledge of politics and geography, acquired during his travels across Central Asia, reaching as far as India in his search for the original Buddhist texts. His pilgrimages, which lasted 16 years, inspired a novel written in about 1570 by Wu Cheng'en (1504?–1582?), *The Journey to the West* (*Xiyouji*), also known as *Monkey*, and one of the most important Chinese narrative works ever written.

As far as Confucianism was concerned, the Tang fostered the ideal of a Confucian State. Many institutions were influenced by the principles of this doctrine, in particular the system of recruiting civil officials through examination, which became progressively established during this dynasty. Above all, in several periods, the creation of a unit of elite functionaries was favored, using the examination system to select them and not the status of the candidate's family, hereditary privilege, or blood ties. In this way the intention was to create a class of administrators inspired by shared values, of which the first should have been culture as an instrument of social promotion, and which would ensure the perfect functioning of the State machine. Although during Taizong's reign, many functionaries were still of noble extraction, important positions were also starting to be awarded to scholars who were selected via written examinations, which were organized on a regular basis. Moreover, it was probably during the reign of Taizong, in 630, that temples dedicated to Confucius were erected in every town, and it was here that local functionaries would go to make sacrifices.

The work of Yan Liben (ca. 600–673) – one of the most famous artists of the dynasty and an emblematic figure in his role as court painter to the first Tang period (he was probably active precisely during the reign of Taizong) – betrays the concept of the sovereign as an exemplary figure, compliant with Confucian principle. The scroll of *The Thirteen Emperors*, which is traditionally attributed to him and which is known through a later copy found in the Boston Museum of Fine Arts, depicts Chinese rulers from the Han to the Sui dynasties. The very didactic style, and not lacking some conservatism, is that of the official portrait typical of the early Tang dynasty, with solemn, impressive figures looming over the others, almost as if the painter were a court historian.

128 AND 129 - THE PAINTINGS BY QING PERIOD ARTIST CHEN YIXI (1648–1709) ILLUSTRATE TWO EPISODES FROM *THE JOURNEY TO THE WEST* (*XIYOUJI*), A WORK BY WU CHENG'EN INSPIRED BY THE TRAVELS OF THE MONK XUÁNZÀNG, WHO RETURNED FROM INDIA BRINGING WITH HIM THE ORIGINAL TEXTS OF BUDDHISM. THE MAIN CHARACTER IN THE NOVEL IS ACCOMPANIED ON HIS ADVENTURES BY HIS HORSE AND THREE IMAGINARY FIGURES WHO PROTECT HIM: SUN WUKONG THE MONKEY KING (FROM WHICH THE BOOK'S ALTERNATIVE TITLE, *MONKEY*, DERIVES); ZHU BAJIE, HALF-MAN HALF-PIG; THE DEMON SHA WUJING (MSC).

THE NEW INSTITUTIONAL ORDER

Taizong consolidated what had been achieved by the Sui emperors and by his predecessor in perfecting institutional mechanisms. The new dynasty's bureaucratic machine retained the heavily centralized basic structure that had been established in the Sui period. At the top there were the Three Departments (*sansheng*): the Department of State Affairs (*shangshusheng*); the Imperial Chancellery (*menxiasheng*); and the Imperial Secretariat (*zhongshusheng*). As had already occurred under the Sui, the Department of State Affairs governed the Six Ministries or Boards (*liubu*) – each with its own Minister (*shangshu*) – now classified on the basis of their importance. The most important was the Board of Civil Appointment (*lebu*), who managed the examinations, in the dynasty's first phase, for filling vacant positions in administration. The second most important was the Board of War (*bingbu*). The Imperial Secretariat was theoretically responsible for issuing approval of any declaration or directive made by the Emperor, drawing up official documents and imperial edicts. The Imperial Chancellery was supposed to verify whatever was produced by the Imperial Secretariat. Subsequently, the Department of State Affairs would implement the various dispositions.

The Presidents and Vice-Presidents of the Three Departments were automatically members of a supreme organ that met daily with the sovereign to issue government directives. On occasion other functionaries – appointed directly by the Emperor – were called upon to join this group of Grand Councilors (*zaixiang*). Then there was the Censorate (*yushi tai*), with its Censor-in-Chief (*yushi dafu*), which investigated any form of abuse and comprised three sections (*yuan*), whilst the Academics (*xueshi*), despite having no official role, could be called upon by the sovereign in exceptional cases. The picture was completed by the Nine Courts (*jiusi*) and the Directorates (*jian*), of which there had been four under the Sui and then were increased to five.

In 629, typical Confucian awareness of the importance of history as a way of legitimating the dynasty led to the establishment of the Bureau of Historical Records (*shiguan*), whose role was to record contemporary events, but also to reconstruct the history of the other dynasties. This occurred for the first time under close government control and did not have, as it had in the past, the contribution of scholars who were not directly linked with the bureaucratic machine. Official historiography was born and it enjoyed enormous power, but at the same time it risked being exploited by the ruling monarch to the detriment of historical truth.

At local level, the Empire was split into districts (*xian*), headed by a magistrate (*ling*). The upper unit was the prefecture (*zhou*), which was commanded by a prefect (*cishi*). Later – in the early 8th century – the prefectures were grouped into ten circuits (*dao*). The Tang maintained, with little variation, the agrarian and fiscal standardization system that had been set up by the Sui, and tried as far as possible to ensure that the land allotment shares were applied, since in some cases they were being abused by the more powerful families. Nonetheless, from the late 7th to the early 8th century, the system began to falter and came to pieces in the mid-8th century with the An Lushan Rebellion.

During the early years of the reign of Li Zhi, the ninth son of Taizong, who became emperor with the name of Gaozong (r. 649–683), there were few significant changes to how the State was organized. From 655, on the other hand, noticeable modifications came about with the appearance on the scene of Wu Zhao (former concubine of Taizong), who had managed to give Gaozong a son. After successfully expelling Empress Wang, Wu ensured that her only son was declared heir to the throne and that she was declared empress herself, gradually depriving Gaozong of his power, until she was in full control at the time of the Emperor's death, in 683. Li Zhe (posthumous name: Zhongzong, r. 683–684), Gaozong's successor, was deposed and his younger, more malleable brother Li Dan (Ruizong, r. 684) was crowned in his place. Then, in 690, Li Zhe usurped the throne and founded a new dynasty, that of the Zhou, with its capital at Luoyang.

Wu Zhao (who came to the throne with the name of Wu Zetian, r. 684/690–704) was a Buddhist, and she made this religion the official doctrine of the Empire. A noteworthy policy of hers was to encourage the development of a body of func-

tionaries selected by the examination system, probably to emancipate them from the conditioning of the great aristocratic families, who therefore saw a decrease in their own power and the possibility of influencing imperial decisions. After she had replaced the old guard with figures loyal to herself and had proclaimed the heir as her son Zhongzong (r. 705–710), whom she had deposed in 684, she reigned with an iron hand until 705, when she was forced to abdicate. She died that year.

Zhongzong returned to power and restored the Tang dynasty, dying himself in 710, possibly poisoned by the scheming Empress Wei. He was once again succeeded by his brother Ruizong (r. 710–712), who abdicated in favor of his son Li Longji (the future Xuanzong, also known as Minghuang) in 712. The reign of Xuanzong (r. 712–755) was the longest of the entire dynasty and it was one of the most prosperous. This sovereign implemented important tax and institutional reforms, including a reduction in the number of Ministers and the fusion of Chancellery and Secretariat into a single organ, subject to a board that took the main government decisions.

To defend the northern frontiers threatened by the Eastern Turks, the Tibetans, and the Qidan, the Emperor embarked upon a reform of the army. As had been the case in the Sui period, the borders were defended by a militia system (*fubing*). In the Tang period one soldier was recruited from every six families and served in the garrisons, distributed mainly in northern China and commanded by local functionaries. Initially, the garrison soldiers were located around the frontiers and in the capital city, where they spent brief periods. Subsequently the forces deployed to defend the capital were all volunteers. In the Xuanzong period it became evident that in the event of a crisis, mobilizing troops from the militias defending the frontiers would cause serious logistical problems, whereas it was far more practical to make use of professional soldiers who were always ready for fast, efficient deployment. This army was commanded by permanent military governors, instead of the commanders appointed temporarily campaign by campaign. The result was a progressive growth in the importance of professional troops – a development that was fraught with consequences for the future.

Xuanzong supported Taoism, and he also implemented strong limitations on the Buddhist religion, above all to offset the securing of vast expanses of land by Buddhist monasteries and communities. The clergy had received enormous donations from the previous government and the Empress Wu, acquiring illegally huge properties that were then confiscated.

Xuanzong was not only a refined man of letters, poet, painter, and calligrapher, he was also a great patron of the arts. He founded the Hanlin (literally: "forest of brushes") Academy, or Hanlinyuan. He made Chang'an a cultural city of world renown and many of the most important men of letters and artists were active during this dynasty, but the golden age ended in 755, when the powerful General An Lushan rebelled. The Emperor was forced to abandon Chang'an and take refuge in the South, in Sichuan. During the journey, the Emperor's favorite concubine, Yang Yuhuan (known to us as Yang Guifei, the "precious consort" Yang), was linked to one of the warring factions and executed. The event left the Emperor distraught and the story is often performed in theatrical works or described in popular narratives of subsequent centuries. In 756, Xuanzong was forced to abdicate and left the throne to the Crown Prince known with the posthumous name of Suzong (r. 756–762).

130 - DURING THE TANG PERIOD THE FARMERS (DEPICTED HERE AS THEY TOIL AND IN RARE MOMENTS OF REST IN A CONTEMPORARY MURAL IN CAVE 23 AT DUNHUANG, IN GANSU) BORE THE GREATEST TAX BURDEN.

131 - THIS PICTURE FROM DUNHUANG SHOWS A CIVIL OFFICIAL ACCOMPANIED BY HIS SQUIRE; IT IS PART OF A PAINTING ON THE LIFE OF BUDDHA, DATED TO THE SECOND HALF OF THE 8TH CENTURY (MG).

132 - In this painting by Qian Xuan (ca. 1235–ca. 1307), Emperor Xuanzong watches Yang Guifei mounting a horse. The tragic love story between the two is dear to Chinese literature (FSG).

133 - Surrounded by a solid retinue of courtiers, Wu Zetian, the first woman to come to the throne, walks majestically in a garden, her robes stirred by the wind (NPM).

133

CHANG'AN AS CAPITAL, COSMOPOLITAN CULTURE AND THE SPLENDOR OF THE ARTS

The Tang dynasty fostered one of the most lively and creative periods of all Chinese history: a halcyon time for the capital. In the mid-8th century, when the An Lushan Rebellion exploded, Chang'an was one of the biggest metropolises in the world with an estimated population of one million inhabitants. It boasted marvelous buildings and its splendor rivaled Constantinople and Baghdad. It was not only an enormous trading centre, but also an important hub of religious studies, where representatives were found of Taoism, Buddhism, and other religions that had arrived in China more recently, such as Zoroastrianism, which developed from the 6th century, Manichaeism, introduced during the time of Gaozong, and Nestorianism, which was authorized by Taizong and then reinstated by Xuanzong, following a short setback during the reign of Wu Zetian.

This cosmopolitan city, populated by people from every nation (Indians, Central Asians, Japanese, Koreans, Tibetans, Arabs, Persians, Syrians), covered an area of about 30 square miles. It was divided into three sectors: the area where the Palace was built, opposite the northern gate; the imperial city; and the outer city. The outer city was composed of 108 blocks, divided into two administrative districts, east and west of the main axis, which ran north-south. The checkerboard plan was defined by wide avenues intersected by narrow streets.

Chang'an was seriously damaged during the An Lushan Rebellion, but even at the end of the dynasty it was astonishingly large. Merchants of various origins, above all Sogdians and Persians, crowded the city's great markets, packed with bazaars and shops. Apart from all types of goods that had arrived from the West along the trade routes of Central Asia (the impact of Western fashions and products in China during the Tang period was striking), numerous Chinese craft products were also sold, including all kinds of ceramics, arranged on store counters, alongside magnificently decorated silk and brocade.

The solid shapes and truly expressive modeling of joyful, exuberant Tang *sancai* or "three-color" wares (of which many items have survived and can be found in collections all over the world) feature glazes in bright hues that flow and blend together in casual and undisciplined patterns, creating extraordinary chromatic effects, whether applied to smooth surfaces or covering relief ornamental motifs that are clearly the legacy of the period's metalworking., while ceramics exhibited both the results of technical experimentation and a tendency toward exoticism. Open-mindedness towards the outside world and a taste for extravagant objects characterize the work of Tang craftsmen. They perfected versatility of form and mastered the techniques coming from abroad in the fields of metalworking and pottery.

134 LEFT - THIS SILVER TANG FLASK IS DECORATED WITH A GOLD REPOUSSÉ DANCING HORSE THAT HOLDS A BASIN OF WINE IN ITS TEETH (MSPS).

134 RIGHT - IN THIS POLYLOBED GOLDEN BOWL WITH HUMAN FIGURES AND FLORAL MOTIFS, THE INFLUENCE OF METALLURGY FROM THE CULTURES OF THE WEST IS PARTICULARLY EVIDENT (MSPS).

135 - THIS PURE SILVER TANG INCENSE BURNER WITH GOLD DECORATIONS WAS AN OBJECT OF LUXURY FOR THE UPPER CLASSES, WHOSE MEMBERS LOVED TO SURROUND THEMSELVES WITH WAFTING INCENSE (MTF).

135

136 - This earthenware architectural tile with a monster mask comes from the Red Pagoda at the Xiuding Temple near Anyang, restored in the 7th century by Taizong, and one of the best preserved (BM).

137 - Two massive painted pottery Lokapala guardians from the Tang period clothed in brightly colored suits of armor. Each is standing on a recumbent demon (CI).

Pottery sculptures, glazed or painted with colored pigments, found in the tombs of the period, where they were placed as grave goods, take us back to a cosmopolitan universe populated by Central Asian cameleers and grooms, Persian and Turkish merchants, Indian jugglers, and other characters with clearly exotic somatic features. They also tell us of the people's love of animals, for horses and camels in particular, creatures of the boundless grasslands of the north and of the desolate wastelands furrowed by the caravan routes, which, to the west, penetrated the heart of Asia. They also provide us with images of graceful ladies at court, with fine, soft, flowing garments, and complicated hairstyles.

The same women are depicted carrying out various pleasant occupations in the scroll paintings attributed to masters, such as Zhang Xuan (ca. 713–742) and Zhou Fang (ca. 730–ca. 800), who were specialized in depicting scenes from a court life that was remarkable for the refined taste and extraordinary luxury it enjoyed during this period.

As well as these models of female beauty the tombs have also given us examples of dynamic horsewomen and female polo players dressed in almost masculine clothes (dress that perhaps reflected the influence of the peoples with whom the Tang had been in contact), and clearly indicates that the women had come out from behind the palace walls and adopted a new lifestyle in the open air. Women played a more active role than was traditional, and in this period even appeared on the literary scene, so getting closer to poetic language.

In the same period in which this pottery was being made, Tang craftsmen were producing white ceramics fired at high temperatures – porcelain – in very simple and essential forms, such as the Xing ware produced in the kilns of Xingzhou, in what is now Hebei. Celadon developed alongside this production and this stoneware had a monochrome glaze in shades of green, yellow-green, and blue-green, which came into its own centuries later in the refined objects of the Song period.

The Yue celadon (from the Yuezhou kilns, in what is now Zhejiang), was particularly prized. *The Classic of Tea (Cha jing)* by Lu Yu, written around 758, claims that for enjoying the beverage green ware, similar to jade, was even superior to white porcelain, which emulated the refinement of silver: "If Xing ware is silver, then Yue ware is jade. This is one reason why it is not as good as Yue ware. If Xing ware is snow, then Yue ware is ice. This is a second reason. Xing ware is white, which makes the tea color red. Yue ware is green, which makes the tea color green. This is a third reason why Yue ware is better."

The great diffusion of this drink in the Tang period led to the growth of the tea industry, which constituted another significant sector of the economy. It was not by chance that in this period Lu Yu's important text was published, defining the techniques for cultivation of the plant, and preparation and tasting of tea, laying the foundations for a practice which would spread all over Asia.

138 - This terra-cotta female figure is decorated with colored pigments and is the perfect example of the preferred female appearance in the 8th century, with plump faces and hair gathered in elegant buns. The long-sleeved robe drops softly and wraps the whole figure down to the feet, which are shod with slippers with upturned toes (MG).

139 - The two details are from a scroll entitled *Ladies Wearing Flowers in their Hair* (Zanhua shinü tu) attributed to Zhou Fang (ca. 730–ca. 800) or traceable, at any rate to one of his pupils; it depicts well-dressed women at court and is one of the best examples of Tang period female portraiture (MPL).

142 - This terra-cotta Tang sculpture depicts a female head with male headgear. On some occasions, upper-class women of the time wore male clothing (MRAXU).

142-143 - This terra-cotta polo player riding a galloping pony expresses a more dynamic model of feminine beauty than is found in traditional representations (CI).

143

In the pictorial field, it was in the centuries between the Han and the Tang dynasty that great landscape painting was developed, thanks also to the contribution of Buddhist art, for example, the splendid wall paintings of Dunhuang dating from the beginning of the Tang period. Some of these (such as those of caves 321 and 323) show significant development in the depiction of landscapes, with the structuring of the space painted in a harmonious continuum that gives a sense of depth to the composition. Unfortunately, little has remained of Tang period landscape painting. However, two masters who lived during the 7th and 8th centuries are known, Li Sixun (651–716) and his son Li Zhaodao (ca. 675–741).

These artists, from noble families closely linked to the court circuit, were exponents of the painting style known as "landscapes in blue and green" (*qinglü shanshui*), which marked a decisive evolution in the use of colors. They developed a decorative style in which the prevalence of the linear element was accompanied by a clever use of color, characterized by very bright shades, probably influenced by wall painting in the Buddhist temples. The predominant shades were cobalt blue and green, obtained from copper, to which some touches of gold were added. Very few examples of their work have survived, and from these it can be deduced that, at the beginning of the 8th century, the tendency was to accent the subjects as little as possible, dedicating greater attention to purely aesthetic aspects. Although until then subjects had been mainly didactic, religious, or political. The style somehow became more delicate and greater importance was given to landscape themes. In the famous *Emperor Minghuang's Journey to Shu* – traditionally attributed to the Li Zhaodao tradition, but more probably a copy from the Song period of a Tang original painted by an artist close to Li – it is evident how the landscape features are deliberately used to highlight the narrative content. In the various subsequent juxtaposed scenes, which are read from right to left, the travelers form a winding procession which makes its way across the various splendidly described natural forms – between high peaks and steep ravines, which confer a strong sense of rhythm on the narrative – before disappearing for good behind the mountains on the left.

It is reported that the paintings of the poet and painter Wang Wei (ca. 699–ca. 759) had a completely different feel, but have unfortunately been lost. Alongside more traditional works, he also produced others that were extraordinarily innovative, from which a new method of depicting the landscape was born, in harmony with the contemplative spirit typical of men of letters. It was poetic, evocative painting, which suggested rather than described. This style would subsequently be revived by a movement known precisely as "literati art." As far as we know, it was fundamentally monochromatic painting, based on the use of nuances and the *pomo* or "broken ink" technique, which involved superimposing various ink washes of different shades. Through the various shades of monochrome ink, the thousands of variations of the landscape were produced, with very intense effects, while line lost some of its importance. This was unlike the technique of the great Wu Daozi (689–758). It was said, on the other hand, that this contemporary of Wang Wei could bring to life the figures he painted precisely because of his strong and expressive lines, and his powerful almost calligraphic strokes. Sadly, his scroll paintings and even his wall paintings have been lost.

144 TOP - TECHNIQUES USED BY LATER PAINTERS ARE EVIDENT IN THE LANDSCAPE ON THIS BANNER WITH SCENES FROM THE HISTORICAL LIFE OF BUDDHA FROM CAVE 17 AT DUNHUANG, DATING BACK TO THE 8TH–9TH CENTURY.

144 BOTTOM - DEVELOPMENTS IN LANDSCAPE ART CAN BE SEEN IN SOME DUNHUANG MURALS, SUCH AS THIS EXAMPLE FROM THE EARLY TANG PERIOD FROM CAVE 323.

145 - LANDSCAPE ELEMENTS ARE DOMINANT IN *EMPEROR MINGHUANG'S JOURNEY INTO SHU*. THE MOUNTAINS ARE NO LONGER RESTRICTED TO A BACKGROUND ROLE AND ARE NOW INTEGRAL TO THE COMPOSITION (NPM).

The Buddhist Wang Wei, as well as being a famous painter, was one of the great scholars and poets of the Tang period, which is considered to be when Chinese poetry flourished. Many of his works, endowed with great freshness and balance, evoke the tranquil atmosphere of the Wanchuan countryside, his birthplace to the south of Chang'an where he spent long periods among the hills, by the waterways, in the pavilions on the lake, and in the bamboo woods. These were all subjects that figured in more than one painting. Among the more than 2000 authors and about 40,000 poems recorded in Quan Tangshi (Complete Collection of Tang Poems), published at the beginning of the 18th century, the name of Wang Wei stands out among other important figures such as Li Bai (Li Taibai, 701–762) and Du Fu (712–779) who were also active during the reign of Xuanzong, who was a great patron and protector of the arts.

Li Bai, a Taoist and an extremely prolific poet, has left us the image of an eccentric man, who led a disorderly and adventurous life, had a weakness for drinking and beautiful women, and was a great enthusiast of friendship. In a way, he lived the life of a "romantic" artist. He was filled with a great love of life, and found joy and consolation in Nature for which he nurtured a feeling of intense love, not without Taoist overtones. The inspiration behind his poetry was very varied, often linked to moments of daily life: the joy of living and love of wine, intimate and ecstatic contemplation of Nature, but also the sadness over a friend's goodbye, melancholy over a disappointment and the passing of the years. Or even, as in this famous work, nostalgia for his birthplace, expressed in simple words: "I wake and moonbeams play around my bed/Glittering like hoarfrost to my wondering eyes/Upwards the glorious moon I raise my head/Then lay me down and thoughts of home arise" (Jing ye si, Quiet Night Thoughts). Works like this, made up of four verses of five (or seven) lines, were known as "truncated verses" (jueju). This was a new type of meter that spread during this period and which appeared alongside "regulated poetry" (lüshi), which had a rigid structure made up of eight verses with five or seven lines. These genres formed the "modern style" (jinti), but the Tang poets also revived the so-called "ancient style" (guti or gushi), which was a form of poetry dating back to the Han period.

The works of Du Fu, a good friend of Li Bai and, like him, a great traveler, are of a completely different type. A refined man of letters and a firm supporter of Confucian values, thanks to his in-depth study of the classics and the poetic texts he achieved total command of form. He was very attentive towards social and political matters and he lived during a troubled historical period, when the revolt of An Lushan threatened the unity of the Empire. He incorporated his strong moral and civil beliefs into his poetry, which was formally irreproachable and rich in cultured quotations, but animated by a realist spirit and a deep compassion for human suffering.

Towards the end of the dynasty, a successful literary functionary who held important roles in the State administration, Bai Juyi (772–846), wrote compositions of great simplicity and spontaneity, which remained famous even among the less cultured. Many of his works imitated yuefu, a genre that was widespread during the Han period and which derived from the proper name of the government office responsible for music and for the collection of poems and anthems (founded, as we have seen, by the Great Emperor Wudi of the Han). Like Bai Juyi, numerous poets from this period were members of the imperial bureaucracy.

One of the principal reasons for the development of poetry during the Tang period was the introduction of the poetic composition as an integral part of the literary exams

for the selection of civil servants. This pushed many of them to embrace poetic language and so intellectuals of humble extraction could now dedicate themselves to poetry, and they favored the spread of a greater variety of subjects, as well as a wealth of differents forms. Poetry was no longer exclusively the preserve of the aristocracy and courtiers. Although in previous periods high poetry tended to concentrate on themes linked with aristocratic and court life, now it represented a faithful mirror of the complex and varied social reality of the time. In this sense the Tang demonstrated a considerable openness which allowed and even promoted considerable freedom of poetic expression.

146 AND 147 TOP - THIS IS HOW QIU YING (CA. 1494–1552) IMAGINED WANG WEI'S MANSION AT WANCHUAN (LEFT, CP); WEN ZHENGMING (1470–1559) WAS ALSO INSPIRED BY A WANG WEI COMPOSITION (RIGHT, CP).

147 BOTTOM - IN GARDEN WITH LITERATI (WENYUAN TU), BY HAN HUANG (723–87), A GROUP OF ERUDITE MEN CONVERSE IN A GARDEN, WHILE A SERVANT PREPARES INK (PM).

THE GOLDEN AGE OF BUDDHISM

As already mentioned, Wendi, the first Sui emperor, saw in the new religion a possible instrument for consecrating his own role as universal sovereign and he had proposed himself as defender of the faith. His successor, Yangdi, favored Buddhist institutions in the southern regions and strengthened the ties with Zhiyi, the founder of the Tiantai sect. In the first part of the Tang period, however, strong limitations on the development of the Buddhist religion had been imposed by Gaozu, who had dictated precise rules which established, for every prefecture, a maximum number of temples and monasteries. Notwithstanding this, and in spite of the swings of fortune that this religion experienced under the various Tang emperors, it was in this period that it reached its height, acquiring more exclusively Chinese characteristics. Between the end of the 6th century, under the Sui, and the middle of the 9th century, Buddhism grew exponentially, permeating society at every level and leaving a strong impression on the whole of Chinese civilization. From China, it spread to all the countries of East Asia, which found, in the doctrinal elaborations carried out in the Middle Kingdom, a fundamental point of reference. Among the most famous schools that contributed to the dissemination of Buddhism were the Tiantai sect (*Tiantaijiao*) founded at the end of the 6th century by the monk Zhiyi (538–597), the Huayan or "Flower Garland sect" (*Huayanjiao*), the "Meditation sect" (*Chanzong*, from the word *chan*, which the Japanese pronounce *zen*), and the "Pure Land sect" (*Jingtuzong*).

The examples that have survived of extraordinary Sui and Tang Buddhist art, are probably nothing in comparison with the splendor of the religious objects, wall paintings, fabrics, sculptures, and architecture with which China was endowed at the time. For instance, Chang'an alone was home to magnificent treasures, without mentioning the many religious institutions and monasteries spread throughout the imperial territory.

Groups and figures in bronze, of which only extremely rare examples remain, and sculptures in stone and other materials, both of large and more modest dimensions, brought to the faithful the image of the buddhas, of the bodishattvas, and of other figures from the rich Buddhist repertoire. Unfortunately, the sculptures of the 7th and 8th centuries were made in perishable materials such as wood or dry lacquer and have almost all been lost, often due to fires during anti-Buddhist persecution in the mid-9th century. However, from the stone sculpture it is possible to get quite a clear idea of the Buddhist art of the time.

One of the most significant examples is Fengxiansi, the Ancestor Worshipping Temple, which was built in Longmen, in Henan during the reign of Gaozong and inspired by the future empress Wu Zetian. It is a cave with an imposing group sculpted in the rock: at the centre is a Vairocana Buddha, seated on a lotus-shaped throne. It was more than 475 ft (145 m) high with its plinth, and was sculpted between 672 and 675. It is flanked by the disciples Ānanda and Kāśyapa and by two standing bodhisattvas. The drapes of Buddha's apparel cover with naturalness the full, soft, and proportioned forms of the body, but perhaps the most innovative elements are the two splendid giant figures to the left of the Vairocana, on the northern wall of the cave. The Heavenly King on the left, dressed in full armor, supports a *stupa* (a votive pagoda) with the palm of his right hand while he

148-149 - THE NORTH WALL OF THE FENGXIANSI (ANCESTOR WORSHIPPING TEMPLE) AT LONGMEN HAS TWO GIANT FIGURES SCULPTURED INTO THE ROCK. THE LEFT-HAND FIGURE TREADS ON A DEMON AND WEARS A SUIT OF ARMOR SIMILAR TO THAT WORN BY GENERALS OF THE TIME; THE OTHER WEARS CLOTHES OF INDIAN STYLE. THE POSE IS RATHER DYNAMIC AND DISTANT FROM THE STATIC VERTICALITY OF PREVIOUS BUDDHIST SCULPTURE, AND IS TYPICAL OF TANG RELIGIOUS ART. THE TEMPLE, ERECTED UNDER GAOZONG, WAS COMPLETED IN 675.

149 TOP - THE MOGAO GROTTOES COMPLEX, SEEN HERE FROM THE OUTSIDE, IS NEAR THE DUNHUANG OASIS IN GANSU. AS A TRADE CROSSROADS BETWEEN CENTRAL ASIA AND CHINA, IT WAS ONE OF THE MOST IMPORTANT CENTERS FOR THE DEVELOPMENT OF BUDDHIST ART IN THE TANG PERIOD.

149 BOTTOM - THIS APSARA, PAINTED ON THE WALL OF CAVE 57 AT MOGAO, IS A HEAVENLY CREATURE, HALFWAY BETWEEN A NYMPH AND A DANCER. DERIVING FROM INDIAN MYTHOLOGY, IT IS FREQUENTLY FOUND IN BUDDHIST PAINTINGS AND IN IMAGES THAT DECORATE THE DUNHUANG ROCK TEMPLES.

crushes a demon with his foot; the other, a demon guardian, is in a menacing pose. The new tendency to give the figure a sense of movement can be observed in these sculptures, and this anatomical precision of the shape gives a new vitality and physicality. Their particular posture, with the body bending realistically, is typical of Tang religious art and was by now distant from the verticality and immobility of previous Buddhist sculpture. As we have seen, only a few decades after the completion of this magnificent work, during the reign of Xuanzong, new laws were passed which limited the expansion of Buddhism. But it was after the An Lushan Rebellion that the real decline began, with the terrible persecutions of the mid-9th century.

THE REGIONALIZATION OF POWER AND THE FALL OF THE TANG

In 757 An Lushan was assassinated by his son and, in the same year, the Tang, aided by Uyghur troops, reconquered Chang'an and then Luoyang. The latter was recaptured by rebels in 759, however, and ended up once again in the hands of the loyalists in 762. The following year, Daizong (r. 762–779) came to the throne and he attempted to restore the unity of the Empire, which, by now, was divided into various regions, mostly under the rule of military leaders whose power was based on independent armies, no longer controlled by the central government. This centrifugal tendency, with various military governors seizing power to the detriment of central authority, was one of the most obvious consequences of the An Lushan revolt, after which the Tang Empire was never the same again. Whereas Daizong gradually succeeded in reestablishing control in the South, which acquired increasing economic power, many territories in the North, including some of the richest regions, remained in the hands of local leaders. In 780 Dezong (r. 779–804) came to the throne and tried in vain to bring these regions back under the control of the central government. While increased social mobility favored the development of the productive classes, a taxation policy was implemented with the objective of reorganizing the tax system, with the institution of a unique tax to be levied in summer or in autumn, depending on the type of harvest and the conditions of the locality. The objective of bringing all the territories back under central control was achieved by Xianzong (r. 806–820). In 807 he launched a series of military campaigns against the Governors of the North with moderate success. He died prematurely in 820, after having succeeded in reaffirming his own authority over the Empire, even if this restoration was not destined to last. For the whole of the subsequent century, the weakening of the central structure due to fighting between factions and intrigues at court, where it was often the powerful eunuchs who were pulling the strings, meant that his successors were unable to keep the regional governors in check.

The middle of the 9th century marked the decline of the Buddhist church, with the great persecution campaigns. As early as 819, the man of letters Han Yu had sent a memorial to the emperor in which Buddhism was denigrated and branded as a "barbarous" religion, a doctrine unknown to Confucian traditions which constituted the foundations of the State. A clear indication that something was changing in the relationship with this religion of foreign origins, which was, however, perfectly integrated into Chinese culture. Then, between 843 and 845, under Emperor Wuzong (r. 841–846), while the Empire was in a state of great crisis, a wave of xenophobia gave rise to a series of restrictive measures – the seizure of property and the conversion of monks and nuns to lay status – that affected not only the Buddhist church but also the Manicheans, Nestorians, and Zoroastrians. In 845 it was established that the Buddhists could keep only one temple in each of the principal prefectures, and four temples in each of the two capitals. This meant the confiscation of vast tracts of farmland, the destruction of tens of thousands of temples, monasteries and sanctuaries, and the secularization of more than 250,000 monks and nuns, as well as an enormous and irreparable loss of works of art and sacred texts. During the 9th century, a series of revolts shook the Empire, culminating in the rebellion led by the merchant, Huang Chao, who conquered Chang'an in 881 and founded the short-lived Qi dynasty (881–884). The devastation that this tragic event brought with it dealt the final blow to the Buddhist church, which had begun a slow revival thanks to the partial repeal of the harshest anti-Buddhist laws under Wuzong's successor. Huang Chao capitulated after only three years, incapable of resisting the loyalist troops' counterattack. A rebel commander, Zhu Wen, moved over to the Tang side, and, after having slaughtered a great number of eunuchs, in 904 he murdered the last emperor Zhaozong (r. 888–904) and seized power. In 907 he founded a new dynasty, that of the Later Liang, establishing his capital further to the east, in Kaifeng (Henan).

150 - NOMADS WITH A TRIBUTE HORSE IS THE TITLE OF A SCROLL TRADITIONALLY ATTRIBUTED TO LI ZANHUA (899–936), BUT PROBABLY OF A LATER DATE (MFA).

151 - THIS PAINTING – IN LI XIAN'S TOMB IN SHAANXI – PORTRAYS EUNUCHS, WHOSE INFLUENCE CONTINUED TO GROW IN THE DYNASTY'S CLOSING DECADES.

The Liang dynasty, even though short-lived, was the longest to survive out of the five dynasties that followed one another over a 50-year period in northern China. In 923 it was succeeded by the Later Tang (whose capital was in Luoyang), which, in 936, yielded to the Later Jin (936–946), with whom the capital returned to Kaifeng, while the Liao Empire (907–1125) of the Qidan was becoming increasingly powerful in the north-east. The Jin were forced to yield 16 of the northern prefectures to them. In 947 the new Later Han dynasty was founded but lasted only three years. It was followed in 951 by that of the Later Zhou, which introduced important reforms in the fiscal area and ended in 960, the year of the foundation of the Song dynasty (960–1279). Notwithstanding the short duration of these dynasties, each of them made a significant contribution to reinforcing central government and to limiting the power of the military governors, a contribution to which the Song were probably indebted. While the Five Dynasties (*wudai*) ruled in the North, central-southern China saw the succession of the so-called Ten Kingdoms (*shiguo*). Official historiography has therefore labeled this period of fragmentation as that of the Five Dynasties and Ten Kingdoms (907–960), but, in reality there were nine southern states because the kingdom of the Northern Han (951–979), the last to be conquered by the Song, despite traditional classification, extended over part of northern China. The economy of the South was more successful than that of the North, as it had been during the last Tang period. The lands to the south of the Yangtze were the most fertile for agriculture and much was done by the southern ruling class to make this sector prosper, as well as those economic activities linked to mercantile concerns and craftsmanship. The coastal regions, in particular, maintained excellent relations with the countries of South-East Asia and maritime trade flourished. In the territories of what are today the provinces of Zhejiang and Fujian, the production of tea and silkworm breeding became important factors in economic development, alongside various artisan activities, such as pottery and paper production.

152-153 - This small jade ornament was made during the period of Liao dominion, whose art was greatly influenced by Tang traditions (BM).

5

THE SONG EMPIRE AND THE SPLENDOR OF URBAN CULTURE

Foundation of the Song Dynasty
and New Social Balance
page 156

The Birth of an Early Urban Bourgeoisie
and the Splendor of City Life
page 158

From the Splendor of Ceramics
to the Charm of Landscape Painting
page 164

The Division of the Song Empire and
the Crisis of an Affluent Society
page 176

FOUNDATION OF THE SONG DYNASTY AND NEW SOCIAL BALANCE

The Song dynasty followed the fragmentation of the Five Dynasties and ushered in a phase of consolidation of central authority, and a great flourishing of culture. Changes and transformations that had started to appear during the later Tang and Five Dynasties periods reached full development during this era. In 960, a *coup d'état* led by Zhao Kuangyin, commander of the Later Zhou army, founded the new dynasty that would rebuild imperial unity. Territorial reunification was not complete, however, and some of the northern regions – the 16 prefectures of Hebei and Shanxi – still remained under control of the Liao Empire. In subsequent decades, the North would be occupied many times by non-Chinese peoples such as the Tangut, who gave rise in the west to the Western Xia or Xi Xia dynasty (1038–1227), and the Jurchen (or Nüzhen), creators of the vast Jin Empire (1115–1234).

Zhao Kuangyin, known historically by his posthumous name, Taizu, remained in power for 16 years. On his death in 977, he was succeeded by his younger brother, Zhao Kuangyi (Taizong), who reigned until 997. During this decade, the foundations were laid for the southward and eastward expansion that characterizes the Song Empire, which is in contrast to the Tang, when the area of Chinese influence mainly involved territories to the north and west.

Although a member of the military aristocracy, this dynasty's founder immediately instituted administrative reforms designed to reduce the power of the army and provincial commanders, and to broaden access into the bureaucracy at all levels through the examination system. After the diffusion of Buddhism during the Tang period, the decisive return to the values of Confucianism during the Song era marked the ascendancy of the civil administration over the military, which had played a fundamental role during the previous Tang and Five Dynasties periods. During the Song era, the military aristocracy experienced a gradual loss of power to the class of civil officials.

Taizu's successor, Taizong, promoted policies similar to those of his brother. A new social class therefore developed, one that had already become important during the Tang dynasty but whose significance showed itself fully during this period on the political level. This new elite was made up of officials who enjoyed a privileged status based on merit instead of hereditary factors. They were mostly scholars who had done well in examinations, irrespective of any possible family connections to the nobility.

The Chinese-Barbarian aristocracy that had held power for centuries in the North saw its influence constantly diminish as the Empire's economic center of gravity shifted to the South. At the time, southern regions were the most important from an agricultural point of view because of enormous advances in rice cultivation (yielding two harvests a year). Apart from agriculture, the South was also the country's driving force in other sectors of the economy.

154 - Taizu is majestically portrayed in this anonymous work from the second half of the 10th century (NPM).

156 - The selection of civil officials by examination was a well-established and standard practice by the time of the Song (NPM).

157 - This Song period painting depicts a scene from the life of the literati at that time (NPM).

THE BIRTH OF AN EARLY URBAN BOURGEOISIE AND THE SPLENDOR OF CITY LIFE

During the Song period, those who had made their fortunes through commerce also acquired more and more prestige. This represented a remarkable triumph, if we consider that social recognition traditionally depended mainly on owning land. For merchants, one of the fastest ways of obtaining respectability consisted in being employed in activities such as the administration of commercial and government monopolies. The State began intervening increasingly in economic activities, and created structures to accomplish their aims. At the end of the 10th century, the Three Departments of the State Financial Commission (sansi) — a sort of financial council — were established, along with the Tea and Salt Bureau, with offices in the major provinces. The Maritime Commerce Bureau would be created later and experienced extraordinary growth during this era, in part because of remarkable progress in naval technology.

River transport also saw a notable increase, providing even more advantages to internal trade. Fundamental importance was given at the time to an extended, efficient system of waterways, including the Grand Canal, which was so desired by the second Sui emperor to connect the North and South of the country. The roadway network was also further expanded and improved to facilitate the distribution of goods. Given the growth of the monetary economy, the government was committed to unifying the various monetary systems inherited from previous dynasties (copper in the North, iron in the South) by coining one single type of money, in copper, as well as proceeding with the issuing of credit certificates.

The merchant class acquired growing prestige and the lifestyle of its most successful representatives came ever closer to that of the aristocracy, at times surpassing it in luxury and splendor. The most powerful merchants managed businesses on a vast scale, even on a continental level, and the volume of exchange, encouraged by greater productivity in both agriculture and manufacturing, reached heights never before seen. The introduction of new crops, such as cotton in the South, proved to be a source of enormous profits for wholesale merchants as well as the producers themselves. In the technical fields, remarkable development was shown in sectors that produced goods for domestic consumption as well as export, such as the metal, ceramic, and paper industries. The paper industry was connected to developments in publishing, which after the invention of the printing press during the Tang era was undergoing a phase of great expansion due to the introduction of movable type in the 11th century. Tax revenues from technical and commercial activities acquired increasing importance compared to those from agriculture.

This was a period of great demographic growth that saw the population of China reach 100 million. Thanks to technical advances in agriculture many farmers could also work as artisans at the same time, and some laborers could be diverted from cultivation during certain periods of the year. The relative improvement in living conditions for the rural population, furthermore, allowed some to move to small towns or large cities and undertake new activities, so creating greater social mobility and availability of manpower. Frequently, however, it was the poorest farmers, who had lost their land through appropriation by large landholders, who moved to the city to seek their fortunes.

Urban centers were no longer merely the seats of bureaucratic power. They became the heart of commercial life, centers of production as well as places of entertainment, where large landowners settled more and more frequently, leaving direct management of their holdings to trusted personnel. A relative relaxation of traditional social restraints encouraged the creation of entire neighborhoods dedicated to recreational activities, where people met in restaurants and tea houses, or gathered to watch acrobats, jugglers, and theatrical performances, or listen to storytellers.

While commercial areas in the past had been required to respect certain pre-established business hours, now they were open day and night. Many people were now comfortable to frequent quite openly establishments where they could be entertained by women of pleasure, some of whom made quite cultured and refined companions. The crowded stands of merchants were no longer confined to special, rigorously defined zones, as in the Tang era, but were more freely distributed across the urban area, as well as outside the city walls, and offered goods of all types, while craftsmen, money-changers, and others offered all sorts of services to a dynamic, diverse clientele.

Qingming shanghe tu (*Along the River during Qingming Festival*), a monochrome ink painting on a silk scroll over 16 ft (4.5 m) long, the work of artist Zhang Zeduan, shows an extraordinary cross-section of city life at the beginning of the 12th century. Many see this as the representation of the area around the Bian River in the capital of Kaifeng (Bianliang), which boasted over a half million inhabitants around the beginning of the 12th century. Major Chinese cities at that time were among the largest in the world. The sequence of images follows right to left, from suburbs along the river to the imposing gate that was one of the entrances to the city. These images offer a vivid, realistic portrait of the bustling activity animating the commercial areas of a great Chinese metropolis a few years before the fall of the Northern Song dynasty and the court's transfer to the South, creating a faithful image of what must have been the intense commercial development of China at the time.

In this painting, the banks of the Bian River, which flowed through the city and constituted an important commercial artery, are dotted with shops, stands, restaurants, taverns, inns, workshops, and businesses of every type, frequented by customers from all classes and environments. With the bridge as its focal point, the scene is crowded with peddlers showing their wares and a diverse, bustling crowd that we can easily imagine is shouting and noisy. We see two porters, two people on horseback, figures mounting other horses, and palanquins. Some wayfarers stop on the bridge to buy something to eat from one of the makeshift tables set up along the wooden parapets; others talk amongst themselves; others still watch the boat traffic down below. Just beneath the bridge a large boat passes, its occupants straining to control it against the current. Small boats of various types and sizes plough through the water, transporting passengers and all sorts of goods from nearby rural merchants or faraway places, even grains and other foodstuffs destined to satisfy the needs of the vast clientele of a fully developed metropolis. A group of porters is unloading sacks along the banks under a merchant's watchful gaze. Other vessels are moored along the banks. On one of these, which may also serve as a dwelling, a woman concentrates on doing laundry; a mother and her child peek out of another house. Beyond the river, toward the city center, carts, various ramshackle carriages, and palanquins – even a camel caravan – travel among a myriad of houses and shops, through the crowded streets leading to the massive gate.

158 - A TRAIN OF CAMELS ADVANCES AMIDST DONKEYS, HORSES AND OTHER ANIMALS, IN A SCENE FROM *QINGMING SHANHE TU*, THE LONG SCROLL FROM THE SONG PERIOD THAT DESCRIBES DAILY LIFE IN A COMMERCIAL AREA OF KAIFENG (PM).

159 - AT THE CORE OF THE PAINTING IS THE ENDLESS BUSTLE OF PEOPLE ON A BRIDGE, WITH A BOAT PASSING UNDERNEATH, ITS SAILORS STRUGGLING TO CONTROL IT DUE TO STRONG CURRENTS (PM).

Although smaller compared to Kaifeng, the Southern Song Capital of Hangzhou had its city walls expanded by the new dynasty's first emperor to accommodate an imposing group of gardens and structures, which overshadowed in sheer size the previous imperial complex in the northern capital. In subsequent decades, Hangzhou would achieve a cultural importance perhaps even greater than that of Kaifeng in the North. Crisscrossed by a large network of canals that gave it a special charm, the city was full of merchants and places of entertainment. When Marco Polo, who extolled its beauty, made a visit during the subsequent Yuan dynasty (1279–1368), it had by then become one of the largest cities in the world and an enormous commercial center. Cities during this era were above all cultural centers, however, and for reasons similar to the European Renaissance, the Song period has been frequently called the "Chinese Renaissance." Enormous technological progress and the development of urban civilization, with a new vision of the world and humanity, characterize this period. Culture in the Song era was the culmination of thousands of years of development. The arts experienced extraordinary changes and achieved unparalleled levels of refinement.

160-161 - THIS 14TH-CENTURY HORIZONTAL SCROLL DEPICTS A SECTION OF SHORELINE OF THE XI HU OR WEST LAKE AT LIN'AN, TODAY'S HANGZHOU, CAPITAL OF THE SOUTHERN SONG

161 - THIS WOODEN BODHISATTVA COUPLE OF THE SONG PERIOD STILL BEARS TRACES OF COLORS USED TO DECORATE THE SURFACE, ENHANCING THE LINES AND DRAPING

162

162 - This carved lacquer tray with pommell scroll design (*TIXI*) engraved in alternating red and black layers dates back to the Southern Song dynasty (FSG).

163 left - This polylobed lacquer bowl, dated 1066, also plays on the two contrasting colors, red inside and black outside (MG).

163 top right - This jade cup (*BEI*) with an essential, severe profile, in the best tradition of Song art, was produced between the 11th and 12th centuries (FSG).

163 bottom - The shape of this Song-period lacquered bowl stand, with a fluted platform design inspired by a lotus flower corolla, is found endlessly in ceramic items of the period. Objects of this kind were often used as stands for porcelain tea bowls (FSG).

164

Ceramic production during the Song dynasty saw significant developments, both aesthetically and technologically. The culture of the era was deeply rooted in traditions from the remote past and the emperors, lovers of the arts, reinstated ancient rituals and ceremonies. This led to an excellent propensity for collecting – in particular antique bronzes – that began to develop specifically during this period. Collectors loved to surround themselves with objects that revived archaic forms. Allusions and references to ancient ritual bronzes are clear in many Song ceramics. Even the "literati-bureaucrats," themselves frequently dilettante painters and enthusiastic collectors, made a cultured public, accustomed to the study of the past through a great body of traditional literature.

The refined taste of the ruling class was expressed in works characterized by remarkable formal purity. The idea of perfection was represented by essential, elegant shapes, not without their own intrinsic power. The revival of traditional Confucian values (subject to intense philosophical revaluation during this era) in the arts took the form of refusing excessive ostentation. In ceramics, this sensibility translated into the creation of refined examples of celadon, with a sober, harmonious elegance in form as well as decoration. Tending toward monochrome, celadon ceramics have pale colors that run from classic jade-green – closely associated in the West with this type of ceramic – to intense azure and violet. The translucent glaze is generally rich and soft to the touch, with a consistency similar to that of jade, the quintessential noble material. Any potential decorations are limited to light, graceful motifs etched on the body, delicately showing through the glaze, merely suggesting rather than explicitly representing. The glaze is frequently veined with a subtle network of crackling, at times fairly evident, at others extremely fine and more or less dark. The addition of crackled glaze gives greater overall elegance and brings out the simple, elemental lines of the piece.

Throughout the country, many kilns competed in producing straightforward yet sophisticated pieces, with perfect proportions and minimal decoration. One of the most interesting sectors during this era was that of the so-called "Five Great Wares": Ding (*dingyao*), Ru (*ruyao*), Jun (*junyao*), Guan (*guanyao*), and Ge (*geyao*). All of these, with the exception of Ding, belonged to the category of *qingci* ("green or blue-green porcelain"), the practical equivalent of our term "celadon." This was glazed stoneware containing a small percentage of iron (from 0.5% to a maximum of 5%), fired at high temperatures (1200° C or more) in a reducing atmosphere.

164 - THIS WHITE PORCELAIN PHOENIX-HEADED EWER, WITH GREEN-TINGED GLAZE, IS PERHAPS THE MOST BEAUTIFUL ITEM OF ITS KIND. IT DATES BACK TO THE PERIOD BETWEEN THE 10TH AND 11TH CENTURIES (BM).

164-165 - VARIOUS KILNS OF HENAN, IN NORTHERN CHINA, PRODUCED GLAZED BLACK WARES WITH WHITE SPLASHES. THIS DISH, MADE OF STONEWARE, WAS PROBABLY PRODUCED AT LUSHAN DURING THE SONG DYNASTY (BM).

166

Some types of especially prized, high-quality ware, once sent as an annual tribute to the court (along with other products from the various provinces), actually ended up earning the favor of the emperors who commissioned the best kilns in the country to produce a certain amount of ceramics under direct imperial control. The request by the court and its entourage for ware with perfect technical characteristics led to a constantly clearer separation between popular ceramics (*minyao*) and "imperial" or "official" ceramics (*guanyao*).

The shapes, decorations, and colors of the glaze on the *guanyao* were dictated by the imperial family and had to reflect their tastes faithfully. These ceramics were produced for brief periods, in limited quantities, and at the specific behest of the royal palace. Although occasionally manufactured where other types of lower quality ware was produced, the production of imperial ceramics was in any case strictly limited to satisfying the courts and placed under extremely rigid controls. In contrast to popular ceramics, especially prized pieces were frequently placed inside tombs and generally kept at the court among the most precious treasures, handed down from generation to generation, from emperor to emperor.

In addition, imperial kilns were located in areas near the capitals for ease of transport as well as control by officials charged by the court with supervising production. Selection of pieces from the factory was extremely rigorous. If production was limited, these limitations were not imposed by economic reasons for savings, but on precise orders to guarantee the emperor and his court exclusive use of these objects. Quality standards were extremely high and techniques were subject to constant improvement and perfection, in step with the advancement of the court's ever more refined tastes.

Among the various types produced in the North during the Song era, the first to earn the title of official ware was Ding ware, a porcelaneous stoneware with a creamy white body, covered in a light ivory glaze. Decorations consisted of engraved, incised or moulded designs. The kilns that produced Ding ware are located in present-day Jiancicun (Quyang county, Hebei), an area found in the Ding prefecture (Dingzhou) during the Song dynasty. Production began during the 8th century, around the middle of the Tang period, and remained active until the 13th or 14th century. Song era ceramics clearly represent the high point of this long period of activity that lasted 600 years. Ding ware was considered worthy of the emperor until a serious flaw was revealed. Applied by immersion of the piece, the glaze had a tendency to run, thus forming small "teardrops" (in Chinese *mang*). Toward the end of the Northern Song period, between the end of the 11th and beginning of the 12th centuries, Ding ware was probably replaced by Ru ware.

166 - THIS DING PORCELAIN BOWL, PRODUCED IN HEBEI, NORTHERN CHINA, DURING THE LATE 11TH TO THE EARLY 12TH CENTURIES, HAS AN INTRICATE MOLDED DECORATION (BM).

167 - THIS ITEM FROM THE SAME PERIOD, RATHER A RARE SHAPE FOR A *DINGYAO* — IT WAS ACTUALLY VERY DIFFICULT TO OBTAIN SUCH A TALL, SLENDER NECK — WAS INSPIRED BY SILVERWARE FORMS (BM).

The kilns that produced *ruyao*, subsequently given the appointment to produce official ceramics, are located in the present-day village of Qingliangsi (near the city of Daying, Baofeng county, Henan), which during the Song dynasty was located in the Ru prefecture (Ruzhou). Perhaps the most exclusive of Chinese ceramics, Ru ware was produced for a very brief period. The imperial kiln is believed to have operated from the end of the 11th to the beginning of the 12th century. The production of official ceramics probably began just before the Xuanhe era (1119–24). The most important examples were made during a period of about 40 years and the zenith of its production was under Emperor Huizong (r. 1100–25), who was a great benefactor and patron of the arts. The production of "official" Ru ware (*ruguanyao*) stopped probably with the end of the Northern Song period, when the court was forced to flee south in 1127. *Ruyao* was already considered quite rare at the end of the Southern Song dynasty. Today, no more than 60 or 70 pieces exist in collections worldwide.

The body of Ru ware has the color of incense ashes and is covered in a splendid glaze with a jade-like brilliance and intense sky-blue color due to the iron fired in reduction (as was typical of *qingci*). This color is restful on the eyes and evokes the shifting softness of silk. The bright glaze has a thick, soapy consistency, with close-knit, artificially induced crackling, and uniformly covers the entire body with the exception of tiny "spur-marks," shaped like "sesame seeds," left on the base by small supports, or "spurs," on which the piece rested in the kiln during firing. The crackling was the result of the application of many layers of glaze, a famous trait of ceramics from the best period. This particular effect might seem like a flaw at first, but is in reality one of the prized features of this ware, deliberately intended, studied, and created by its craftsmen. If the glaze is observed through a magnifying glass, it is noticeable that it contains very few air bubbles, "as rare as stars at dawn" (an expressive definition given by Chinese literature on the subject).

Before the discovery of the Qingliangsi site in 1986, the

search for the kilns that produced Ru ware was concentrated in the Linru county (near the Ru River, in central Henan), an area found in the Ru prefecture (Ruzhou) during the Song dynasty. But the great site discovered in 1964 was in reality one of two that produced most of the Jun ceramics. The other Jun kiln site is found in Henan. *Junyao* in fact comes from the proper name of Junzhou, a place located in the present-day Yu county, near Kaifeng (Henan), that was one of the main producers. Jun ceramics were divided into four categories based on the type of glaze: blue, lavender-blue, lavender-blue with purple splashes, and purple-and-blue streaked (the last created by spraying small amounts of copper and firing in a reducing atmosphere). The brightness of the glaze is similar to that of an opal and the purple-colored veining, where present, gives these ceramics a quiet sense of beauty that evokes the image of a sunset.

In weight, quality, and form, *junyao* recalls the solid ceramics intended for everyday use widespread in northern China during the Song and Jin dynasties. However, some forms are the same as those found in higher quality Ru and Ding wares. Therefore, it is assumed the most valuable examples of Jun ceramics are those produced for the imperial court.

168 LEFT - THE GLAZE OF THIS JUN-WARE PLATE MADE IN THE 12TH OR 13TH CENTURY, WHEN NORTHERN CHINA WAS RULED BY THE JIN, IS OPALESCENT LAVENDER SUFFUSED WITH PURPLE AND VARIEGATED WITH PURPLE SPLASHES (PDF).

168 RIGHT - THE *JUNYAO*, SUCH AS THIS SOLID BULB BOWL, CONTINUED TO BE PRODUCED IN THE SUBSEQUENT YUAN DYNASTY (PDF).

169 - THIS *RUYAO* BOWL STAND WITH FINE CRACKLE GLAZE WAS PRODUCED AT QINGLIANGSI IN THE LATE 11TH–EARLY 12TH CENTURIES (LEFT, BM); THE VASE, ALSO RU WARE, DATES BACK TO THE EARLY 12TH CENTURY (RIGHT, PDF).

170 LEFT - THIS OCTAGONAL VASE, WITH RELIEF LINES IMITATING ARCHAIC BRONZES, HAS A THICK GREEN-BLUE GLAZE. IT WAS PRODUCED IN THE 12TH CENTURY IN THE IMPERIAL KILNS OF THE SOUTHERN SONG (MOC).

170 RIGHT - THIS SMALL VASE, A PRODUCT OF THE JIAOTAN KILN (IN HANGZHOU), HAS A THICK GLAZE AND THE DARK CRACKLE CHARACTERISTIC OF SOUTHERN SONG GUAN WARE (FSG).

171 LEFT - THIS SONG PERIOD *GEYAO* INCENSE BURNER WITH THICK CRACKLED GLAZE IS IN THE SHAPE OF AN ARCHAIC BRONZE *GUI* (MSC).

171 RIGHT - THIS IMPRESSIVE LONGQUAN CELADON TEMPLE VASE WITH CARVED DECORATION FROM THE YUAN PERIOD IS DATED 1323 AND HAS A TALL NECK AND FLARING TRUMPET MOUTH (PDF).

In about the mid-12th century, when the court moved south (following the invasion of the North by the "barbarian" Jin) and a new southern capital was established at Hangzhou, new production of official ware had to be established, as had already occurred at the northern capital. This was how Southern Song Guan came into being: a porcelaneous stoneware produced to imitate the wares being made in the North before the Jin invasion. The new emperor intended to confirm by any means the continuity of Song tradition and the cultural values of the first part of the dynasty, which had been so brutally interrupted by the occupation, and so legitimize his right to the succession and his claim to the Mandate of Heaven. As we have seen, the Song encouraged the economic expansion of the southern regions with great improvements in farming and craft production. The pottery industry of the South-East had continued to develop on the basis of a solid existing tradition. Some of the country's biggest production areas were located in the provinces of Jiangxi, Fujian, and Zhejiang, and Guan developed on the foundation of this tradition. The style tended to lean to the archaic and were inspired by ancient ritual bronzes. However, the graceful outline, the color, the in-

tense glow, and the crackled surface, deliberately imitating jade, were combined in forms designed to transcend the simple imitation of metal prototypes and achieve extraordinary effects. Again, crackling here gives an extremely refined decorative effect that the potters sought intentionally.

The body color of these vessels ranges from gray-off-white to ochre, as well as gray-black. The glaze varies through greenish to blue-tinged, including various nuances of gray. The rim of the vessel is often brown-purple or bluish, because the fine coating allows the underlying material to breathe. The edge of the foot is dark brown, however (or almost black): "brown mouth and iron foot" (*zikou tiezu*) is how Chinese scholars and collectors define this typical Guan trait. The glaze is semi-transparent and has an "oily" appearance. An almost tactile characteristic, created by the consistency of the finish and the quality of the surface, which is also an aspect of jade that was deeply appreciated as far back as Neolithic times.

It should be remembered that another type of pottery, also produced in the South during more or less the same period, may easily be confused with Guan. This is called Ge, and at first glance has very similar features, but in reality a careful scrutiny of the two types will show significant differences in the gloss and the distribution of the crackling. In Ge this is in two orders, as seen in several examples of Southern Song Guan (in other words presenting one more superficial network of crackle and another deeper down), but in two different colors: golden yellow and iron black. This combination was known to Chinese scholars as "gold thread and iron wire" (*jinsi tiexian*). Ge glaze seems almost as if it has been coated in butter, reflecting light to create a discreet, muted glow. Its color varies: rice-white, rice-yellow, milk-white, butter-yellow, gray-blue, or gray-green. Air bubbles trapped in the glaze are dense and resemble groups of pearls.

Another important type of celadon, also produced in the South but not included in imperial porcelain, is the so-called "Longquan celadon," which was made in a vast area between the south of Zhejiang province and the north of Fujian province. In this area a noteworthy kiln complex developed, with the most important located at Dayao and Jincun. During the Southern Song period they expanded considerably and changed style, passing from production of wares with etched decoration – which reflected the influence of Yue ware (made in the South) and Yaozhou ware (made in the North) – to a type of vessel approaching the more refined, rarified taste with the archaic style tendencies of the Southern Song court. Several of the best examples are quite reminiscent of Southern Song Guan. This production reached the peak of development in the second half of the Song dynasty, but continued, still to very high standards, in subsequent dynasties, especially the Yuan and Ming. The color of glaze used for this celadon varies from gray-green to a tone of pale bluish-green that is very difficult to achieve and highly prized, capturing the sort of gentle glimmer seen in jade. These are extremely precious objects and famous all over the world.

In the field of painting, the Five Dynasties period (907–960) saw the emergence of great landscape painting. For centuries the Chinese have considered this genre the highest form of visual art, alongside calligraphy. The creation and contemplation of a landscape painting were the prerogative of men of culture, and conceived as a tool for spiritual growth and elevation. The word for "landscape" in Chinese, *shanshui*, comprises the characters *shan* (mountain) and *shui* (water): mountains and hills represent *yang* male energy, and valleys and watercourses incarnate *yin*, female energy. So mountains and water constitute the two chief elements of a landscape, symbolizing the alternating of *yin* and *yang* energy, whose interaction produces all beings. The third point is the void: from the Taoist perspective, it is the void that attracts and carries the two vital principles of *yin* and *yang*, and which would be ineffective without them. Here, then, are the three elements: mountains, water, void.

A painting depicting a mountain is a spiritual path, a microcosm that reflects a macrocosm, condensing into a limited stage the laws that regulate the universe and life of its inhabitants. It is not the depiction of the precise location, but rather the representation of the location of the mind through that particular mountain. Jing Hao (ca. 870–940), in his *Bifaji* (*Notes on the Art of the Brush*), gave precise instructions on what the scope of landscape painting should be: what the painter should depict is not the exterior resemblance, but the correspondence to the essential principles of nature. In order to achieve a perception of totality, he should experiment with the essence of individual phenomena by their concentration. Each manifestation has its own essence, its own *li*, in other words the immanent principle of each thing. This was a crucial concept in the neo-Confucian theory that became widespread in China during the Song period. For the painter this is an outright spiritual practice, the result of patient observations and meditation. As he paints, he projects an interior world where elements of the outside world have already been assimilated. In order to do this, a lengthy apprenticeship is required so that the forms of nature can be interiorized.

After the initial flourishing of the Five Dynasties, it was during the Northern Song dynasty (960–1127) that great landscape painting developed. Fan Kuan (active ca. 990–1030) and Guo Xi (active ca. 1020–80), were the greatest artists of the time. In his *Travelers Among Streams and Mountains*, one of the greatest masterpieces of this genre, Fan Kuan depicts a mountain landscape of northern China with admirable realism, to the point that rather than observing the painting we feel as if we are moving around inside it. A massive mountain in the background, illustrated very simply, gives the impression

of a looming mass yet still soaring skywards. It is the image of the mountain's majesty. The opus is an example of the Northern Song manner, and is constructed on various levels, separated by an area of mist and void. In landscape paintings the void contributes dynamically to creating a third dimension for the image. When illustrating great spaces, the overlapping of various planes, often separated by areas of void, and each represented with its own different perspective, creates a feeling of depth. This is a "mobile" perspective that in no way limits the observer, confined to a specific spot, but generates a sequence of viewpoints, as might happen during a train journey. Often this effect is accentuated by recourse to the horizontal scroll system, in which the observer "scans" – from right to left – the pictorial space, proceeding through the various stages of the narration. The artist must paint what he knows exists in a specific place, not that can be discerned from a specific viewpoint. Consequently, the landscape aspires to being a sort of "cross-section" of the universe in which all possible events potentially occur.

About 50 years after Fan Kuan, it was Guo Xi, in his *Early Spring* (1072), who painted with equal realism the details of a mountain landscape dominated by a great massif, rendered in chiaroscuro effect thanks to ink washes. Guo Xi's paintbrush lingers softly in the tiniest recesses of the landscape, in its ravines, in the valleys (*yin*), overlooking not a single detail of nature. Yet this realism still allows the imagination to wander free and reach the end of a true spiritual path. This trend for realism in painting, which we see expressed in Fan Kuan and Guo Xi, was in part stimulated by the new Confucian spirit that spread with the onset of the Song dynasty. Prevailing neo-Confucianism fuelled the faith of humanity's ability to know the world through a careful and rigorous observation of natural phenomena, setting out to seek the essence of things.

172 - EARLY SPRING IS THE MOST WELL KNOWN OF GUO XI'S PAINTINGS (ACTIVE CA. 1020–80) TO REACH US. A MONUMENTAL WORK THAT IS ONE OF THE MILESTONES IN THE HISTORY OF CHINESE ART, AS WELL AS BEING ONE OF THE MOST ANCIENT SURVIVING PAINTINGS IN INK ON SILK WITHOUT THE USE OF OTHER COLORS (NPM).

172-173 - CONVERSELY, A STRIKING USE OF COLOR IS FOUND IN A THOUSAND LI OF RIVERS AND MOUNTAINS, THE ONLY EXTANT WORK OF WANG XIMENG (1096–1119), A YOUNG PAINTER IN THE CIRCLE OF EMPEROR SONG HUIZONG, A GREAT PATRON OF THE ARTS AND A PAINTER HIMSELF (PM).

174

With the loss of the northern regions, invaded by the Jin, the court took refuge in the South and the new capital of Hangzhou. The first Southern Song dynasty emperor was Gaozong (r. 1127-62), who reestablished the Academy that had been created by Huizong in the North, at Kaifeng. Southern Song dynasty landscape painting had two major artists, Ma Yuan (active ca. 1180–1224) and Xia Gui (active ca. 1200–40), both close to the court, and who developed more delicate tones for this genre, now so distant from the power and monumentality of the northern masters. A vein of melancholy, influenced a little by the atmosphere of the South, and also by the political situation, pervades the work of these artists. Ma and Xia introduced a new type of off-center and very evocative perspective. In several compositions, especially those of Ma Yuan, we can note how most of the elements are focused to a corner of the painting, given a unique tension by the contrast of void and solid. Mountains and trees with jagged profiles, sketched in with strong brushstrokes, contribute to foster powerful suggestion. For these masters, painting was more than a means for describing the outside world realistically: it was a tool for expressing sentiments.

So-called "literati painting" had already begun to develop during the Northern Song period, inspired by the figure of Wang Wei, a poet and painter of the Tang period. For these artists it was not a question of studying and describing reality, but of borrowing the forms of nature to give voice to their own sensations and inner emotions. The minimal, almost calligraphic, stroke they employed evoked rather than described. Two of the greatest figures of this trend were Su Dongpo, also known as Su Shi (1037–1101), and Mi Fu (1051–1107), who both lived during the early period of the dynasty.

Mi Fu was an independent spirit and not a member of the Academy, but he nonetheless influenced the art of his time very deeply. This famous calligrapher and painter has been attributed with the vertical scroll now owned by the Freer Gallery of Art (Washington, D.C.), in which clouds and mists swathe the distant hills. Although the attribution to Mi Fu has been doubted, this is still the oldest of the extant large paintings realized in the style associated to the name of this artist, in which ink washed of various intensities and precise horizontal brushstrokes create the illusion of a landscape with lyrical overtones. The use of void is also significant, distinguishing in a very evident manner the planes through which the painting evolves, conferring on the composition a singular sense of depth.

174-175 - With Mi Fu (1051–1107), the stroke becomes essential, almost calligraphic. In *Mountains and Pines in Spring*, attributed to him, empty space quite clearly differentiates the two planes of the painting (NPM).

175 top - *On a Mountain Path in Spring*, by Ma Yuan (active ca. 1180–1224), is a fine example of the type of composition where landscape elements are concentrated in a corner of the painting (NPM).

175 bottom - This early 12th-century vertical scroll in the Freer Gallery of Art is traditionally attributed to Mi Fu (FSG).

THE DIVISION OF THE SONG EMPIRE AND THE CRISIS OF AN AFFLUENT SOCIETY

The 10th century closed with the end of the reign of the second Song emperor, Taizong (r. 977–997), who was succeeded by Zhengzong (r. 998–1022). The dawn of the new century saw growing pressure from the Liao Empire of the Qidan, reinforced in preceding decades, and with whom the Chanyuan treaty had been signed in 1005. This threat was flanked, to the west, by the emerging might of the Tangut, who in 1038 established the Western Xia dynasty. In about the middle of the century, another two peace treaties – in 1042 and 1044 – confirmed the imperial desire to find an agreement, first with the Liao and then with the Xia. Although these treaties forced the Song to pay extensive tributes in silk, silver, and other prized commodities, the cost of military action would have been much higher. Moreover, the peace along the northern boundaries allowed both legal and illegal trade which was heavily weighted in favor of the Chinese, given that the volume of exports towards the empires of the north and west was higher than that of the imports. Nor can it be excluded that considerations of this nature may have weighed heavily on government decisions. The reiterated preference to pay tributes to ensure tranquility along the frontiers is illuminating when compared to the attitude of this opulent society that focused so much on trade, preferring to negotiate with the enemy to ensure lucrative business, rather than oppose it with costly military campaigns of uncertain result. In the second half of the century, the peril of a new Xia offensive became more acute, precisely when the Empire was in a situation of serious difficulty. Social and economic transformations taking place meant that a series of radical reforms was required. Many functionaries and scholars were well aware of the fact that the stability of the State was being threatened by several chronic dysfunctions, which had to be remedied: concentration of land ownership in a few hands, the inequality of taxation, social unbalance, nepotism in bureaucracy, and, not least of all, the huge military costs for defense and the inefficiency of that military apparatus. Literati and statesmen such as Li Gou (1009–59) and Fan Zhongyan (989–1052) proposed substantial reforms in these areas, but they were strongly opposed by the forces of conservatism.

It was during the reign of the Emperor Shenzong (r. 1068–85), with Prime Minister Wang Anshi (1021–86), that the reformist wing succeeded in making itself heard, initiating a widescale project that aimed to rationalize the taxation system and improve living conditions for several classes, including small landowners and merchants. Wang was convinced that the government would reap advantage by fostering productivity in individuals by offering aid and funding, because this would then increase revenue. The State would lend money to farmers so they could make the most of their land without resorting to loans from the big landowners. The State loans could then be repaid, with interest, at the time of harvest. Craftsmen were also to be allowed to request funding for starting up and developing their businesses, and for small-scale merchants it became possible to detach themselves from the excessive power of the great merchant corporations. The burden of tax was shared out more equally, so reducing amounts demanded from peasants. Tax evasion by the rich, whether they were landowners or merchants, was curbed by limiting exemptions applicable to the very wealthy. Wang Anshi also reformed the military by reducing army costs by introducing a militia to guarantee public security at local and national level. He also attempted institutional reform by reorganizing the examination system. He stressed the importance of technical and practical expertise in economic, tax, and military applications linked to the exercise of government, and that no longer should only mnemonic knowledge of Confucian classics and command of other traditional disciplines be priorities in the training of scholar functionaries. The reform program inevitably provoked violent opposition from the conservatives. They were supported by the great landowners and richer merchants, headed by

Sima Guang (1019–86). When Shenzong died in 1085, Wang Anshi was thrown out of the government and most of his dispositions were abolished, although some of them were revived and enacted in subsequent centuries. The factional disputes continued throughout the reign of Zhezong (r. 1086–1100). With his successor, Huizong (r. 1101–25), the reform party returned to the limelight with Prime Minister Cai Jing (1046–1126), whose attempts at renewing the financial sector had to cope with the chronic ailments of the Song Empire, including the concentration of lands in the hands of a few, great families. The factional infighting continued to affect the stability of the State, until a new threat appeared on the horizon in the form of a Jurchen invasion.

176 - The large retinue accompanying the Northern Song emperor on any journey or procession was a tangible sign of imperial dignity and prestige (MSC).

177 - This 1347 painting by Zhao Yong (1289–ca. 1362), copy of a work by Li Gonglin (ca. 1041–1106), depicts a Tangut riding a horse (FSG).

This nomad population had materialized in eastern Manchuria in the 10th century, founding the Jin Empire (1115–1234), with whom the Song had initially formed an alliance to counteract Liao mastery (1118–20). In just a few years, the Jin went from being allies to invaders, and conquered the territories controlled by the Liao. They soon turned against the Song Empire, which was unable to fight off the advance, weakened as it was by domestic discord and popular rebellions, including the revolt of 1120 in the South, under the leadership of Fang La, which caused the deaths of hundreds of thousands of people.

The Jurchen, who had unbeatable cavalry and sophisticated military engineering, succeeded in occupying all of northern China in just a few years, and in 1127 conquered and pillaged the capital, Kaifeng. They took prisoner Huizong and his son Qinzong (who had become Emperor after his father's abdication two years earlier), as well as all of the court. Another of Huizong's sons, the ninth, was far away from Kaifeng at the time the capital fell, so he was able to reestablish the dynasty in the South. He founded his capital in 1138 at Lin'an, present-day Hangzhou, in Zhejiang. The new Song Emperor, Zhaogou (Gaozong), reigned in the South from 1127 to 1162, and was the first sovereign of the Southern Song dynasty (1127–1279). In 1142 a humiliating peace treaty was signed with the Jin (whose sovereignty the Song agreed to recognize and to pay a large annual tribute in silk and silver), but this did ensure the South relative stability for the next 20 years, with the opportunity of intensifying trade and economic growth. Under the Jin Emperor Hailing (r. 1150–61) in the North, the nomad invaders gradually assimilated Chinese culture. However, his successor Shizong (r. 1161–90) halted this assimilation and instigated a policy of reaffirming the ancient Jurchen lifestyle. Between 1161 and 1162 hostilities resumed against the Song. In 1163 the Song emperor Gaozong abdicated in favor of his adopted son Xiaozong, who reigned until 1189. A new peace treaty with the Jin was signed in 1165. They remained masters of all northern China until the Mongol victory of 1234. From the end of the 12th century, from the time of the new Jin emperor Zhangzong (r. 1189-1208), the Jurchen assimilation of Chinese culture continued to intensify and this may have been one reason for the weakening of the northern Empire, which fell to heavy Mongol incursions just a few decades later. Unable to reconquer the North, the Southern Song, however, managed to make the South the economic and cultural core of the country. The rapid development of the South (in particular in the south-west and along the coast) was the result of a process lasting centuries, and which had already borne significant fruit at the time of the Five Dynasties. Despite the Song State's extraordinary level of civilization, and a prosperity guaranteed by massive trade development, it was undermined by a fragility that made it vulnerable when faced with the great surrounding "barbarian" empires. The ascendance of civil administration over the military apparatus (purposely pursued to counterbalance too much power collecting in the hands of military commanders, which had led to the end of the Tang period) and the consequent rise of the new class of "scholar functionaries" who gradually took over from the ancient Chinese-Barbarian aristocracy, were just some of the elements that came into play in causing the weakening of the Empire. Although the final decades of the Song dynasty enjoyed a state-of-the-art and well-equipped army, as well as a powerful navy, none of this was sufficient for saving the country from the attack of the forces that came down from the north. The military plan might have been more effective – and events might have taken a different turn – if it had not been so rigidly subject to civilian power and if military commanders had been able to enjoy greater autonomy and freedom of decision. But the fact of the matter is that as the mighty Mongol hordes arrived on the scene, the fate of the Song was sealed. Following the defeat of the Jin and the conquest of the North in 1234, the Mongols founded the Yuan dynasty in 1271, and in just a few years they also conquered the South, and brought the Southern Song dynasty to an end in 1279.

178 AND 179 - COURT LADIES PREPARE THE NEWLY WOVEN SILK IN THIS FAMOUS SCROLL PAINTED IN THE NORTHERN SONG PERIOD, EARLY 12TH CENTURY, AND ATTRIBUTED TO EMPEROR HUIZONG (1082–1135). IT IS A COPY OF A WORK BY THE TANG PERIOD ARTIST ZHANG XUAN (ACTIVE CA. 713–42) (MFA).

6

THE ARRIVAL OF THE MONGOLS
AND THE CHINA OF MARCO POLO

The Material Culture
of the Steppe Populations
page 182

The Mongol Conquest
page 192

A New Social Order:
The Importance of the Merchants
page 194

The Reply of the Literati:
The Splendor of Yuan Painting
page 196

New Forms of Art: The Birth of Theater
page 200

The Collapse of the Yuan Dynasty:
Towards Modernity
page 202

THE MATERIAL CULTURE OF THE STEPPE POPULATIONS

The great Eurasian Steppe stretches from the plains of Hungary to the extreme northern reaches of Asia. The Asian section of this immense territory is located near the present-day autonomous region of Xinjiang in western China, with Manchuria to the east, Siberia to the north, and the Great Wall to the south, creating a symbolic watershed between the worlds of the nomadic and settled peoples. The military organization of these populations has always attracted great attention because, until the advent of firearms, they were often able to dominate nearby groups because of their formidable cavalry and highly skilled archers. Yet many other equally significant aspects of their civilization have for some time remained in the shadows. Most of the written sources concerning the empires of the steppe, and the peoples who created them, can be traced to the settled peoples who found themselves in conflict with them. Given the confrontational relationship between the two groups, descriptions of the material culture of these "barbarians" are frequently vague and incomplete. Archeologists have had to make great efforts to piece together a clear picture. Recent archeological discoveries have thrown new light on the existence of a rich material culture, significant enough to increase the knowledge of the origins of Chinese civilization itself and the reciprocal influences that passed between these two worlds over the course of the centuries. In the period immediately previous to the Mongol conquests, between the 10th and 13th centuries, the three principal structures unifying the nomadic peoples of the steppe were the Liao Empire (907–1125) of the Qidan, the Western Xia or Xi Xia Empire (1038–1227) founded by the Dangxiang or Tangut, and the Jin Empire (1115–1234) of the Jurchen.

The Liao dynasty, founded by the Qidan (Khitan) people, takes its name from the Liao River in Manchuria, where these tribes originally settled along its upper reaches. In their phase of greatest expansion, they occupied a territory that extended west to the Altai Mountains, east to the Sea of Japan, and south to present-day Hebei. This people's artistic production shows many influences of both Chinese and Central Asian origins. Liao artisans produced splendid examples of ceramics and porcelain, perhaps influenced by those from the states of the Five Dynasties and Ten Kingdoms period – such as the southern Wuyue State (907–978) – as well as the Song, collected as tribute following the signing of peace agreements with the powerful confederation. The most characteristic shapes are those imitating leather containers for liquids (wine, water, or milk) typically carried by the Qidan during long treks. However, *sancai* or "three-color" ceramics have also been recovered, inspired by the Tang, along with refined porcelain wares expressly produced in official kilns for the imperial family and high-level functionaries, recognized by the character *guan* ("official") inscribed on the base. From the manufactured articles discovered near the supreme capital of Shangjing, north of present-day Chifeng, as well as near Chifeng itself (the Gangwa site) and present-day Beijing, it is clear that a remarkable quantity of high-quality porcelain ware was produced in these kilns, probably by Chinese artisans originally from the 16 northern prefectures under control of the Qidan. In addition to clear Chinese influences, some Liao ceramics show the influence of Central Asian designs and motifs, probably of Turkish and Uyghur origin. Eight "three-color" glazed ceramic sculptures of *luohan* (or *arhat*), created during the Liao period in the typical Tang style, have been discovered (seven of them in Yi county, in Hebei). Their striking, concentrated facial expressions show all the tension of an intense search for spiritual perfection. Splendid Buddhist wooden sculptures were also produced under the Liao, including some Bodhisattva Guanyin (Avalokitesvara) finely crafted figures. Burial masks of gold, silver, and bronze were also found on corpses in dozens of Qidan tombs, evidence of this people's ancient burial practices.

180 - A GREAT ADVANCEMENT IN PORCELAIN MANUFACTURE OCCURRED IN THE YUAN PERIOD (1279–1368), WHEN JINGDEZHEN, IN JIANGXI, AND DEHUA, IN FUJIAN, BECAME THE MAIN CENTERS OF PRODUCTION IN SOUTH CHINA. THIS WHITE PORCELAIN FIGURE OF GUANYIN DATES BACK TO END OF THE 13TH CENTURY (MG).

182 - THE CERAMICS CREATED IN NORTH CHINA DURING THE LIAO DOMINION, SUCH AS THIS BOTTLE WITH GREEN GLAZE (LEFT, IBC) AND THE "THREE-COLOR" CAPRICORNUS (RIGHT, MCT), REPRESENT A SYNTHESIS OF NORTHERN TRADITION AND THEMES OF FOREIGN DERIVATION.

183 - This ceramic figure of a *luohan* or disciple of the Buddha (*arhat* in Sanskrit), in "three-color" glazed stoneware, belongs to a set of eight Liao-period sculptures of which seven survive. The figures have been found in a cave in Yi county, Hebei province (BM).

184 AND 185 - IN SOME LIAO TOMBS, FUNERARY MASKS IN GOLD (LEFT, IMICRA), SILVER (RIGHT, MC), AND GILT BRONZE, MIRRORING THE FEATURES, SEX, AND AGE OF THE DECEASED, WERE FOUND ON THEIR FACES. IN SOME CASES THE BODIES WERE WRAPPED IN A KIND OF MESH OF GOLD OR SILVER WIRE.

186-187 - TOUCHES OF GOLD ENLIVEN THIS MURAL FROM LIAO TOMB 2, ON MOUNT BAO NEAR CHIFENG, INNER MONGOLIA. THE PAINTING PORTRAYS THE MOVING STORY OF SU HUI, A WOMAN OF THE QIN DYNASTY, DEPICTED IN THE ACT OF SENDING A PIECE OF BROCADE ON WHICH SHE WEAVED SOME WORDS FORMING A POEM TO HER FARAWAY HUSBAND.

Originally from Qinghai, the Dangxiang (or Tangut) were one of the Qiang tribes that had harassed the Chinese along their north-western borders since ancient times. References to the Dangxiang appear for the first time in Chinese sources somewhere around the beginning of the Tang dynasty, at the end of the 6th century. In the early part of the 11th century, the Dangxiang controlled a vast area that spread from the western zones of Inner Mongolia to Ningxia, Gansu, and Qinghai, all the way to northern Shaanxi. In 1038, they founded the Xia dynasty with Xingqingfu (later renamed Zhongxingfu) as their capital, near present-day Yinchuan in Ningxia. Between 1907 and 1909, Pyotr Kuzmich Kozlov (1863–1935) led a Russian expedition on a series of explorations in an area at the edge of the Gobi Desert, in the north-west of Inner Mongolia. In March 1908, Kozlov discovered buried under sand the site of Heicheng or Khara-Khoto, the "Black City," one of the most important in the Xia State and among the first to be taken by the Mongol advance in 1227. He sent back thousands of manuscripts and printed documents, objects, statues, and Buddhist paintings, now in St. Petersburg. Some of the writings in the Tangut language were translations of Buddhist texts from Sanskrit, Chinese, and Tibetan. A bilingual Tangut-Chinese dictionary, compiled in 1190 by the Tangut scholar Gule, was also discovered that allowed the comparative study of the Tangut language. This discovery revealed the Xia culture's great wealth and gave birth to the development of Tangut studies. Sir Aurel Stein (1862–1943) explored the site in 1914, uncovering other objects and manuscripts. Between 1927 and 1935, Sven Hedin (1865–1952) and Xu Bingchang (1888–1976) carried out a joint Chinese-Swedish expedition that opened new archeological digs. In the first half of the 1980s, the Archaeological Institute of Inner Mongolia continued further explorations, reconstructing the city's possible appearance and uncovering artifacts in wood, iron, and bronze, along with coins, textiles, leather goods, ceramics, weapons, utensils, and religious objects. The religious objects revealed the importance of the Buddhist religion during the growth of the Xia State, since their rulers were great promoters of this faith. The discovery of Xia imperial tombs – located 15 miles (25 km) west of Yinchuan on the eastern slopes of the Helan Mountains – was also important, showing the profound influence Chinese culture exercised on the development of this Empire. Their burial typology recalls Tang and Song tombs, although some aspects also recall Liao customs. Many Xia rulers surrounded themselves with Chinese objects, brought to light in large quantities in their tombs and various sites in Inner Mongolia, particularly areas bordering the Song Empire, together with manufactured objects that show clear Chinese influence, for example, in Xia ceramics and metallurgy. Between 1982 and 1986, large quantities of ceramics produced by the Xi Xia were discovered in Ningxia. The most significant finds were made at the Ciyaopu and Huiminxiang porcelain kiln sites in Lingwu county. These fragments help reconstruct an outline of Xia ceramic production as well as important information on Xia history.

The Jurchen (or Nüzhen) were nomadic tribes who lived in Manchuria during the 5th and 6th centuries along the middle and lower Amur River (Heilongjiang). At the time when Tang control of the northern regions began to vacillate, the Qidan took the advantage and the Jurchen, along with other populations in the north-east, became vassals of the Liao Empire. At the end of the 11th century, however, they found a powerful leader in Aguda, head of the Wanyan tribe, who began open rebellion against the Liao in 1114, and the following year founded the Jin dynasty, whose name means "gold." Allied with the Song, by 1123 the Jurchen had conquered most of the Qidan territories, including their southern capital near present-day Beijing, and captured their emperor in 1125. The following year, they occupied the Northern Song capital of Kaifeng (Bianjing) and established their rule over the northern regions of China. Porcelain ware with the imperial mark, evidently pillaged from the Song capital, has been uncovered at various sites in Inner Mongolia. The conquest of Kaifeng also gave the Jin control of several kilns that produced imperial ceramics during the Northern Song period; for example, those in Junzhou (in Yu county, western Henan) where Jun ware were produced. The Chinese porcelain tradition would, therefore, end up powerfully influencing the ceramics of the Jin.

188 - The Xia imperial tombs are known as the "Pyramids of China" due to their shape. More than 200 tombs of noblemen have been discovered, and nine royal burials.

189 - The two splendid gold items — a polylobed plate (left, IBC) and a goblet (right, IBC) — with engraved decoration — seem to hint at the meaning of the Jin name, i.e. "gold".

190-191 - Two cranes spread their wings and interlock their beaks in this Jin-era jade pendant. The crane, traditional emblem of longevity and a good omen, also symbolizes the wisdom of age (MC).

191 top - Tiny tortoises on two lotus leaves embellish this delicately made jade ornament produced during the Jin period. This stone, which was believed to embody great moral virtues, was originally used in rituals (MC).

191 bottom - Corollas of flowers and leaf-laden stems entwine on this Jin-era jade. This was considered the most precious of hardstones and has been crafted since Neolithic times. Jade was also valued for its hardness and rarity (MC).

THE MONGOL CONQUEST

As we have seen, the Mongols were not the first of the so-called "barbarians" to occupy northern China. Over the course of Chinese history, various confederations of nomadic tribes have managed to gain supremacy over the peoples settled in the northern regions and establish empires. In many cases this involved renouncing their own traditions, becoming progressively more sinicized, and adopting in part the conquered peoples' lifestyle. However, only the Mongols were successful in uniting the entire Chinese territory under their rule. In 1271, Kublai Khan founded the Yuan dynasty (the name means "origins") by building on the accomplishments of Temujin (1167–1227), who had unified the various nomadic tribes and was proclaimed Genghis Khan (Universal Ruler) in 1206. After creating an empire that stretched west all the way to the borders of Europe, in 1211 Genghis Khan began a series of attacks against Jin territory and, in 1215 conquered the area around present-day Beijing and Manchuria. In 1227, the great leader was killed in a battle against the Xi Xia and the Grand Khanate passed into the hands of Ogodai (r. 1229–41), who brought an end to the Jin Empire in 1234. The conquest of the entire country was completed under his successors: Guyuk (r. 1247–48), Mongke (r. 1252–59), and Kublai (r. 1260–94). In the mid-13th century, the Mongols invaded Sichuan and Yunnan provinces to the south-west, and between 1272 and 1279 completed the conquest of the country with the annexation of the Yangtze River valley and the southern regions. The Southern Song capital of Hangzhou fell in 1276, under pressure from the Mongol army commanded by General Bayan. The Song capitulated in 1279, after brief resistance by functionaries and military commanders who remained loyal to the dynasty and retreated to the extreme south.

Faced with Mongol annexation of the southern regions, part of the literati class began a sort of passive resistance, retreating from public life and refusing to serve their new masters. Others, however, lent their services to the ruling Mongols to help them administer the country with different criteria from those used during the decades of conquest and to adapt to the requirements of quite a different and much more complex situation than that of nomadic warriors. Among these scholars was Liu Bingzhong (1216–74), a former *chan* monk, whom Kublai, a few years before the unification, in 1267, had ordered to design the new capital to go by the name of Khanbaliq (City of the Khan), in Chinese *Dadu* (Great Capital). During the summer, the Khan and his court transferred from Khanbaliq, built on the site of present-day Beijing, to the "Supreme Capital" of Xanadu in Inner Mongolia.

In 1249, Liu Bingzhong presented the Khan with a memorial in 10,000 characters (*Wanyanshu*) that contains a celebrated phrase taken from a Han era text: "On horseback, you can conquer the world, but you cannot govern it" (*Yi mashang qu tianxia, bu ke yi mashang zhi*). Even before unification, Liu had conceived a series of reforms, immediately applied by Kublai. In organizing the state, the Khan drew on Tang and Song institutions, though over time these various bodies ended up exercising different functions from those of previous eras. In civil administration, the Imperial Secretariat was reestablished (*zhongshusheng*), overseeing the Ministries (*bu*); broad powers were conferred on the Bureau of Military Affairs (*shumiyuan*), reaffirming the military's primary place inside the administration. The Censorate (*yushitai*) was also kept, with the function of watching over the entire bureaucratic apparatus. Kublai rejected the examination system, however, for selecting members of the bureaucracy, who would still be chosen for decades (till 1314) by recommendation or due to class and family connections – as was the case with the military. There were many non-Chinese functionaries, among them many Turks and Uyghurs. Those ethnic Chinese and Jurchen who managed to reach public positions, for example by attending schools in the capital, were in any case under the control of Mongol or Central Asian supervisors (*daruhachi*, in Chinese *daluhuachi*).

192 - THE REDOUBTABLE MONGOL ARCHERS WERE CAPABLE OF SHOOTING ARROWS BEHIND THEM WHILST GALLOPING ON THEIR SWIFT CHARGERS (NPM).

193 - KUBLAI SHOWED THAT HE FELT HIMSELF TO BE NOT ONLY INHERITOR OF THE GREAT TRADITION OF HIS PEOPLE, BUT ALSO OF THE CENTURIES-OLD CHINESE CIVILIZATION.

A NEW SOCIAL ORDER: THE IMPORTANCE OF THE MERCHANTS

One of the characteristics of the new social organization, reflected in fiscal and judicial matters as well as in penal codes, was the principle of distinguishing between the various ethnic groups. Chinese society was divided into four classes: the Mongols, who made up a privileged category dominated by the warrior aristocracy; the class of the *semuren*, which included 31 different ethnic groups from Central and Western Asia, allied with the Mongols during the conquests, whose members were mainly involved in mercantile and financial activities or inside the bureaucracy (even European merchants such as Marco Polo were part of this group); the *hanren*, who were the inhabitants of Northern China, who along with Chinese included Jurchen, Qidan, and Koreans; the *xin furen* or "new subjects," or rather the population from the southern part of the Song Empire, the last to be conquered, who were strongly discriminated against in terms of the possibility of entering the ranks of the bureaucracy. High positions were reserved for Mongols first and *semuren* second. Merchants from this second category were favored over those of Chinese ethnicity, and monopolized many of the financial activities.

The mercantile class profited most from the *Pax Mongolica*, because between the 13th and 14th centuries travelers were allowed to move more freely and with few impediments throughout a territory that extended across the entire continent to the threshold of Europe. Caravan routes through Central Asia were safer and much busier than in the past. The system of post stations was expanded at regular intervals along roads across the entire empire; travelers here could find a change of horses, supplies of provisions, and means of transportation. The Grand Canal was rebuilt and the shift of the capital from faraway Karakorum to Beijing encouraged the construction of a new section of the canal network in the area north of the Yellow River. Maritime traffic was also stimulated toward South-East Asia and the ports of the Indian Ocean and Arabia. On reaching China, merchants converted precious metals into paper currency that circulated across the entire territory, encouraging commercial exchange.

Thanks to this greater facility of movement, many Western merchants and travelers pushed all the way to China, bringing goods as well as inventions and ideas. Oriental travelers also went in the opposite direction, helping to expand the horizons of late medieval Europe. Mongol emissaries reached all the way to Bordeaux, completing Marco Polo's overland voyage in reverse. Westerners, Europeans or Central Asians, and foreigners in general, were welcome in the court of the Grand Khan, where many of them performed important functions, especially if they held specific technical skills in special arts or professions (such as architects, engineers, geographers, astronomers, or doctors). Those belonging to the *semuren* easily found positions as tax collectors or administrators for aristocrats and, at higher levels, managers of State finances. The Mongols especially preferred foreign merchants, above all Muslims. United in associations called *ortogh*, they managed traffic along the Silk Road and financed the caravans that brought Chinese goods to the West, gaining financial advantages in exchange. Furthermore, they held exclusive rights to the profitable collection of taxes and monopolized banking and credit activities, making loans that frequently bordered on usury.

This was the China encountered by Marco Polo (1254–1324), the Venetian merchant who set off in 1271 for far off "Cathay," where he remained for more than 20 years. His memoirs, collected in his *The Travels of Marco Polo* (also known as *Il Milione – Million Lies*) record a vivid description of China at the time of Kublai, for whom he, as well as other foreigners, seems to have held some official position.

194-195 - The most representative of Yuan dynasty ceramics is underglaze red or blue painted porcelain, like this mid-14th century plate decorated with peonies and *qilin* (mythical animal), from Jingdezhen (MADL).

195 - This *meiping* vase, from the same period as the previous item, is decorated with a dragon in white slip on a cobalt blue ground. It is an interesting example of the art of Yuan ceramics and only two other similar items exist (MG).

195

THE REPLY OF THE LITERATI: THE SPLENDOR OF YUAN PAINTING

Faced with the new laws imposed by the Mongol rulers, many belonging to the scholarly class, who in normal times would have dedicated themselves to studies for entering the bureaucracy, now found themselves excluded. In particular, the Southern elite, especially in the early part of the Yuan era, had few possibilities for entering state civil administration and remained outsiders. Painting from the early Yuan period was strongly influenced by these political and social problems, and the extraordinary development of literati painting during this period was a direct consequence. The trend begun during the Northern Song dynasty by individuals such as Mi fu and Su Shi was continued by numerous southern artists active during the Yuan period. Many from the literati class who retired from public life, either because they were constrained by circumstances or determined not to contribute to the regime installed by the "barbarian" conquerors, turned to this refined art, which was also a worthwhile means of support. Even active bureaucratic functionaries, such as Zhao Mengfu (1254–1322) from the first generation of Yuan painters, also made their contribution to this discipline.

With the dissolution of the Southern Song Painting Academy in Hangzhou, other important artistic centers developed. One of these was Wuxing, north of Hangzhou, where a group of artists, poets, and men of letters active between the end of the Song and beginning of the Yuan dynasty took the name, "The Eight Talents of Wuxing." Among these was Qian Xuan (ca. 1235–ca. 1307), perhaps the most celebrated scholar painter from the early Yuan period who refused to collaborate with the new dynasty. Aside from delicate compositions of flowers, created with uniform, thin lines and light layers of color, Qian Xuan produced landscape paintings with archaic tones, that recalled pre-Song masters, particularly the great Tang tradition of *qinglü shanshui*, "landscapes in blue and green," (the style associated with the Li family). In 1286, Kublai Khan invited some of the artists from Wuxing to practice their art at Khanbaliq, but Qian Xuan was not among those who transferred to the North. We do not know whether he was not invited or refused the proposal.

One who accepted the invitation, on the other hand, despite the fact he may have had family ties to the imperial Song clan, was the younger Zhao Mengfu, a student of Qian Xuan. Zhao became one of the most outstanding figures in the artistic world of that period, in addition to carrying out prominent projects within the Yuan administration, where he constantly worked to the advantage of the Chinese cause and was among the most active supporters of the return to the system of examinations. Zhao Mengfu's apparently casual yet austere style in reality concealed his intent to draw from the masters of the past, and the influence of Gu Kaizhi was particu-

and branches of trees and foliage, a technique that would influence various subsequent painters. Zhao Mengfu also painted other subjects such as human figures, flowers, and birds, as well as a variety of animals. His paintings of horses, a genre in which he excelled and for which he became famous in the court of Kublai, are particularly interesting. These paintings also clearly recall the ancient masters, in particular Han Gan (ca. 720–ca. 780), the famous painter of horses from the Tang era to whom Zhao makes clear reference in the calligraphy included on one of his most well-known works.

larly significant in his early works. He aimed to rediscover that "spirit of antiquity" (*gu yi*) expressed in his paintings through more or less explicit allusions directed toward and understood by any cultured observer from that era. In keeping with what his master Qian Xuan had begun, Zhao Mengfu contrasted his own style with that of academic painters, whose paintings were frequently characterized by bright colors and remarkable displays of virtuosity that produced outstanding decorative effects. In his *Autumn Colors on the Qiao and Hua Mountains*, the tendency toward archaism and the study of great works by famous masters such as Dong Yuan – a landscape painter active during the Five Dynasties period, whose influence is clear in the drawing and spatial organization – brought completely innovative results. In place of the thinner outline strokes of earlier works, he used eye-catching vigorous, thick brushstrokes, almost sketched, outlining the trunks

196 - THE *MOUNTED OFFICIAL* PAINTED BY ZHAO MENGFU (1254–1322) IN 1296 CONTAINS A SHORT INSCRIPTION WITH A TRIBUTE TO HAN GAN (CA. 720–CA. 780), MASTER OF THE TANG PERIOD FROM WHOM THE AUTHOR DREW INSPIRATION FOR HIS CREATION OF THIS FAMOUS FIGURE OF A FUNCTIONARY ON HORSEBACK (PM).

196-197 AND 197 - BOTH QIAN XUAN IN HIS *HOME AGAIN*, A DETAIL OF WHICH IS SEEN HERE (LEFT, METNY), AND ZHAO MENGFU IN HIS FAMOUS *AUTUMN COLORS ON THE QIAO AND HUA MOUNTAINS* (RIGHT, NPM), DRAW INSPIRATION FROM ANCIENT MASTERS, PARTICULARLY THE WORKS OF TANG LANDSCAPE PAINTERS.

Zhao Mengfu's work was extremely important for the development of landscape painting in the middle Yuan period, which culminated at the end of the dynasty with the group named by Dong Qichang (1555–1636), painter and critic from the Ming era (1368–1644), as the "Four Great Masters of the Yuan": Huang Gongwang, Ni Zan, Wu Zhen, and Wang Meng. Mostly active in the southern regions, these literati artists also practiced calligraphy and poetry in addition to their painting, with the exception of Wang Meng who was exclusively a painter. Taoist Huang Gongwang (1269–1354) loved to paint broad mountain landscapes, many of them inspired by the landscapes that surrounded him in the Fuchun Mountains area, near Hangzhou, where he spent the last years of his life. The teachings of Zhao Mengfu, with his thick and apparently rough brushstrokes, were perfectly interiorized by this artist, who combined them with an extraordinary ability to put together well-structured masses, with long waving lines delineating the mountains, betraying the influence of Dong Yuan. Ni Zan (ca. 1301–74) was a follower of Taoism just like Huang, but much more eccentric. His painting communicates a sense of serene detachment from mundane reality, something he always stayed away from, refusing commissions and escaping any form of involvement in public life. His ink-monochrome landscapes, in a relatively smaller format, have an extreme essentiality, with a rarefied atmosphere, nearly dematerialized masses, and thin trees that stand out against broad expanses of water and distant lowlands. Created with sparse touches of very dry ink, they are pervaded by a sense of intimate mystery. Ni Zan generated an unmistakable style that would be attempted by many artists in subsequent eras. Wu Zhen (1280–1354), in addition to landscapes, was also a great painter of bamboo, making up probably the greater part of his work. A fervent Taoist, he led a withdrawn life. Like Ni Zan, he loved to paint river landscapes, frequently populated by fishermen. In the poetry and painting of the era, fishing represented a metaphor for retreat into solitude, away from public life and the worries of the world – to lead the life of a hermit. Frequently sketched with great immediacy and rapid strokes, lively and essential, his fishermen actually seem more intent on loafing rather than catching fish. Wang Meng (ca. 1308–85), grandson of Zhao Mengfu, probably learned the rudiments of his art from his famous grandfather. The mountain rises up majestically to become the pivotal point of his compositions, just as in paintings by the great masters of the Song era, and yet in many of his works, a sense of restlessness and unease, almost as if facing a distorted representation of reality, takes the place of the clear realism of the Song artists who transmitted the image of an orderly, coherent universe. The intense expressivity produced by the play of light and dark, the contorted shapes, the nervous strokes, and insistent rhythm of dense brushstrokes, are all accentuated by the use of color, separating this painter from the austere monochromes of many of his contemporaries.

198 - Produced between the end of the Yuan and the early Ming dynasty, in a particularly worrying period, this plain ink on paper painting, *Remote Stream and Cold Pines*, by Ni Zan (ca. 1301–74), hints at the desire to retire to a secluded life, away from the world's illusions (PM).

199 - In *Ge Hong Moving House* (left, PM), Wang Meng (ca. 1308–85) guides the observer through a succession of vertical spaces, so as to suggest a narrative sequence. In *Red Peaks and Jade Trees*, by Huang Gongwang (1269–1354) (right, PM), the mountains are rendered with well-structured ovoid forms.

NEW FORMS OF ART: THE BIRTH OF THEATER

In the cultural field, another important consequence came from the exclusion of many men of letters from public employment. The literati painters of the era found a new means of support in an art form earlier performed only for pleasure. In the same way, those who showed a certain literary talent and were no longer able to serve the State, exploited this talent by dedicating themselves to literary genres traditionally considered second-rate, such as popular literature and theater. Texts intended for entertainment had also existed previously, but during the Yuan period dramatic writing become a literary form of its own, the expression of an urban class from the poorer neighborhoods of the city. Performances enjoyed great success and many city centers had outright theater districts. Hundreds of plays were written in the vernacular during the brief period of the Yuan dynasty. The fact that the best-educated authors in the literary field now turned to this art form raised the average level of production. However, many writers used pseudonyms, since this genre was not considered in keeping with literary dignity.

One particular genre reached its full development during this period and that was *zaju* ("miscellaneous drama"). Already widespread during the Song era, performances of this mixed type of theater included spoken sections with musical accompaniment, as well as dancing and singing (*qu*). One of the most famous theatrical texts from the *zaju* genre is *Zhaoshi gu'er* ("The Orphan Zhao"), a Yuan era libretto that has also given rise to many Western theatrical adaptations. Plots in general were quite varied and ran from love stories to police intrigue. Traditional themes dealt with filial piety, marriage and conjugal fidelity, family relationships, and the contrast between the various human passions. Stories were frequently inspired by legendary episodes, or derived from classics, but set in a contemporary context. Characters became stereotypes, recognizable through their gestures and costumes.

Theater reached its greatest development in two main centers: Beijing, and the commercial cities in the south-east, including Hangzhou, where there was a different theatrical tradition compared to the North. Major authors included the Beijing writer, Wang Shifu, author of *Xixiangji* (*The Romance of the West Chamber*) and Gao Ming (Gao Zecheng), active in the south at the end of the dynasty, who is attributed with *Pipaji* (*The Romance of the Lute*).

200 - ZAJU ACTORS OF THE YUAN ERA ARE SPLENDIDLY PORTRAYED IN A MURAL PAINTING IN THE WATER GOD'S TEMPLE, ONE OF THREE COMPOSING THE GUANGSHENGSI, A TEMPLE ON THE SOUTHERN SLOPES OF THE HUOSHAN, NORTH-EAST OF HONGTONG IN SHANXI. THE WORK IS AN IMPORTANT REFERENCE SOURCE FOR THEATER OF THIS PERIOD.

201 - THIS TERRA-COTTA FIGURINE PRODUCED DURING THE YUAN DYNASTY ALSO REPRESENTS A ZAJU ACTOR OF THE TIME. THIS KIND OF "VARIED THEATER" INCLUDED RECITED PARTS ACCOMPANIED BY MUSIC (MPHEN).

201

THE COLLAPSE OF THE YUAN DYNASTY: TOWARDS MODERNITY

Kublai's death in 1294 ushered in a period of crisis for the dynasty, which was undermined by internal struggles for the succession, as well as runaway inflation, and the growing discontent of the poorest classes. The agricultural South, especially the regions in the south-east where most of the rural population was concentrated, effectively maintained the rest of the country and the financial burden of state management also weighed on this area. While the Mongols and other privileged classes enjoyed remarkable tax advantages, with partial or even total exemptions, small farmers were subjected to heavy taxation, made even more burdensome by the tax evasion of the great southern property owners. The beginning of the 14th century saw the outbreak of a succession of popular revolts over subsequent decades, because of deteriorating living conditions for farmers, aggravated by several disastrous natural catastrophes and the heavy labor forced on the rural population in order to maintain the efficiency of land and river transportation, and complete numerous public works. These rebellions also had a religious and messianic inspiration, and were led by individuals from the lowest classes of the population. One example was the "Red Turbans" (*hongjin*) rebellion that broke out in Anhui between 1351 and 1366. Since these insurrections were directed generically against the upper classes, they never gathered the support of landowners and so were substantially inconclusive. The situation changed radically, on the other hand, when increasing discrimination against the Chinese also affected the large landowner class and caused them to drop their support of the dynasty. The future founder of the Ming dynasty, Zhu Yuanzhang, in close contact with the rebel leaders in Anhui, connected with the Red Turbans. He became the leader of one of these rebellions and, in 1368, conquered Beijing, and ended the Mongol domination of China.

With the fall of the Mongol Yuan dynasty and the foundation of the Chinese Ming dynasty, which ruled China for almost three centuries, from 1368 to 1644, the country gradually embarked on the path to modernity. One of the issues currently most disputed involves which instant should be indi-

202 AND 203 CENTER - THE MING DYNASTY (1368–1644) SAW ONE OF THE GREATEST PHASES OF PORCELAIN ART. THESE TWO ITEMS, THE SMALL CUP FROM THE REIGN OF YONGLE (1403–24) (LEFT, PM) AND THE *MEIPING* VASE FROM THE XUANDE ERA (1426–35) (RIGHT, PM), ARE FINE EXAMPLES OF THE GREAT "BLUE-AND-WHITE" TRADITION: WHITE PORCELAIN WITH UNDERGLAZE BLUE DECORATION.

203 LEFT AND RIGHT - THE USE OF GLAZES IN PORCELAIN DECORATION IS DEMONSTRATED BY THESE TWO SPLENDIDLY MADE OBJECTS: A DISH FROM THE HONGZHI PERIOD (1488–1505), WITH FLORAL AND FRUIT MOTIFS IN UNDERGLAZE BLUE ON A YELLOW GLAZE GROUND (LEFT, PM), AND A *GU*-TYPE VASE WITH CLOUD AND DRAGON MOTIFS IN UNDERGLAZE BLUE AND OVERGLAZE ENAMELS, FROM THE WANLI ERA (1573–1619) (RIGHT, PM).

cated as the start of the Modern Era of Chinese history. Traditionally this date was established as being the moment of the first Opium War (1839–42), when Qing (1644–1911) China suffered a defeat at the hands of Great Britain and was forced to sign the mortifying Treaty of Nanjing (1842), in which it was obliged to hand over Hong Kong to the British and open various ports to foreign entry. Behind this vision there was an assumption that modernity in Chinese society would have to be assessed in the light of Western civilization's impact on it, taking it for granted that contact with the latter would promote the Middle Country's progress into the Modern Age.

In recent years, however, there has been an increasing trend to acknowledge that an independent transformation was in force in China several centuries before that, and this gradually led to the country embarking on the way of modernity, through a long path of modernization that began in at least the late Ming period, if not in the Song dynasty. From about the 16th century, in many areas of China, especially in the coastal regions of the South, we will notice that there were significant developments in the organization of traditional production that led to quite noticeable social and cultural changes, with a general improvement of living conditions in many areas. The most recent historical research has in part modified the traditional image of late imperial China, which had previously been seen as an essentially backward rural civilization, with scant commercial development, and has also brought to light how, in the last few centuries of the Empire, there was a noticeable increase in wealth and in commodities traded, in particular in many areas of the South, configuring a far more dynamic picture of the Chinese economy of that time. The debate about the start of the Chinese Modern Era, on the existence of an independent "Chinese way" to modernity, and the evaluation of the meaning and importance of developments that occurred in this direction during the Ming and Qing dynasties, is still open, leaving room for various interpretations and controversies.

INDEX

c = caption

A
Africa, 18
Aguda, military leader, 188
Altai, mountains, 182
Amur, river, 188
An Lushan, military leader, 12, 130, 132, 134, 146, 149, 150
Ānanda, disciple of the Buddha, 148
Anhui, 35, 45, 70, 202
Anyang, 12, 24, 25, 26, 30c, 35, 136c
Arabia, 194
Asia, 138, 182
Asian Art Museum (San Francisco), 115, 115c
Avalokitesvara, Bodhisattva, 182

B
Bagdad, 134
Bai Di, people, 49
Bai Juyi, poet, 146
Ballad of Mulan, 109
Ban Chao, military leader, 82, 82c
Ban Zhao, historian, 93
Banpo, 21, 21c
Bao, mount, 184c
Baofeng, 168
Baoji, 40
Beijing, 41c, 49, 182, 192, 194, 200, 202
Bezeklik, 126c
Bian, river, 159
Bianjing (Kaifeng), 188
Bianliang (Kaifeng), 159, 188
Bifaji (*Notes on the Art of the Brush*), 172
Binyangting, 115
Bo, 26
Bohai, 35
Bordeaux, 194
British Museum (London), 110, 111c
Bronze Age, 12, 26

C
Cai Jing, minister, 177
Cao Cao, military leader, 103, 104
Cao Pi, military leader, 103
Cao Zhi, poet, 84
Central Asia, 12, 75c, 82, 84, 112, 124c, 126, 129, 149c, 194
Cha Jing (*The Classic of Tea*), 138
Chang'an, 12, 38, 72, 75c, 112, 122, 124, 126, 132, 134, 146, 148, 150
Changsha, 84
Changtaiguan, 52
Changzhi, 48c
Chanyuan, treaty, 176
Chanzong, Buddhist sect, 148
Chen Yixi, painter, 129c
Chifeng, 182, 184c
Chu, state, 35, 45, 49, 52, 52c, 53, 58, 94, 95
Ciyaopu, 188
Confucius, philosopher, 12, 38, 45, 53, 53c, 54, 55, 74, 94, 129
Constantinople, 134
Cultures:
 Dian, 35, 99c
 Hongshan, 21, 23c
 Liangzhu, 21, 23c
 Longshan, 21, 21c
 Majiayao, 20c
 Yangshao, 20c, 21, 21c, 38
Cuo, King, 51c

D
Da Qin (Rome), 82
Dadu, 192
Daizong, Emperor, 150
Dangxiang, people, 188
Datong, 107, 110, 115, 116c
Dawenkou, 21
Dayao, 171
Daying, 168
Dehua, 182c
Deqing, 105c
Dezong, Emperor, 150
Di, people, 106
Dynasties:
 Chen, 107, 122, 123c
 Eastern Han, 12, 77c, 82, 82c, 90c, 91c, 95, 103
 Eastern Jin, 103c, 104, 105c, 107
 Eastern Zhou, 12, 38, 45, 45c, 46c
 Han, 10, 12, 32, 58, 70, 71c, 72, 72c, 74, 75, 77c, 82, 84, 84, 87, 87c, 89c, 93, 94, 95, 103, 122, 124, 129, 144, 146, 192
 Later Han, 152
 Later Jin, 152
 Later Liang, 150, 152
 Later Tang, 152
 Later Zhao, 115c
 Later Zhou, 152, 156
 Liu Song, 107
 Ming, 75c, 103c, 171, 198, 198c, 202, 202c, 203
 Northern Han, 152
 Northern Qi, 116c
 Northern Song, 159, 167, 168, 172, 175, 177c, 178c, 188, 196
 Northern Wei, 103, 103c, 104, 107, 107c, 112c, 115, 116c
 Northern Zhou, 122
 Qi, 58, 150
 Qin, 12, 38, 45, 49, 52, 58, 59, 59c, 60, 70, 71, 72, 124, 184c
 Qing, 8, 129c, 203
 Shang, 12, 24, 25, 25c, 26, 26c, 28c, 30c, 32, 33c, 35, 35c, 38, 40, 41
 Song, 10, 12, 126c, 138, 152, 156, 156c, 158c, 159c, 160, 160c, 163c, 165, 167, 169, 170, 170c, 172, 173, 176, 177, 178, 182, 188, 192, 194, 196, 198, 200, 203
 Southern Song, 160, 160c, 163c, 168, 170c, 171, 175, 178, 196
 Sui, 10, 12, 103, 107, 122, 123c, 124, 124c, 126, 129, 130, 131, 132 148
 Tang, 6c, 10, 11c, 12, 19c, 87, 109c, 111c, 115, 115c, 123, 123c, 124, 126, 129, 130, 131, 131c, 132, 134, 134c, 136c, 138, 138c, 140c, 142c, 144, 144c, 146, 147, 148, 149, 149c, 150, 152, 152c, 156, 158, 159, 167, 175, 178, 178c, 182, 188, 197, 197c
 Western Han, 6c, 8c, 12, 72, 72c, 75, 79c, 80c, 89c, 93, 93c
 Western Jin, 77c, 105c, 106
 Western Zhou, 12, 26c, 30c, 38, 39c, 40, 40c, 41, 41c, 42c, 45, 52
 Xia, 8, 12, 18, 19c, 24, 25, 26
 Yuan, 8, 10, 12, 160, 169c, 170c, 171, 178, 182c, 192, 194c, 196, 198, 198c, 200, 200c, 202
 Zhou, 10, 12, 24, 26, 38, 39, 40, 45, 52, 54
Ding, ceramic ware, 165, 167, 167c, 169
Dingzhou, 167
Dong Qichang, art critic and painter, 198
Dong Yuan, painter, 197
Dong Zhongshu, philosopher, 72
Dou Wan, princess, 72c
Du Fu, poet, 146
Dunhuang, 75c, 112c, 115, 115c, 116c, 131c, 144, 144c, 149c

E
East Asia, 148, 152
Erligang, 12
Erlitou, 12, 26, 26c
Europe, 8, 12

F
Fan Kuan, painter, 172, 173
Fan Zhongyan, statesman, 176
Fang La, military leader, 178
Faxian, monk, 112
Feizi, progenitor of the Qin lineage, 58
Fengxiansi, temple, 148, 149c
Five Dynasties and Ten Kingdoms, period, 10, 12, 152, 156, 172, 178, 182, 197
Freer Gallery of Art (Washington, D.C.), 40, 40c, 175, 175c
Fu Jian, King, 106
Fu Xi, one of the Three Augusts, 19c
Fuchun, 198
Fufeng, 41, 42c
Fuguishan, mount, 103c
Fuhao (Lady Hao), 25, 33c
Fujian, 35, 152, 170, 171, 182c

G
Gandhara, 115
Gangwa, 182
Gansu, 21, 58, 106, 115, 131c, 149c, 188
Gao Ming, writer, 200
Gaochang, 126, 126c
Gao Zecheng, writer, see Gao Ming, 200
Gaozong, Emperor, 130, 131, 134, 148, 149c, 175, 178
Gaozu, Emperor, 71, 71c, 72, 126, 148
Ge, ceramic ware, 165, 171
Ge Hong, philosopher, 109
Genghis Khan, military leader, 192
Gobi, desert, 188
Gongsun Long, philosopher, 55
Great Britain, 203
Great Wall, 60
Gu Kaizhi, painter, 110, 111c, 197
Guan, ceramic ware, 165, 170, 170c, 171
Guan Yu, military leader, 103c
Guangdong, 35
Guanghan, 35, 37c, 95
Guangwu, Emperor, 82
Guangzhou (Canton), 80c
Guanyin, Bodhisattva, 8c, 115c, 182, 182c
Gule, scholar, 188
Guo Xi, painter, 172, 173, 173c
Guyuk (Khan), military leader, 192

H
Han, river, 41, 45
Han Feizi, philosopher, 55
Han Gan, painter, 197, 197c
Han Huang, painter, 147c
Han Yu, scholar, 150
Hangzhou, 160, 160c, 170, 170c, 175, 178, 196, 198, 200
Hanlin Academy (Hanlinyuan), 132
Hebei, 26, 45, 138, 156, 167c, 182, 183c
Hedin, Sven, 188
Heicheng (Khara-Khoto), 188
Helan, mountains, 188
Henan, 12, 21, 25c, 35, 107c, 165c, 169, 188
Hong Kong, 203
Hongtong, 200c
Hongzhi, Emperor, 202c
Hou Han shu (*Book of Later Han*), 82
Houji ("Lord of Millet"), 38
Houma, 48c, 49
Hu, people, 72c
Hua'nan, 35
Huai, river, 45
Huan, river, 25c, 26
Huang Chao, military leader, 150
Huang Gongwang, painter, 198, 198c
Huayan, Buddhist sect, 148
Hubei, 26, 33, 45, 49, 52
Hui, King, 52c
Hui Shi, philosopher, 55
Huiminxiang, 188
Huizong, Emperor, 168, 173c, 175, 177, 178, 178c
Hunan, 28c, 35, 45
Hungary, 182
Huoshan, mount, 200c

I
Imperial Academy, 24
India, 115, 129c
Indian Ocean, 194
Inner Mongolia, 184c, 188, 192

J
Jiancicun, 167
Jiangdu, 124
Jiangsu, 21, 45, 71c, 95
Jiangxi, 170, 182c
Jiankang, 122
Jiaotan, 170c
Jiaxiang, 93
Jin, people and empire, 156, 169, 169c, 170, 175, 178, 189c, 191c
Jin, state, 49
Jin Hailing, Emperor, 178
Jincun, 171
Jing Hao, painter, 172
Jingdezhen, 182c, 194c
Jingtuzong, Buddhist sect, 148
Jun, ceramic ware, 165, 169, 169c, 188
Junzhou, 188
Jurchen (or Nüzhen), people, 156, 177, 178

K
Kaifeng, 150, 152, 159, 159c, 160, 169, 175, 178, 188
Kāśyapa, disciple of the Buddha, 148
Khanbaliq, 192, 196
Koguryo, 124, 126
Kokonor, lake, 126
Korea, 126
Kozlov, Pyotr Kuzmich, 188
Kublai Khan, military leader and Emperor, 12, 192, 194, 196, 197, 202
Kumarajiva, 112

L
Laizi, example of Confucian virtues, 93
Leigudun, 52c
Leitai, 77c
Li Bai, poet, 146
Li Cang, Marquis of Dai, 95c
Li Dan (Ruizong), Emperor, 130, 131
Li Gonglin, painter, 177c
Li Gou, statesman, 176
Li Longji (Xuanzong), Emperor, 131, 132
Li sao (*The Lament*), 52
Li Shimin (Taizong), Emperor, 126
Li Si, minister, 58, 60
Li Sixun, painter, 144
Li Taibai, poet, see Li Bai, 146
Li Xian, tomb of, 150c
Li Yannian, musician, 87
Li Yuan (Gaozu), Emperor, 126
Li Zanhua, painter, 150c
Li Zhaodao, painter, 144
Li Zhe (Zhongzong), Emperor, 130, 131
Li Zhi (Gaozong), Emperor, 130, 131
Liao, river, 182
Liao, people and empire, 8c, 152, 152c, 156, 176, 178, 182, 182c, 183c, 184c
Liaoning, 21
Lienü zhuan (*Traditions of Exemplary Women*), 93, 111c
Lin'an (Hangzhou), 160c, 178
Lingwu, 188
Linru, 169
Liu Bang, military leader, 12, 70, 71, 71c
Liu Bei, military leader, 103
Liu Bingzhong, statesman, 192
Liu Sheng, Prince, 72c
Liu Xiang, scholar, 93
Liu Xie, scholar, 110
Liu Xijun, poet, 72
Liulihe, 41c
Longmen, 110, 115, 148, 149c
Longquan, 170c
Lord Above (Shangdi), 24
Lu, state, 45, 53, 54
Lü Buwei, minister, 60
Lu Yu, writer, 138
Lunyu (*The Analects*), 53, 53c
Luo Guanzhong, writer, 104
Luoyang, 26, 38, 45, 103, 103c, 107, 108, 109, 115, 124, 130, 131, 150
Luoyi (Luoyang), 12, 38
Lushan, 165c

M
Ma Yuan, painter, 175, 175c
Machang, 20c
Mancheng, 72c
Manchuria, 122, 124, 178, 182
Marquise of Dai, 84, 84c, 87c, 95, 95c, 97c
Marquise Hao, see Fuhao, 32
Mausoleum of Emperor Jingdi (Hanyangling), 207c
Mausoleum of Qin Shi Huangdi, 6c
Mausoleum of Wu Liang, 93
Mawangdui, 84, 84c, 87c, 94, 95c
Mazuo, 90c
Mencius, philosopher, 54, 55, 55c
Meng Ke, philosopher, see Mencius, 55c
Mengzi, philosopher, see Mencius, 55c
Mi Fu, painter, 175, 175c, 196
Milky Way, 18
Mingdi, Emperor, 53, 82, 82c
Mingdu pian (*On the Famous Capital*), 84
Minghuang (Xuanzong), Emperor, 132
Mogao, 75c, 115c, 149c
Mongke (Khan), military leader, 192
Mongolia, 35, 126
Mozi (or Modi), philosopher, 54

Museum of Fine Arts (Boston), 129
Mythical Emperors, 18, 19c

N
Nanjing, 103c, 104, 110, 115, 122, 203
Nanyue, kingdom, 80c
Nelson-Atkins Museum (Kansas City), 115
Ni Zan, painter, 198, 198c
Ningxia, 188
Ningxiang, 30c, 35c
Nü jie (*Lessons for Women*), 93
Nü Wa, female divinity, 18, 19c

O
Ogodai (Khan), military leader, 192
Ordos, 35, 126
Oriental Asia, 18, 74,

P
Persia, 126
Pingcheng, 103c, 107
Pingshan, 51c
Pit K0006 ("pit of the civil officials"), 58c
Pliny, 82
Polo, Marco, 160, 194
Prabhutaratna, Buddha, 112c

Q
Qian Xuan, painter, 132c, 196, 197, 197c
Qiang, people, 38, 188
Qidan (Liao), people, 152, 176
Qin Shi Huangdi, Emperor, 10, 12, 58c, 59c, 60, 60c, 63c, 124
Qinghai, 188
Qingliangsi, 168, 169, 169c
Qiu Ying, painter, 147c
Qu Yuan, poet, 52
Quyang, 167

R
Red Eyebrows, revolt of the, 82
Red Turbans, revolt of the, 202
Rong, people, 45
Ru, ceramic ware, 165, 168, 169, 169c
Ruizong, Emperor, 130, 131
Ruzhou, 168

S
St. Petersburg, 188
Sanji, 51c
Sanxingdui, 17, 19c, 35, 37c
Sea of Japan, 182
Seres, people, 82
Sha Wujing, literary figure, 129c
Shaanxi, 21, 26, 41, 140c, 150c, 188
Shandong, 35, 53
Shang jun shu (*The Book of Lord Shang*), 59
Shangjing, 182
Shang Xi, painter, 103c
Shang Yang (Lord Shang), 59
Shanxi, 26, 116c, 126, 156, 200c
Shenzong, Emperor, 176, 177c
Shiji (*Historical Records*), 24, 58
Shizishan, 95
Shizong, Emperor, 178
Shu jing (*Classic of Documents*), 38
Shu, state, 103, 104
Shun, one of the Mythical Emperors, 19c, 58
Siberia, 182
Sichuan, 35, 103, 132, 109c
Sima, family, 104
Sima Guang, historian, 176
Sima Jinlong, tomb of, 110, 111c
Sima Qian, historian, 24, 58, 62
Sima Xiangru, poet, 75c
Sixteen Kingdoms, period, 106, 115c
Spring and Autumn, period, 45, 45c
Stein, Aurel, 188
Su Dongpo, painter, 175
Su Hui, woman of the Qin dynasty, 184c
Su Shi, painter, see Su Dongpo, 175, 196
Suixian, 52c
Sun Wei, painter, 109c
Sun Wukong, literary figure, 129c
Supreme Ancestor, 24
Suzong, Emperor, 132

T
Tai Kui, painter, 110
Taiwan, 35
Taiyuan, 116c, 126
Taizong, Emperor, 126, 126c, 129, 130, 131, 134, 136c, 156, 176
Taizu, Emperor, 156, 156c
Tangut, people, 126, 156, 176, 177, 182, 186
Tao Qian, scholar, 109
Tao Yuanming, scholar, see Tao Qian, 109
Tarim, 82c
Temujin, military leader, see Genghis Khan, 192
Terracotta Army, 59c, 62
Three Dynasties, period, 26
Tiantai, Buddhist sect, 148
Tomb 5 at Anyang, 25, 33c
Tuoba, people, 106, 107, 112, 115
Tuoba-Wei, people, 112
Turfan, 126, 126c

V
Vairocana, Buddha, 148

W
Wanchuan, 146, 147c
Wang, family, 75
Wang, Empress, 130
Wang Anshi, minister, 176, 177c
Wang Mang, military leader, 75, 82
Wang Meng, painter, 198, 198c
Wang Shifu, writer, 200
Wang Wei, poet and painter, 144, 146, 147c, 175
Wang Ximeng, painter, 173c
Wang Xizhi, calligrapher and painter, 110
Wang Yirong, scholar, 24
Wangjiafeng, 116c
Wanli, Emperor, 202c
Wanyan, people, 188
Warring States, period, 6c, 45, 46c, 48c, 49, 58
Wei, state, 58
Wei, Empress, 131
Wei, river, 12, 62
Wei Bo Xing, tomb of, 41, 42c
Wen, King, 38
Wen Zhengming, painter, 147c
Wendi, Emperor, 72, 80c, 122, 123c, 124, 148
Wu, culture, 45
Wu, King, 38
Wu, state, 52, 103, 104
Wu Cheng'en, writer, 129, 129c
Wu Daozi, painter, 144
Wu Zetian, Empress, 130, 131, 132c, 134, 148
Wu Zhao, Empress, see Wu Zetian, 130
Wu Zhen, painter, 198
Wu'an, tomb of, see Xu Xianxiu, 116c
Wudi, Emperor, 74, 75, 75c, 87, 94
Wusun, people, 72
Wuxing, 196
Wuyue, state, 182
Wuzong, Emperor, 150

X
Xi Hu (Western Lake), 160c
Xi Xia (Western Xia), people and empire, 156, 176, 182, 188, 189c, 192
Xi'an, 21, 38, 58c, 62, 87, 112
Xia Gui, painter, 175
Xianbei, people, 106
Xiang Yu, military leader, 70, 71, 71c
Xianyang, 12, 59c, 62, 72
Xianzong, Emperor, 150
Xiao Tong, scholar, 110
Xiaotun, 25c
Xiaozong, Emperor, 178
Xie He, art critic, 110
Xijiang, river, 35
Xin Zhui, Marquise of Dai, 95c
Xin'gan Dayangzhou, 35
Xiangjiang, river, 35
Xing, ceramic ware, 138
Xingqingfu, 188
Xingzhou, 138
Xinjiang, 126, 126c, 182
Xintian, 49
Xiongnu, people, 72, 72c, 74, 75c, 82, 106

Xiuding, temple, 136c
Xu Bingchang, scholar, 188
Xu Xianxiu, tomb of, 116c
Xuande, Emperor, 202c
Xuandi, Emperor, 75
Xuanhe, era, 168
Xuanzang, pilgrim monk, 129, 129c
Xuanzong, Emperor, 131, 132, 132c, 134, 146, 149c
Xun Qing, philosopher, see Xunzi, 55c
Xunzi, philosopher, 55, 55c, 60

Y
Yahehuayuan, 87
Yan, state, 58
Yan Liben, painter, 123c, 126c, 129
Yang Guang (Yangdi), Emperor, 124
Yang Guifei, concubine, 132, 132c
Yang Jian (Wendi), Emperor, 122
Yang Yuhuan, concubine, see Yang Guifei, 132
Yangdi, Emperor, 123c, 124, 124c, 126, 148
Yangzhou, 124
Yangzi, river, 18, 21, 28c, 35, 41, 52, 103, 104, 122, 152
Yao, one of the Mythical Emperors, 19c
Yaozhou, 171
Yellow River (Huanghe), 10, 35, 38, 124, 194

Yellow Turbans, revolt of the, 82, 94, 103
Yi, 182, 183c
Yi of Zeng, Marquis, 49, 52c
Yide, Prince, 140c
Yinchuan, 188
Yinxu, 12, 25c, 26
Yongle, Emperor, 202c
Yongningsi, temple, 103c
Yu, one of the Mythical Emperors, 58
Yu, 169, 188
Yue, culture, 45
Yue, state, 52
Yue, ceramic ware, 105c, 138, 171
Yuexianpu, 35c
Yuezhou, 138
Yungang, 115
Yunnan, 35, 97c

Z
Zhang Qian, traveler, 74, 75c, 84
Zhang Xuan, painter, 138, 178c
Zhang Zeduan, painter, 159
Zhangdi, Emperor, 82
Zhanguozi (Record of the Warring States), 45
Zhangzong, Emperor, 178
Zhao, state, 58
Zhao Boju, painter, 71c

Zhao Gao, son of the First Emperor, 70
Zhao Hu, King, 80c
Zhao Kuangyi (Taizong), Emperor, 156
Zhao Kuangyin (Taizu), Emperor, 156
Zhao Mengfu, painter, 196, 197, 197c, 198
Zhao Mo, King, 80c
Zhao Tuo, King, 80c
Zhao Yong, painter, 177c
Zhaogou (Gaozong), Emperor, 178
Zhaozong, Emperor, 150
Zhejiang, 45, 105c, 138, 152, 170, 171, 178
Zheng, King, 45, 60
Zhengzong, Emperor, 176
Zhezong, Emperor, 177
Zhiyi, philosopher, 148
Zhongshan, state, 49, 51c
Zhongxingfu, 188
Zhongzong, Emperor, 130, 131
Zhou Fang, painter, 138, 138c
Zhu Bajie, literary figure, 129c
Zhu Geliang, military leader, 103, 104
Zhu Wen, military leader, 150
Zhu Yuanzhang (Hongwu), Emperor, 202
Zhuangbai, 42c
Zhuangzi, philosopher, 52, 54
Zhuanxu, legendary king, 58
Zhukaigou, 35

BIBLIOGRAPHY

CLUNAS, CRAIG, *Art in China*, Oxford University Press, Oxford & New York 1997
DE GIORGI, LAURA AND SAMARANI, GUIDO, *La Cina e la storia. Dal tardo impero ad oggi*, Carocci editore, Rome 2005
Echoes of Great Times. The Most Beautiful Works of Arts in Ancient China, Cultural Relics Publishing House – China Intercontinental Press, Beijing 2006
FAHR-BECKER, GABRIELE (ED.), *The Art of East Asia*, vol. I, Könemann, Köln 1999, pp. 1-311, "China".
GILES, HERBERT A., *Chinese Poetry in English Verse*, B. Quaritch, London 1898
Gulik, R.H. van, *Hsi K'ang and his Poetical Essay on the Lute*, Tuttle, Tokyo and Rutland 1969
KESSLER, ADAM T., *Empires Beyond the Great Wall: The Heritage of Genghis Khan*, Natural History Museum of Los Angeles County, Los Angeles 1994
NEEDHAM, JOSEPH, *Science and Civilization in China*, Cambridge University Press, Cambridge 1976
PIRAZZOLI-T'SERSTEVENS, MICHÈLE (ED.), *La Cina*, 2 vols., Storia Universale dell'Arte, Sezione Seconda: Le Civiltà dell'Oriente, pt. 5, UTET, Turin 1996
RAWSON, JESSICA, *Ancient China. Art and Archaeology*, Harper & Row, Publishers, New York 1980
RAWSON, JESSICA (ED.), *The British Museum Book of Chinese Art*, British Museum Press, London 1992
RAWSON, JESSICA (ED.), *Mysteries of Ancient China. New Discoveries from the Early Dinasties*, British Museum Press, London 1996
ROBERTS, JOHN A.G., *A History of China*, 2nd ed., Palgrave Macmillan, Basingstoke 2006
SABATTINI, MARIO AND SANTANGELO, PAOLO, *Storia della Cina*, 3rd ed., Laterza, Bari 2006
SCARPARI, MAURIZIO, *Ancient China: Chinese Civilization from its Origins to the Tang Dynasty*, Barnes and Noble, New York 2000
SICKMAN, LAURENCE AND SOPER, ALEXANDER, *The Art and Architecture of China*, 3rd edition, The Yale University Press Pelican History of Art Series, Yale University Press, New Haven 1992
Three Thousand Years of Chinese Painting, Yale University Press, New Haven & London – Foreign Languages Press, Beijing 1997
TREGEAR, MARY, *Chinese Art*, Oxford University Press, Oxford 1980
VAINKER, SHELAGH J., *Chinese Pottery and Porcelain: From Prehistory to the Present*, Gorge Braziller Inc., New York 1991
WALEY, ARTHUR, *Translations from the Chinese*, Alfred A. Knopf, Inc., New York 1941

Abbreviations used in the captions
AAM: Asian Art Museum (San Francisco)
BL: British Library (London)
BM: British Museum (London)
BNF: Bibliothèque Nationale de France (Paris)
CARPC: Archaeological Collection of the People's Republic of China (Beijing)
CI: Christie's Images Ltd.
CP: Private Collection
CRPH: Cultural Relics Publishing House
EL: Eskenazi Ltd. (London)
FSG: Freer/Sackler Galleries, Smithsonian Institution (Washington, D.C.)
HFAM: Hakutsuru Fine Art Museum (Hyogo, Japan)
HM: Hanyangling Museum (Xianyang, Shaanxi)
IAACSS: Institute of Archaeology of the Chinese Academy of Social Sciences (Beijing)
IBC: Institute of Cultural Relics (Beijing)
ICBCX: Xi'an Centre for the Conservation of Cultural Relics (Xi'an, Shaanxi)
IMICRA: Inner Mongolia Cultural Relics and Archaeology Institute
MADL: Musée Adrien Dubouché (Limoges)
MBLY: Lijiashan Bronze Museum (Yunnan)
MC: Beijing Capital Museum
MCD: Museum of the City of Datong (Shanxi)
MCT: Tongliao Museum (Inner Mongolia)
MET: Museum of the Terracotta Warriors and Horses of Qin Shihuang (Lintong, Xi'an, Shaanxi)
METNY: The Metropolitan Museum of Art (New York)
MFA: Museum of Fine Arts (Boston)
MG: Musée des Arts Asiatiques-Guimet (Paris)
MIK: Museum für Indische Kunst (Berlin)
MMI: Inner Mongolia Museum (Hohot)
MMX: Xianyang Municipal Museum (Shaanxi)
MOC: Museum of Oriental Ceramics (Osaka)
MPA: Anhui Provincial Museum (Hefei)
MPG: Gansu Provincial Museum (Lanzhou)
MPGU: Guizhou Provincial Museum (Guiyang)
MPHEB: Hebei Provincial Museum (Shijiazhuang)
MPHEN: Henan Provincial Museum (Zhengzhou)
MPHUB: Hubei Provincial Museum (Wuhan)
MPHUN: Hunan Provincial Museum (Changsha)
MPJ: Jiangxi Provincial Museum (Nanchang)
MPL: Liaoning Provincial Museum (Shenyang)
MPY: Yunnan Provincial Museum (Kunming)
MRAXU: Xinjiang Uighur Autonomous Region Museum (Urumqi)
MPS: Shanxi Provincial Museum (Taiyuan)
MSC: Museum of Chinese History (Beijing)
MSPS: Shaanxi Provincial History Museum (Xi'an)
MTF: Famen Temple Museum (Fufeng, Shaanxi)
MTHD: Museum of Dabaotai Han Tomb (Beijing)
MTRN: Western Han Nanyue King's Tomb Museum (Guangzhou)
MX: Xuzhou Museum (Jiangsu)
MZF: Zhouyuan Museum (Fufeng, Shaanxi)
NAM: Nelson-Atkins Museum (Kansas City, Missouri)
NIFA: Nezu Institute of Fine Arts (Tokyo)
NM: Nanjing Museum (Jiangsu)
NPM: National Palace Museum (Taipei)
PDF: The Percival David Foundation of Chinese Art (London)
PM: Palace Museum (Beijing)
ROM: Royal Ontario Museum (Toronto)
SHM: Shanghai Museum (Shanghai)
SM: Sanxingdui Museum (Guanghan, Chengdu, Sichuan)
UBCQ: Qufu Cultural Relics Management Bureau (Shandong)

Page 1 Courtesy of the Eskenazi Ltd, London
Pages 2-3 Thierry Ollivier/Photo RMN
Pages 4-5 Araldo De Luca/Archivio White Star
Page 7 Legacies Images
Page 8 Freer Gallery of Art, Smithsonian Institution, Washington, D.C., Purchase, F1935.13
Page 9 The Nelson-Atkins Museum of Art, Kansas City, Missouri. Purchase: Nelson Trust, 34-10. Photograph by Jamison Miller
Pages 10-11 Royal Ontario Museum/Corbis
Page 13 Elisabetta Ferrero/Archivio White Star
Pages 14-15 Legacies Images
Page 16 Legacies Images
Page 18 left Legacies Images
Page 18 right Legacies Images
Page 19 Legacies Images
Page 20 top The Bridgeman Art Library/Archivi Alinari, Firenze
Page 20 bottom Legacies Images
Page 21 left Legacies Images
Page 21 right The Trustees of British Museum
Page 22 top Legacies Images
Page 22 bottom Legacies Images
Pages 22-23 Legacies Images
Page 25 left Legacies Images
Page 25 center Legacies Images
Page 25 right Legacies Images
Page 26 Legacies Images
Page 27 left Legacies Images
Page 27 right Legacies Images
Page 28 Legacies Images
Pages 28-29 Legacies Images
Page 29 Legacies Images
Page 30 Legacies Images
Page 31 Legacies Images
Page 32 left Legacies Images
Page 32 right Royal Ontario Museum/Corbis
Page 33 Legacies Images
Page 34 Legacies Images
Page 35 Legacies Images
Pages 36-37 Legacies Images
Page 37 left Legacies Images
Page 37 right Legacies Images
Page 38 Freer Gallery of Art, Smithsonian Institution, Washington, D.C., Gift of Charles Lang Freer, F1911.40
Page 39 left Legacies Images
Page 39 right Freer Gallery of Art, Smithsonian Institution, Washington, D.C., Purchase, F1925.2
Page 40 Freer Gallery of Art, Smithsonian Institution, Washington, D.C., Purchase, F1935.21
Page 41 left Legacies Images
Page 41 center Legacies Images
Page 41 right Legacies Images
Page 42 left Legacies Images
Page 42 right Legacies Images
Page 43 Legacies Images
Page 44 left Legacies Images
Page 44 right Legacies Images
Page 46 left Christie's Images Ltd. 1992
Pages 46-47 The Trustees of British Museum
Page 47 Freer Gallery of Art, Smithsonian Institution, Washington, D.C., Purchase, F1935.13
Pages 48-49 Legacies Images
Page 49 Legacies Images
Page 50 Legacies Images
Pages 50-51 Legacies Images
Page 51 Legacies Images
Page 52 left Legacies Images
Page 52 right Legacies Images
Page 53 Legacies Images
Page 54 Legacies Images
Page 55 Legacies Images
Page 56 Araldo De Luca/Archivio White Star
Page 58 Araldo De Luca/Archivio White Star
Page 59 left Araldo De Luca/Archivio White Star
Page 59 right Araldo De Luca/Archivio White Star
Page 60 Erich Lessing/Contrasto
Page 61 The Bridgeman Art Library/Archivi Alinari, Firenze
Pages 62-63 Araldo De Luca/Archivio White Star
Page 64 Araldo De Luca/Archivio White Star
Page 65 Araldo De Luca/Archivio White Star
Page 66 Araldo De Luca/Archivio White Star
Page 67 Araldo De Luca/Archivio White Star
Pages 68-69 Araldo De Luca/Archivio White Star
Pages 70-71 Burstein Collection/Corbis
Page 71 top Burstein Collection/Corbis
Page 71 bottom Legacies Images
Page 72 Legacies Images
Page 73 Legacies Images
Pages 74-75 Freer Gallery of Art, Smithsonian Institution, Washington, D.C., Gift of Charles Lang Freer, F1913.47
Page 75 top Legacies Images
Page 75 bottom Getty Images
Pages 76-77 Cultural Relics Publishing House
Page 77 Legacies Images
Page 78 left Legacies Images
Page 78 right Legacies Images
Page 79 Legacies Images
Page 80 Legacies Images
Pages 80-81 Legacies Images
Page 81 left Legacies Images
Page 81 right Legacies Images
Page 82 Legacies Images
Page 83 Getty Images
Page 84 left Legacies Images
Page 84 right Legacies Images
Page 85 left Legacies Images
Page 85 right Legacies Images
Pages 86-87 Asian Art & Archaeology, Inc./Corbis
Page 87 Legacies Images
Pages 88-89 Courtesy of the of Eskenazi Ltd, London
Page 89 Legacies Images
Page 90 Legacies Images
Page 91 left Legacies Images
Page 91 right Cultural Realics Publishing House
Page 92 Legacies Images
Page 93 Legacies Images
Page 94 Legacies Images
Page 95 Asian Art & Archaeology, Inc./Corbis
Page 96 Legacies Images
Page 97 left Legacies Images
Page 97 right Legacies Images
Page 98 Asian Art & Archaeology, Inc./Corbis
Pages 98-99 Asian Art & Archaeology, Inc./Corbis
Page 99 Legacies Images
Page 101 Legacies Images
Pages 102-103 Legacies Images
Page 103 Legacies Images
Page 104 Royal Ontario Museum/Corbis
Page 105 left Royal Ontario Museum/Corbis
Page 105 right Thierry Ollivier/Photo RMN
Page 106 Thierry Ollivier/Photo RMN
Page 107 Richard Lambert/Photo RMN
Pages 108-109 Legacies Images
Page 110 Legacies Images
Pages 110-111 Cultural Realics Publishing House
Page 111 Legacies Images
Page 112 Thierry Ollivier/Photo RMN
Page 113 Legacies Images
Page 114 Legacies Images
Page 115 Asian Art Museum, San Francisco
Page 116 Legacies Images
Pages 116-117 Archivio Scala, Firenze
Pages 118-119 Legacies Images
Page 121 Legacies Images
Pages 122-123 Burstein Collection/Corbis
Page 123 Legacies Images
Page 124 The Trustees of British Museum
Page 125 Legacies Images
Page 126 Legacies Images
Page 127 Legacies Images
Page 128 Legacies Images
Page 129 Legacies Images
Page 130 Legacies Images
Page 131 Legacies Images
Page 132 left Freer Gallery of Art/The Art Archive
Page 132 right Freer Gallery of Art/The Art Archive
Page 133 Legacies Images
Page 134 left Legacies Images
Page 134 right Legacies Images
Page 135 Legacies Images
Page 136 The Trustees of British Museum
Page 137 Christie's Images Ltd. 1998
Page 138 Gianni Dagli Orti/Musée Guimet Paris/The Art Archive
Page 139 left Legacies Images
Page 139 right Legacies Images
Page 140 Legacies Images
Page 141 Erich Lessing/Contrasto
Page 142 Legacies Images
Pages 142-143 Christie's Images Ltd. 1996
Page 144 top The Trustees of British Museum
Page 144 bottom Legacies Images
Page 145 Legacies Images
Page 146 Legacies Images
Page 147 top Legacies Images
Page 147 bottom Legacies Images
Pages 148-149 Brian A. Vikander/Corbis
Page 149 top Legacies Images
Page 149 bottom Legacies Images
Page 150 Legacies Images
Page 151 Legacies Images
Pages 152-153 The Trustees of British Museum
Page 151 Cultural Relics Publishing House
Page 154 Legacies Images
Page 156 Legacies Images
Page 157 Legacies Images
Page 158 Legacies Images
Page 159 Legacies Images
Pages 160-161 Freer Gallery of Art, Smithsonian Institution, Washington, D.C., Gift of Charles Lang Freer, F1911.209
Page 161 The Trustees of the British Museum/Photo RMN
Pages 162-163 Freer Gallery of Art, Smithsonian Institution, Washington, D.C., Gift of Arthur M. Sackler, S1987.372
Page 163 top Freer Gallery of Art, Smithsonian Institution, Washington, D.C., Gift of Arthur M. Sackler, S1987.727
Page 163 center Photo RMN
Page 163 bottom Freer Gallery of Art, Smithsonian Institution, Washington, D.C., Gift of Arthur M. Sackler, S1987.368
Page 164 The Trustees of British Museum
Pages 164-165 The Trustees of British Museum
Page 166 The Trustees of British Museum
Page 167 The Trustees of British Museum
Page 168 left The Percival David Foundation of Chinese Art, London
Page 168 right The Percival David Foundation of Chinese Art, London
Page 169 left The Trustees of British Museum
Page 169 right The Percival David Foundation of Chinese Art, London
Page 170 left Legacies Images
Page 170 right Freer Gallery of Art, Smithsonian Institution, Washington, D.C., Gift of Charles Lang Freer, F1911.347
Page 171 left Legacies Images
Page 171 right The Percival David Foundation of Chinese Art, London
Page 172 Legacies Images
Pages 172-173 Legacies Images
Pages 174-175 Legacies Images
Page 175 top Legacies Images
Page 175 bottom Freer Gallery of Art, Smithsonian Institution, Washington, D.C., Gift of Charles Lang Freer, F1908.171
Page 176 Legacies Images
Page 177 Legacies Images
Page 178 Legacies Images
Page 179 Legacies Images
Page 180 Richard Lambert/Photo RMN
Page 182 left Legacies Images
Page 182 right Legacies Images
Page 183 HIP/Archivio Scala, Firenze
Page 184 Legacies Images
Page 185 Legacies Images
Pages 186-187 Legacies Images
Page 188 Legacies Images
Page 189 left Legacies Images
Page 189 right Legacies Images
Pages 190-191 Legacies Images
Page 191 top Legacies Images
Page 191 bottom Legacies Images
Page 192 Legacies Images
Page 193 Legacies Images
Page 194 left P. Pleynet/Photo RMN
Page 195 right M. Beck-Coppola/Photo RMN
Page 196 Legacies Images
Pages 196-197 Legacies Images
Page 197 Legacies Images
Page 198 Legacies Images
Page 199 left Legacies Images
Page 199 right Legacies Images
Page 200 Legacies Images
Page 201 Getty Images
Page 202 The Palace Museum, Beijing
Page 203 left The Palace Museum, Beijing
Page 203 center The Palace Museum, Beijing
Page 203 right The Palace Museum, Beijing
Page 208 Legacies Images

208 - THIS TERRA-COTTA FIGURINE OF A MAIDEN, DECORATED IN COLORED PIGMENTS, WAS FOUND IN THE MAUSOLEUM OF EMPEROR JINGDI (157–141 BC) OF THE WESTERN HAN DYNASTY NEAR XI'AN IN SHAANXI (HM).